Genius Loci:
'the distinctive atmosphere or
pervading spirit of a place'

May you find it!

IRELAND THE BEST
100 PLACES

Published by Collins
An imprint of HarperCollins Publishers
Westerhill Road
Bishopbriggs
Glasgow G64 2QT
www.harpercollins.co.uk

1st edition 2019

Series editor: Peter Irvine

A catalogue record for this book is available from
the British Library

ISBN 978-0-00-835468-8

10 9 8 7 6 5 4 3 2 1

Printed in China by RR Donnelley APS Co Ltd

If you would like to comment on any aspect of this book,
please contact us at the above address or online.
e-mail: **the.best@harpercollins.co.uk**

IRELAND THE BEST
100 PLACES

John McKenna and Sally McKenna

INTRODUCTION

In every country, there are special places that inspire in us a particular emotional resonance whenever we find ourselves in that hallowed place.

These special places seem to act as lightning conductors for our deepest feelings and understanding of history, culture and landscape. You walk into the Gallarus Oratory, on the Slea Head Drive, for instance, and it inspires both a sense of awe – how did they do this – and a sense of the long reach of history. This has been here for so long, so long.

You look into the blue of a Harry Clarke stained glass window, or hear a reader reciting a passage from James Joyce's *Finnegans Wake*, on Bloomsday in Dublin, and you marvel at the creativity of the human mind across the ages, its playfulness, its profundity, its ability to fashion our emotions.

This book is about the Places in Ireland that inspire those emotions. Over the last thirty years we have travelled the roads of Ireland, researching and writing books. And everywhere we have travelled, we have also marvelled – at the grace of The Twelve Bens in Connemara, or the ramrod straightness of the Mourne Walls, or the shock of the ice cold water at Guillamene, or the pagan power of St Aengus Church, in Burt, County Donegal.

Ireland is a small and remote country, a footnote of geography at the end of Europe. Yet it offers astonishing riches, in landscape, in culture, in historical artefacts of all sizes and ages, as we hope we have shown with this selection of 100 Places.

We have tried to balance the objectivity of experience with the subjectivity of personal preference: we love these places, of course, and hope that you will also. But we realise that every traveller can make their own list of 100 Special Places in Ireland, and that not everyone will share our belief that a sausage and soda farl sandwich eaten at the St George's Market in Belfast on a Saturday morning is an experience to rank with that first glimpse of The Giant's Causeway, or the power of Newgrange, or watching a Macnas parade in Galway city. But our 100 Places intrigue us, and delight us.

Ireland the Best 100 Places is a photography book with descriptive text. But we hope that it will also serve as a practical and useful manual, and so when we let you know exactly how to find each place, we then also recommend the best places to sleep, eat and walk nearby. You will find even greater detail in this book's companion volume *Ireland the Best*.

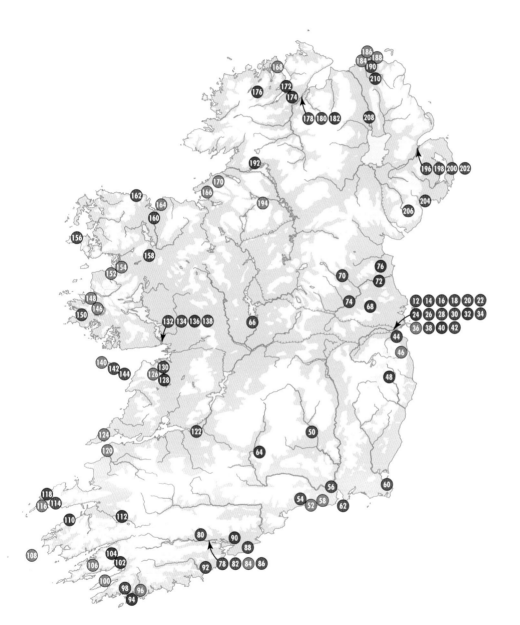

For orientation, we've divided Ireland up into Dublin and the East, the Midlands, Cork and the South West, Galway and the West, and Northern Ireland.

The 100 Best Places are assigned into three categories: Magnificent Places, Reflective Places and Human Places.

MAGNIFICENT PLACES

These are places that will take your breath away: the magnificent Book of Kells, the Ogham Stones in UCC, the Sheep's Head Way, Skellig Michael, The Burren, Kylemore Abbey.

REFLECTIVE PLACES

These are spiritual places that will slow you and then stop you in your tracks, and make you ponder the hidden depths of Ireland's heritage as you listen to Seamus Heaney recite a line from his own poems in HomePlace, park the car on the side of the road and visit the Poulnabrone Dolmen, walk across the Peace Bridge in Derry, watch the stars from the Bubble Domes at Finn Lough.

HUMAN PLACES

Places where you feel and enjoy the warmth of human endeavour, the inspiration of human achievement: Bloomsday in Dublin, listening to Irish music in O'Donoghue's pub, the parades of Dingle Wren and Macnas, the Wall Murals in Belfast, the Céide Fields – evidence of farmers, builders and craftspeople at work, 6,000 years ago.

CONTENTS

DUBLIN AND THE EAST

THE MIDLANDS

CORK AND THE SOUTH WEST

GALWAY AND THE WEST

NORTHERN IRELAND

FIND | WALK | EAT | SLEEP

*Overleaf: Twelve Bens.
See page 146
for more details.*

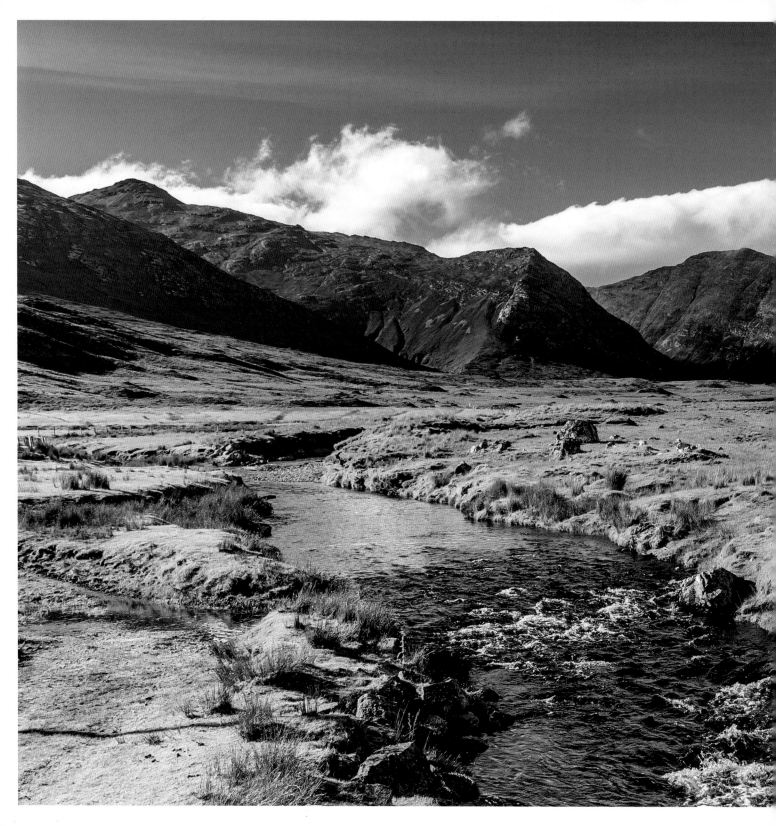

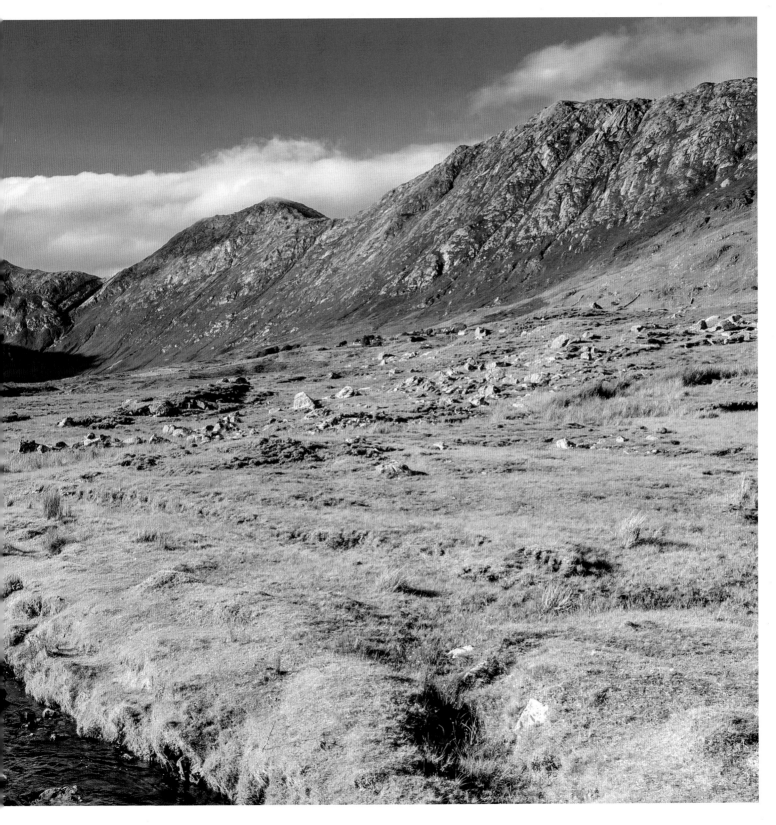

WHELAN'S
DUBLIN

For three decades, Whelan's has been the signature destination for Dublin's alternative music scene. You might be one of the lucky few who saw Jeff Buckley play here, but whether it's a superstar-in-waiting you've come to see, or just some of your friends who are starting out on their musical pathway, Whelan's offers an intimacy to the musical experience. Its coolness and confidence is understated, and it has resisted change whilst everything around it on Wexford Street has been transformed. A modest little star whose vibe makes pretty much every gig special.

FIND | WALK | EAT | SLEEP PAGE 213

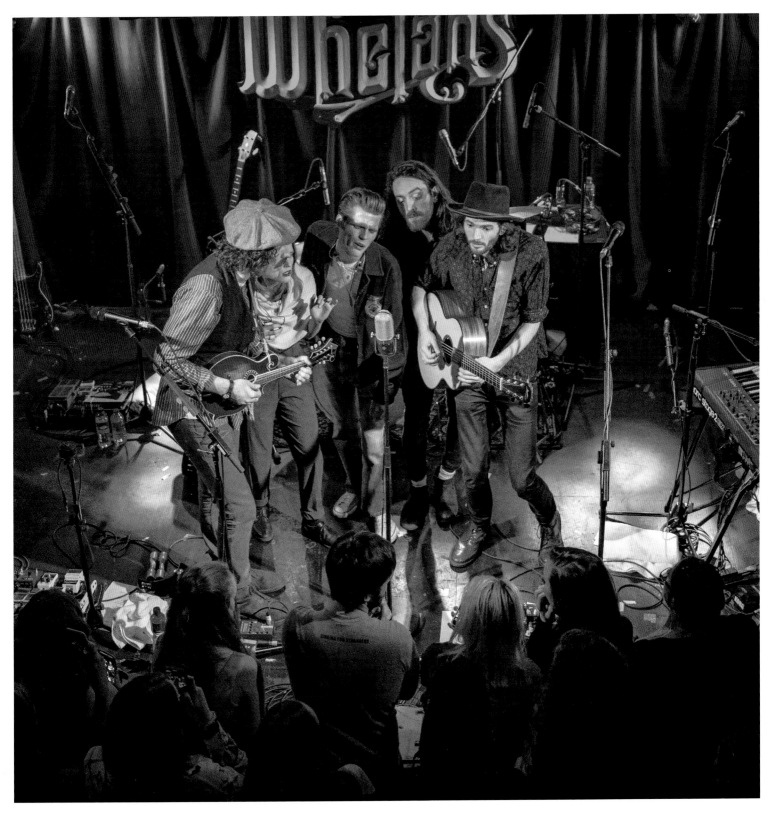

THE WINDING STAIR
DUBLIN

When restaurateur Elaine Murphy converted an iconic bookstore and opened The Winding Stair as a restaurant back in 2006, with chef Aine Maguire in the kitchen, the two women rescued traditional Irish cookery from the museum of the culinary arts, and brought it screaming into the 21st century. A style of cooking associated with nostalgia and poverty was suddenly revealed to be progressive and soulful, so the punters fell upon their dishes of Dingle crab with soda bread, and poached fish with Cheddar mash, and bread and butter pudding with whiskey sauce, and those punters have been packing out the light-filled upstairs dining room, which looks upon the River Liffey and the Ha'penny Bridge, ever since, creating one of Dublin's great dining rooms. Ms Murphy's act of culinary resurrection remains one of the most important events in Irish food history and make sure, before you climb those winding stairs, to check out the fine bookstore that remains on the ground floor.

FIND | WALK | EAT | SLEEP PAGE 213

BLOOMSDAY
DUBLIN

In 1924, James Joyce scrawled in a notebook: 'Today 16 of June 20 years after. Will anybody remember this date.'

The answer, as Molly Bloom could have told him, is: Yes.

June 16th, 1904, the date on which Joyce set his masterpiece *Ulysses,* is celebrated by Joyceans each year as Bloomsday. Folk dress in period costume, walk some of the routes described in the novel, recite passages from Joyce's writings, and generally make a good old song and dance about the greatest novel of the 20th century. Bloomsday is charming, even if you don't eat Leopold Bloom's breakfast of grilled mutton kidneys, or have a bowl of giblet soup.

FIND | WALK | EAT | SLEEP **PAGE 213**

ASSASSINATION CUSTARD
DUBLIN

Assassination Custard is the restaurant as performance art. The performer cooks are Ken and Gwen, he as lanky as she is short, partners in life and work, and art. They run a room with a counter, a three-hob stove, and a pair of tables, squeezed into a nondescript room in a block of Iveagh Trust flats. They wear T-shirts blazoned with slogans such as: 'Have you tried our famous tripe?' They like to work with all the queer gear: lamb ribs; brawn fritters; monkfish cheeks; goat kidneys; ray jowls; and, yes, their famous tripe. They write a tiny menu on paper bags each day, and the best advice is simply to order everything, from the lamb heart curry to the panelle to the dandelions with anchovy to the chopped liver. No other cooking is so iconoclastic, so wild and crazy, and yet so perfectly, precisely rendered.

FIND | WALK | EAT | SLEEP **PAGE 213**

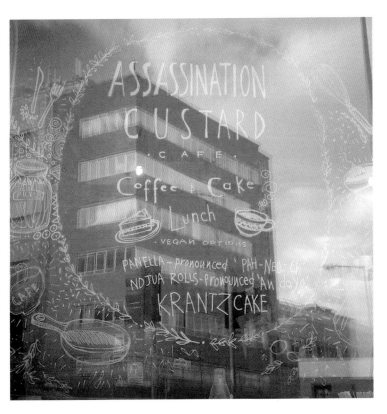

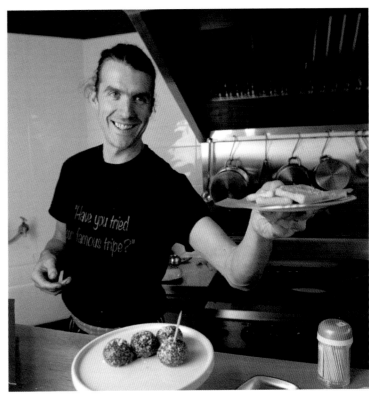

THE ALL-IRELAND HURLING FINAL AT CROKE PARK
DUBLIN

Whilst modern Gaelic football has followed sports such as rugby in becoming an intensely physical contest, hurling remains the most balletic, swift and beautiful sport to spectate. Teams are organised according to Irish counties, and rivalries are particularly intense, with a handful of counties – Kilkenny; Clare; Tipperary; Cork; Galway; Waterford – fielding teams of enviable skill and stamina. The 'Clash of the Ash' is when Ireland's regional GAA (Gaelic Athletic Association) champions battle with *hurl* and *sliotar* to win the All-Ireland Hurling Final, and hoist the Liam McCarthy Cup in front of over 80,000 fans in Dublin's Croke Park stadium. Tradition has it that the winning captain, having hoisted the cup, should then give a speech.

FIND | WALK | EAT | SLEEP PAGE 213

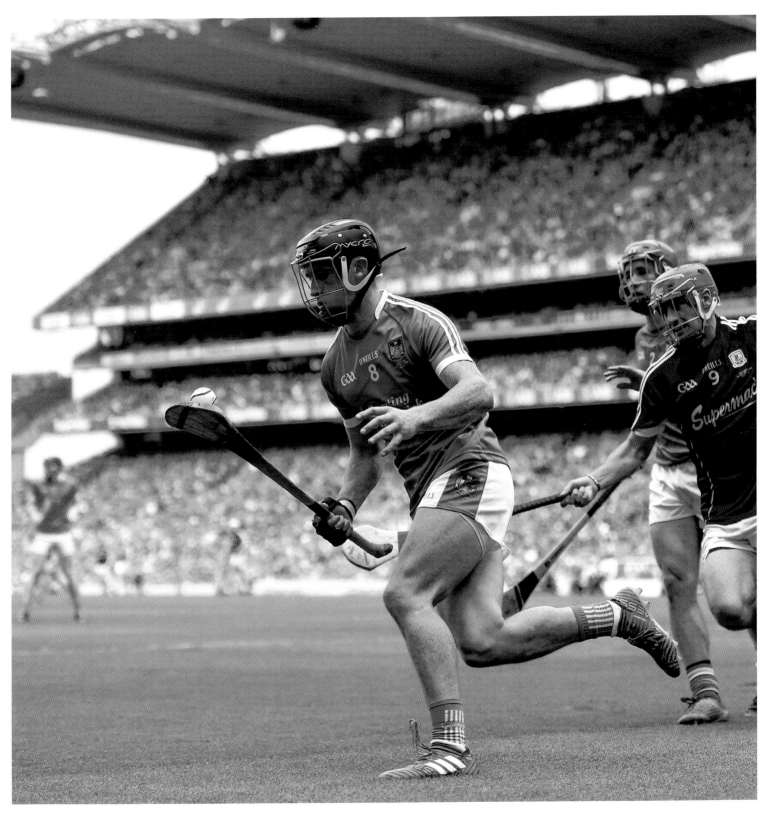

HORSESHOE BAR
AT THE SHELBOURNE HOTEL
DUBLIN

The grand dame of Dublin hotels, b.1824, is back to its best after a period of ownership changes. The Shelbourne is not just an hotel: it's a place to be and be seen, and you can simply sit by the fire in the foyer and watch the life of Dublin happen. A drink in the Horseshoe Bar, named for its iconic, curving bar, is a rite of passage for anyone coming to the city and, depending on who you choose to believe, everything has happened here from the founding of The Chieftains to the origins of the Celtic Tiger.

FIND | WALK | EAT | SLEEP **PAGE 214**

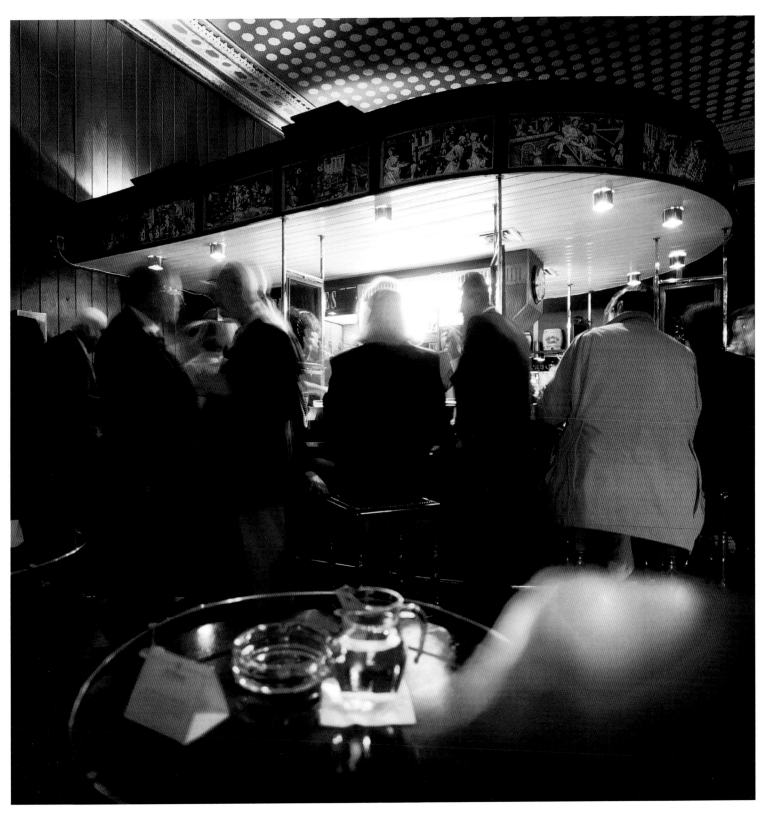

THE EVE OF ST AGNES WINDOW,
BY HARRY CLARKE
HUGH LANE GALLERY, DUBLIN

The Eve of St Agnes illustrates Keats' poem of the same name, and was created in 1924, when Harry Clarke was at the height of his creative powers.

Harry Clarke is the Charlie Parker of stained glass art, a bolt from the blue who created the bolt into the blue, with lustrous colours and Symbolist styling, every aspect of his work a sundering of the past and the creation of a magnificent new art form: the architecture of light.

You could enjoy a mighty pilgrimage of churches throughout Ireland, just observing Harry Clarke windows, from County Antrim to County Wicklow, even taking in Bewley's Café on Grafton Street in Dublin. But the window in the Hugh Lane, which is in two sections, comprising 22 panels, has been described by Clarke's biographer, Nicola Gordon Bowe, as 'probably the finest expression of the technique which Harry made uniquely his own'. You could spend a lifetime examining and enjoying it, this amazing 'revel in blue'.

Opposite page: the full window (top-left) and three details.

FIND | WALK | EAT | SLEEP **PAGE 214**

THE CHEF'S TABLE
CHAPTER ONE RESTAURANT, DUBLIN

Stop a random sample of Dubliners on the street to ask which is the city's finest restaurant, and a sizeable majority will tell you that it is Chapter One. That's not just because chef-patron Ross Lewis and his team offer superlative modern Irish cooking in an intimate, luxe basement space, beside the Hugh Lane Gallery, it's also because Chapter One is a restaurant that people have enormous affection for, and will return to at any and every opportunity. So many birthdays are celebrated here that their theme tune should be 'Happy Birthday'.

The chef's table, directly adjacent to the calm and meticulously maintained kitchen, has become a prized food lover's trophy but, however you experience it, Chapter One offers one of the best cultural experiences in Ireland.

FIND I WALK I EAT I SLEEP **PAGE 214**

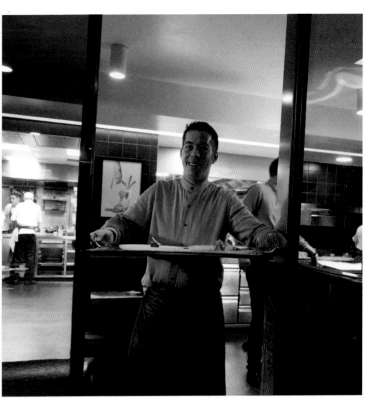

O'DONOGHUE'S
DUBLIN

A legendary haunt for musicians who stage fine music sessions, O'Donoghue's is celebrated as the bar where groundbreaking Dublin folk group The Dubliners first came together to play in the early 1960's, sparking a revival of Irish folk music and balladry. On a busy night, which is pretty much every night, the bar at the front redefines the term 'crowded', and the crowd spills out into the back yard. And, yeah, that little guy sitting over in the corner is Bruce Springsteen, obeying the iron rule that every global celebrity simply must pay a visit to O'Donoghue's.

FIND | WALK | EAT | SLEEP PAGE 214

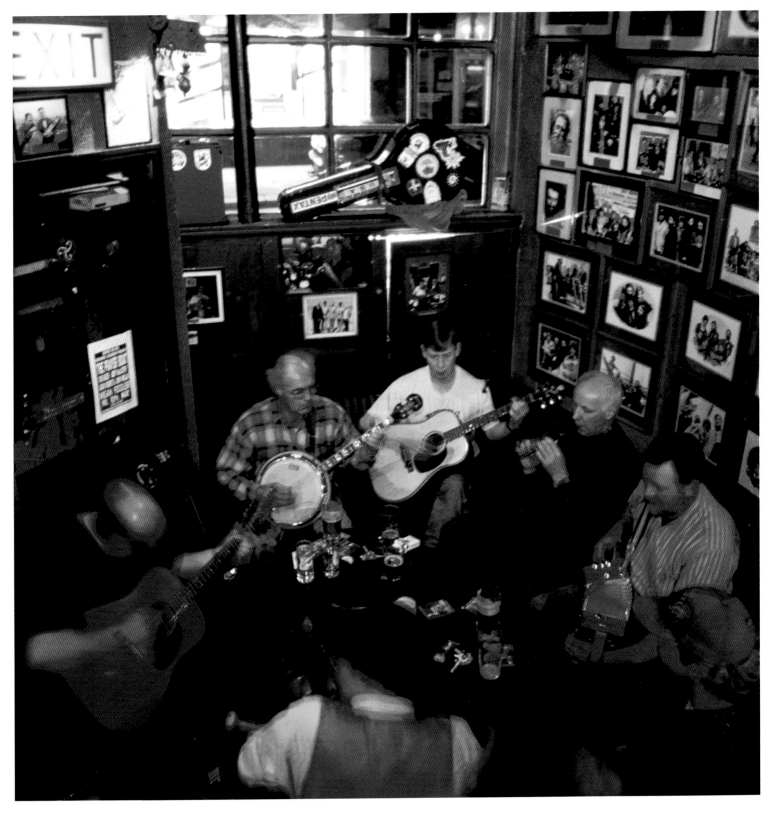

SUNKEN SITTING ROOM
NO 31, DUBLIN

The heavy wooden mews door opens, you take several
steps across the walled courtyard, then step in the door
of No 31, and immediately a glimpse of white-painted
block walls and the Picasso print on the wall signals that
you are in that rarest of Dublin destinations: a modernist
masterpiece. If you have always wanted to have your own
arch villain's lair, seemingly transplanted directly from a
James Bond movie, then here it is; simply bring your own
Persian cat and cigarette holder. In fact, No 31 is two
houses: the classic Sam Stephenson-designed 1960's mews
house, and an elegant Georgian house that opens onto
Fitzwilliam Street. It's one of the city's great secrets.

FIND | WALK | EAT | SLEEP PAGE 214

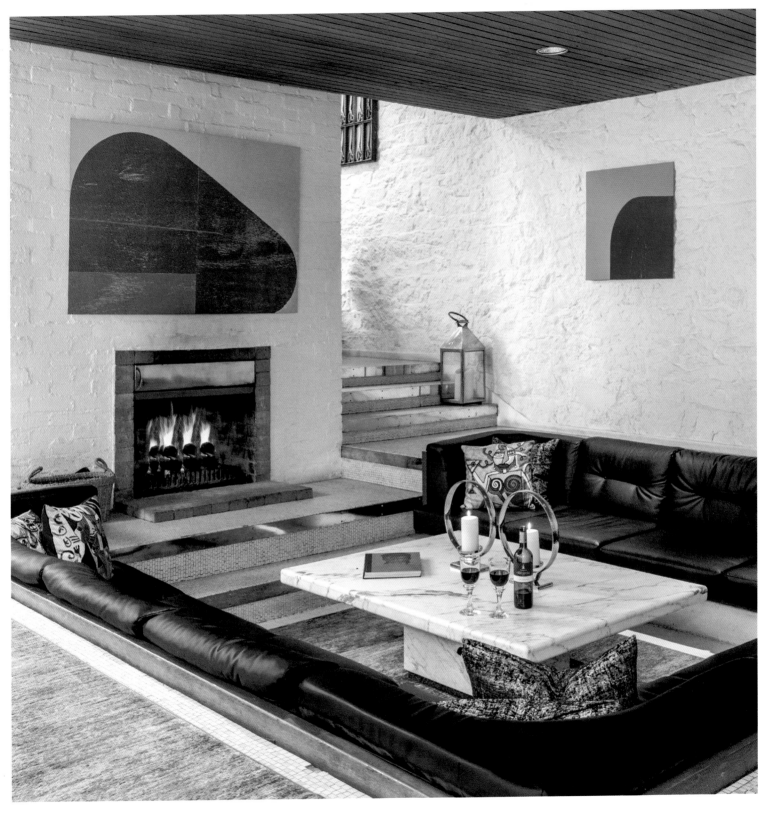

THE FORTY FOOT
DUBLIN

Hailed by Loudon Wainright in *The New York Times* as one of the 10 Best Places to swim in the world, the Forty Foot features in James Joyce's *Ulysses,* when Stephen and Haines walk down the hill from the Martello Tower with Buck Mulligan, who plunges into the water for a morning dip, having first tapped Stephen for two pence. Whilst it was originally a male-only site – women first staged a protest swim here in 1974 – today swimmers of all ages use it all year round, and it's particularly popular for the traditional Christmas swim. Thanks to its considerable depth, you can jump in even at low tide. The water is very clean, and very cold.

FIND | WALK | EAT | SLEEP PAGE 214

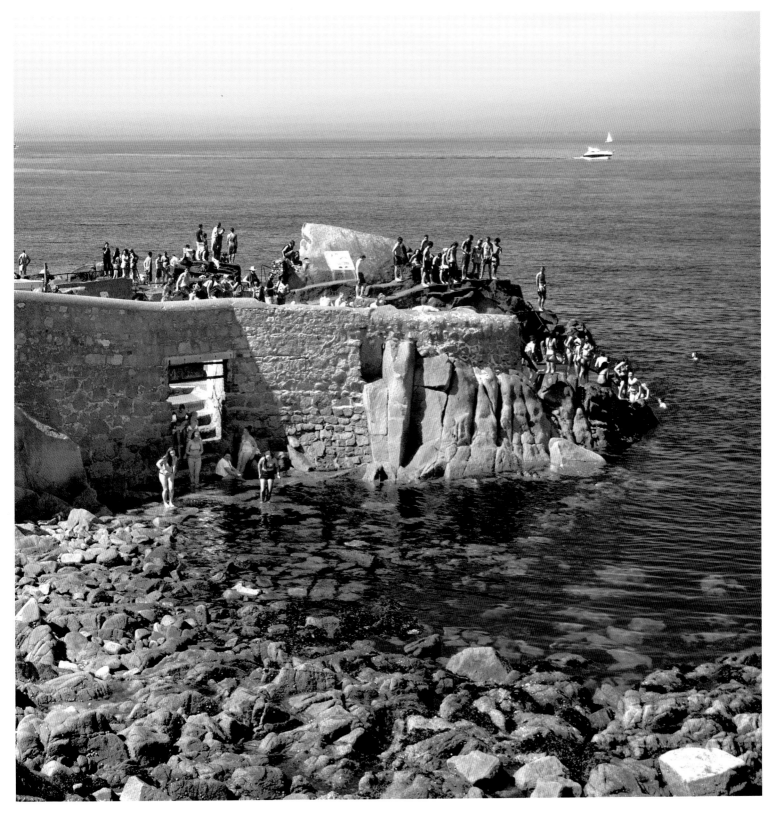

THE LONG HALL
DUBLIN

With an original interior dating from 1881, which remains
perfectly preserved, The Long Hall is one of the glories of
Dublin's pub culture. If there is a bar in Heaven, then it will
look exactly like this red-hued hostelry, an exuberant shrine
of phantasmagoric Victoriana replete with chandeliers,
ornate glass, vintage timepieces, bevelled mirrors, gold leaf,
as well as alcohol, affability and the lustrous patina of age.
There has been a licence on the site since as far back as
1766, and the Fenians planned their uprising in here in the
1860's. In the 1980s, Phil Lynott filmed part of the video for
the song *Old Town*, sitting alone at the bar.

FIND | WALK | EAT | SLEEP **PAGE 215**

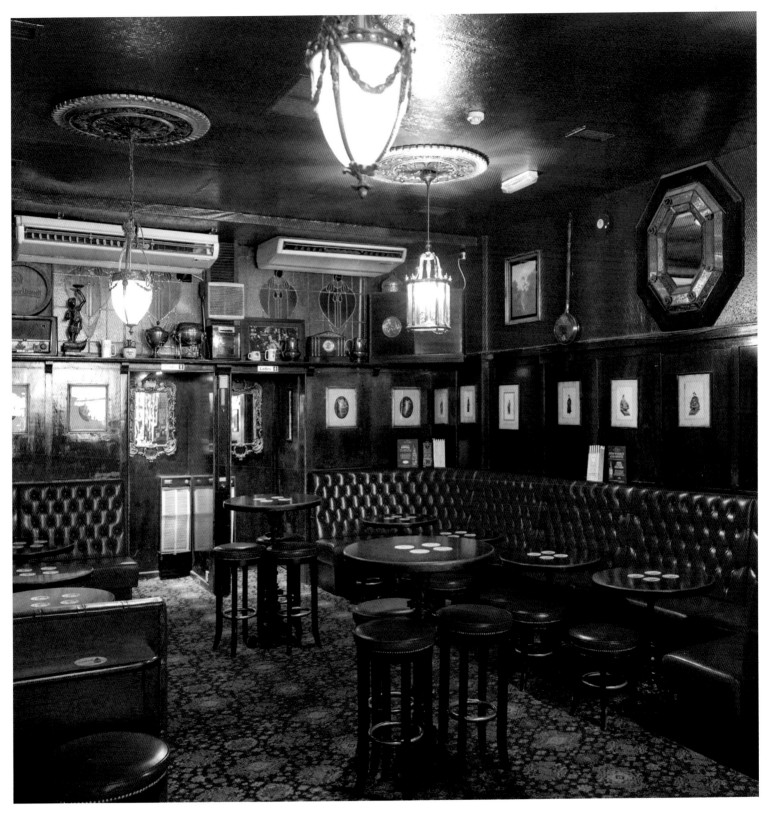

TRINITY COLLEGE
AND THE BOOK OF KELLS
DUBLIN

The 9th-century Book of Kells is one of the greatest creations of Western art, and has been described as Ireland's Sistine Chapel. A richly decorated, intricately drawn, and enormously colourful rendition of the four Gospels of the New Testament, which uses an extensive array of pigments, it is now believed that the book was created on the island of Iona, off the west coast of Scotland, before being taken to the Abbey of Kells, County Meath. Today, the book is exhibited, page by page, in the 18th-century Library building on the campus of Trinity College: it is a simply remarkable distillation of art and culture, full of humour, and many mistakes.

Whilst many visitors come to Trinity College to see the Book of Kells, the college campus also hosts the Science Gallery and the Long Room Library, a 61-metre-high room filled with 200,000 of the Library's oldest books. Designed by Thomas Burgh and built at a cost of £20,000 between 1712 and 1732, it is one of the largest single-chamber libraries in existence, and enjoys the 'puritanical severity' that is characteristic of Irish architecture.

FIND | WALK | EAT | SLEEP **PAGE 215**

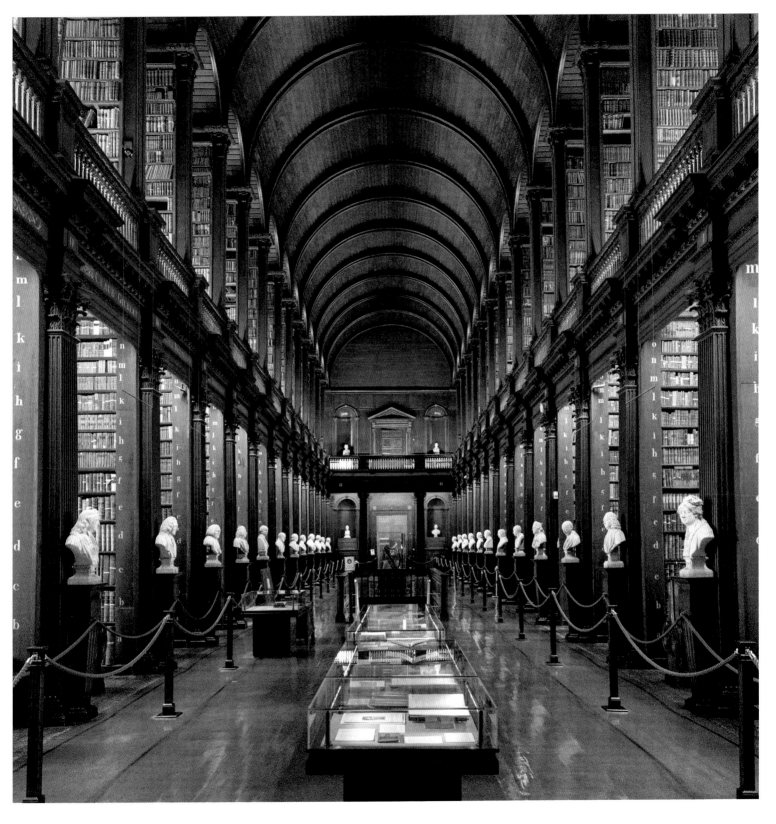

SAMUEL BECKETT BRIDGE
DUBLIN

In many ways the River Liffey defines and describes the city of Dublin. Dublin never turned its back on the river, like many an Irish town – all the buildings face the water. But it is the bridges that really give the river its character, from the oldest Mellows Bridge, to the Ha'penny Bridge, that got its name from the toll that was charged when the bridge was privately owned.

It's fitting that Dublin should have bridges dedicated to those two old mates, Samuel Beckett and James Joyce, though goodness knows the pair of them might have found it a bit of a lark to be spanning the River Liffey several hundred metres apart. Beckett's bridge, like Joyce's, was designed by elite starchitect Santiago Calatrava. Calatrava took inspiration from the design of the harp that used to feature on Irish coins, so the structure looks like an Irish harp lying on its side. The bridge can actually rotate on its hydraulic mechanism through 90 degrees to allow maritime traffic to pass.

Beckett's bridge also denotes a new centre, built around it and the National Conference Centre, and the Financial Services zone. This new centre has become as culturally significant to the capital as its famous Georgian streetscapes and doors.

FIND | WALK | EAT | SLEEP **PAGE 215**

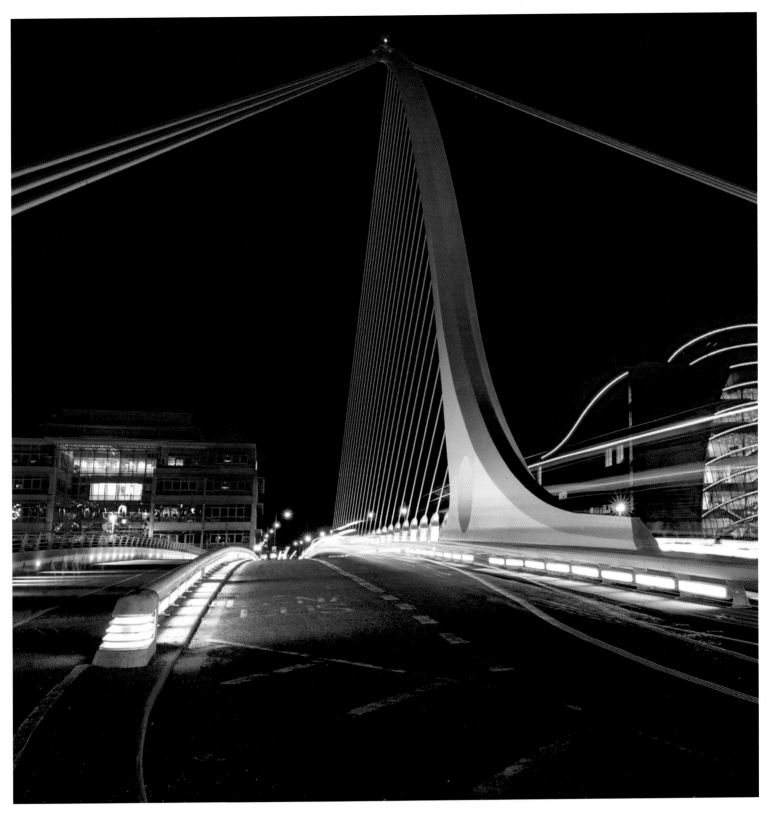

YEATS ROOM
NATIONAL GALLERY OF IRELAND, DUBLIN

Jack B. Yeats is not just a brilliant Irish painter. He was also, in an unlikely event, the Republic's first ever Irish Olympic medallist, having been awarded a silver medal in the 1924 Paris Olympics, in the arts and culture category, for his painting *The Liffey Swim*. It is his later work, however, that we find most powerful, wildly colourful abstracted images of enormous power. Samuel Beckett described Yeats as 'The great of our time… he brings light as only the great dare to bring light to the issueless predicament of existence' and John Berger appositely noted that Yeats' work gives 'an awareness of the possibility of a world other than the one we know'. The later works in the Yeats' Room of the National Gallery bring that world vividly to life, and they are beautifully displayed. The Gallery, of course, has many, many other great works by great artists – Caravaggio; Goya; Vermeer; Rembrandt; Monet – and the extensive revamp by superstar Dublin architects Heneghan Peng has been a winning success.

Opposite page (below): Jack B. Yeats (1871–1957): The Liffey Swim, 1923. Photo © National Gallery of Ireland.

FIND | WALK | EAT | SLEEP **PAGE 215**

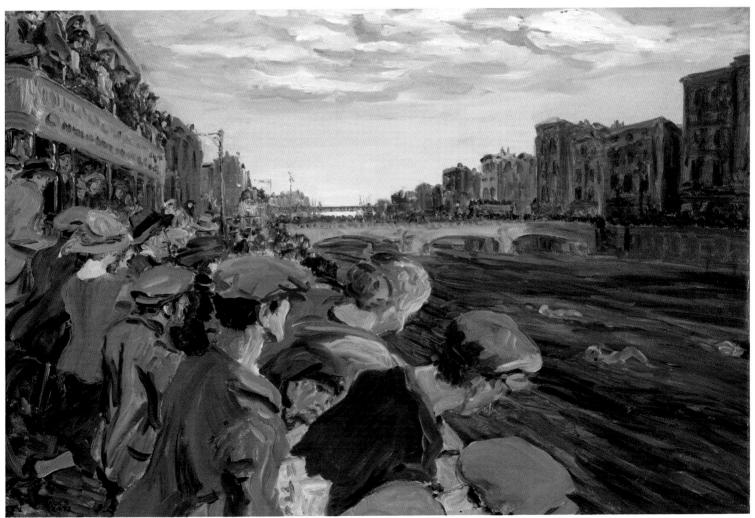

EILEEN GRAY EXHIBITION
NATIONAL MUSEUM OF IRELAND, DUBLIN

When Wexford-born Eileen Gray designed and constructed her Modernist house, E-1027, at Roquebrune, near Monaco, between 1926 and 1928, she created the first ever piece of Modernist architecture. Ms Gray is also famous for having created the 20th century's most expensive piece of furniture – her 'dragon chair' sold at Christie's in 2009 for the staggering sum of £19.4 million, having been owned by Yves Saint Laurent. Ms Gray's striking, singular furniture designs are respectfully exhibited in the National Museum at Collins Barracks, alongside many personal items that trace her development as both designer and architect.

FIND | WALK | EAT | SLEEP **PAGE 215**

A NEW ARCHITECTURE
AILTIREACHT NUA

AIRFIELD ESTATE
DUNDRUM, DUBLIN

A storybook sweet working farm, in the midst of the Dublin suburbs, seems too good to be true, but Airfield is real, and may be the finest oasis in the entire city. The estate was home to two remarkable sisters, Letitia and Naomi Overend, dynamic and charitable women who also liked to drive around in the Rolls Royce motor car which you can view at the estate. Today, Airfield is run by a charitable trust, which maintains the farm as a beautiful working farm, runs a superb restaurant which uses the farm produce, and organises many educational and workshop events. It is an idyllic place.

FIND | WALK | EAT | SLEEP **PAGE 215**

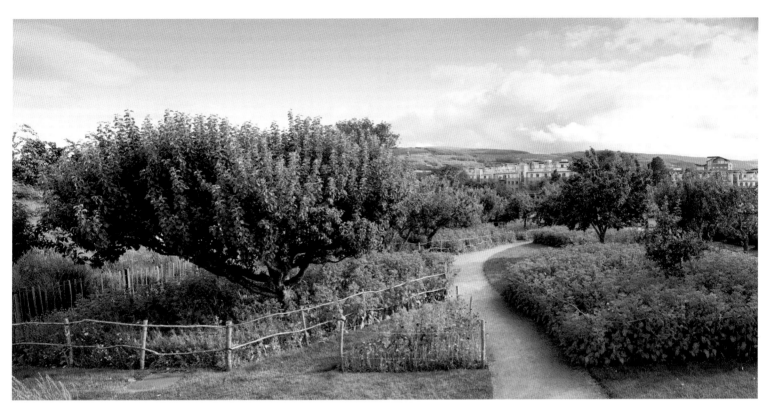

POWERSCOURT WATERFALL & GARDENS
ENNISKERRY, WICKLOW

Located 6km from the main Powerscourt Estate, this Wicklow Mountains waterfall drops a massive 121 metres, making it one of the highest waterfalls in Ireland. To reach the falls, you walk through a woodland with giant redwoods, oaks, beech and larch, and it is an excellent site for birdwatching. The beauty of the falls does have a melancholy element, however, as there have been a series of fatalities over the last 170 years, when people attempting to climb the falls perished.

The gardens of the Powerscourt Estate spread over 47 acres, overlooked by the Palladian mansion, which in turn overlooks Triton Lake and, between it, a series of terraces designed by Daniel Robertson complete with statuary, and formal planting. The gardens include a walled garden with Ireland's largest herbaceous border, and a Japanese garden, planted in 1908, with a grotto.

FIND | WALK | EAT | SLEEP **PAGE 216**

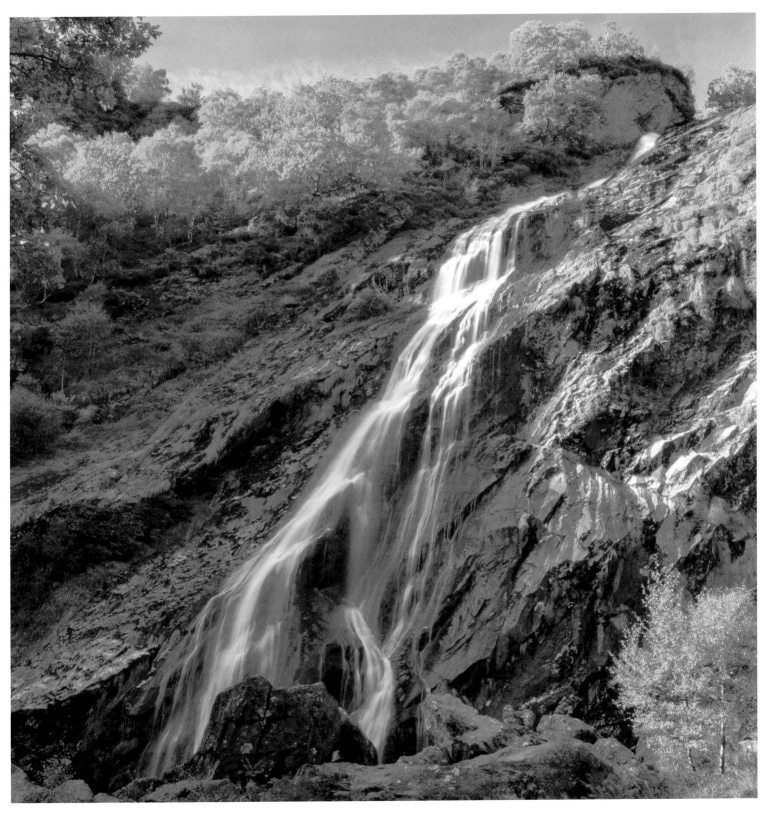

GLENDALOUGH
WICKLOW

The Glendalough Valley is known as the Valley of the Two Lakes, and within it there is a 6th-century monastic settlement founded by Saint Kevin, whose reputation for sanctity meant that the monastery became a notable place of pilgrimage – seven trips to Glendalough was considered the equivalent of a pilgrimage to Rome. The glacially moulded valleys remained a popular destination, both for religious followers and for antiquarians and travellers who wished to admire its ruins. Today, visitor numbers are enormous, and on a busy day it can be difficult to imagine the serenity that is the hallmark of this iconic destination. The surrounding area is now the Wicklow Mountains National Park.

FIND | WALK | EAT | SLEEP PAGE 216

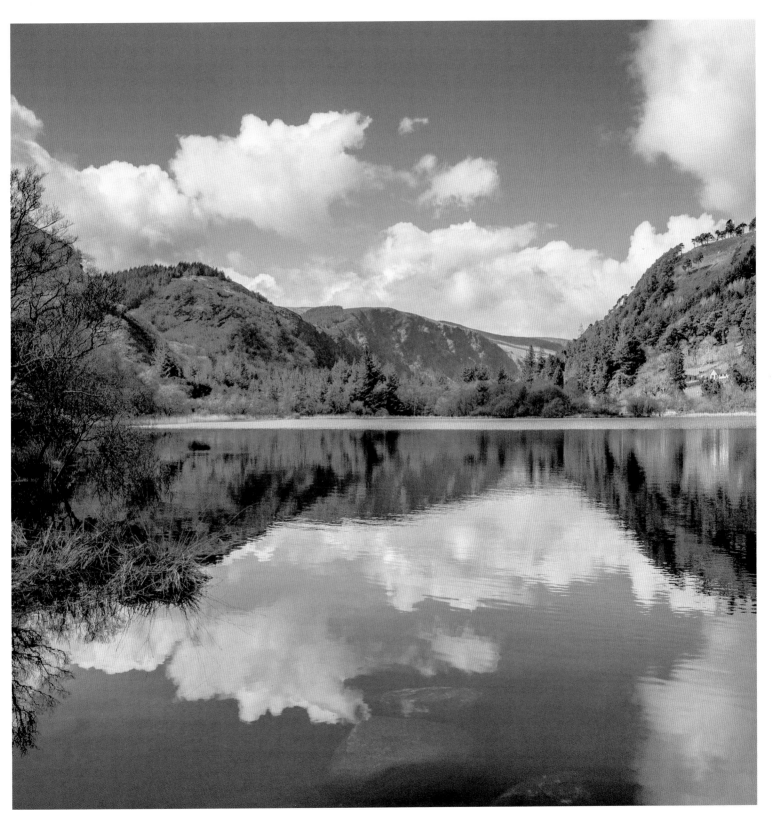

KILKENNY DESIGN CENTRE
KILKENNY

Kilkenny established itself as the craft capital of Ireland back in 1963, when a Government initiative aimed at promoting good design in industry led to the creation of the first Kilkenny Design Workshops. Today, the Kilkenny Design Centre, in the Castle Yard of magnificent Kilkenny Castle, is the place to find the Kilkenny designs, and many other Irish crafts, under one roof. There are covetable ceramics, crystal, textiles, jewellery and other hand-made gifts that reveal that Kilkenny remains the craft capital of Ireland.

FIND | WALK | EAT | SLEEP **PAGE 216**

COPPER COAST GEOPARK
WATERFORD

The 17km-long Copper Coast, stretching between Fenor in the east and Stradbally in the west, is a UNESCO Global Geopark, with a visitor centre in Bunmahon, housed in a converted church. The name derives from the copper mining that was carried out here in the 19th century, especially in Bunmahon, and you can see the ruins of several of the mines today. The coastline is geologically fascinating, rugged, dramatic and peaceful, and boasts several Blue Flag beaches amongst its ten beaches, and extraordinary sea stacks.

FIND | WALK | EAT | SLEEP PAGE 216

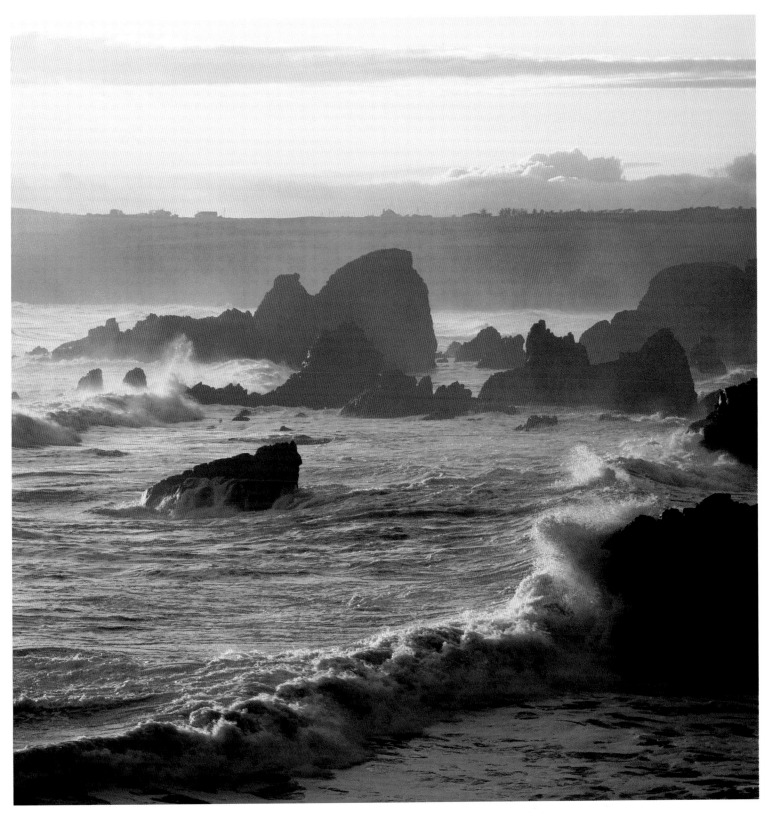

WATERFORD GREENWAY
WATERFORD TO DUNGARVAN

An off-road Greenway, taking the route of the old railway line between Waterford and Dungarvan, the Waterford Greenway was an enormously popular success from the day it opened, and it is commonplace to see cyclists of every age – from babes-in-arms strapped into their bike seats to Lycra-clad octogenarians with sleek Claud Butler bikes – travelling the accommodating flat route. The Greenway takes in eleven bridges, three viaducts, an atmospheric tunnel, and travels from river to sea. Its success has given birth to a range of services from bike hire to coffee shops to glamping sites. Start at WIT West Campus or other access points. Sensible people choose to stay the night in The Tannery and have a night out in Dungarvan, then return the following day.

FIND | WALK | EAT | SLEEP **PAGE 216**

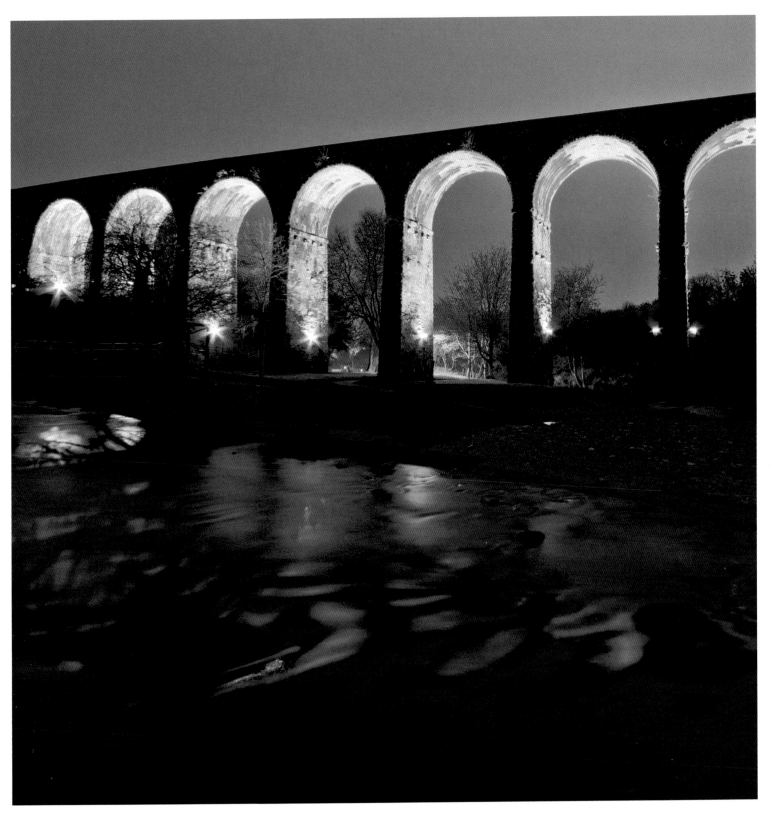

WATERFORD WALLS
WATERFORD CITY

Waterford claims to have more of its ancient walls extant
than any other city in Ireland, and indeed only Derry in
Northern Ireland has more impressive city walls. The city
is the oldest in Ireland, and can trace its origins back
to the Vikings, who made a settlement here in the early
10th century. Reginald's Tower, at the junction of the Quay
and the Mall, is allegedly the oldest tower of mortared stone
in Europe. The walls have won fame in recent years thanks
to the inspiring Street Art Festival, which has seen more
than 100 street artists from all over the world bestow vividly
colourful works on ancient gables, bridges and walkways;
and touring the art trails during the August festival is a joy.

FIND | WALK | EAT | SLEEP PAGE 216

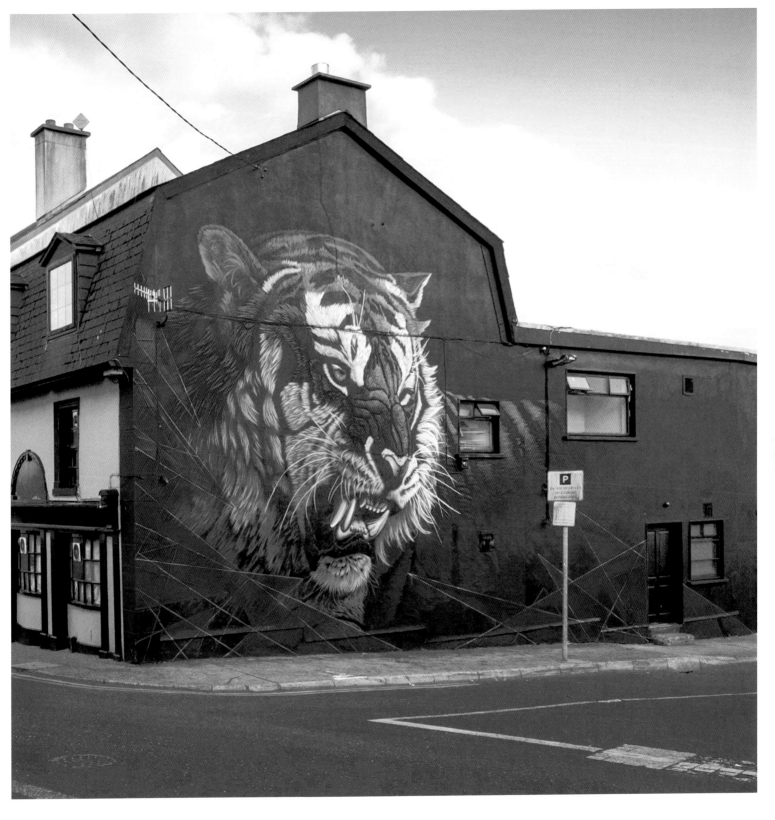

GUILLAMENE SWIMMING COVE
TRAMORE, WATERFORD

The cove at Guillamene is no longer a men-only destination, though the sign remains as a relic of the past. Nowadays, families use this deep-water pool, accessed via steep steps against the cliff face, that takes you into the cove, which has a concrete diving platform. For many wild swimmers, Guillamene is the archetypal experience, and can be swum at all tides and it's hugely popular for a Christmas swim.

FIND | WALK | EAT | SLEEP PAGE 217

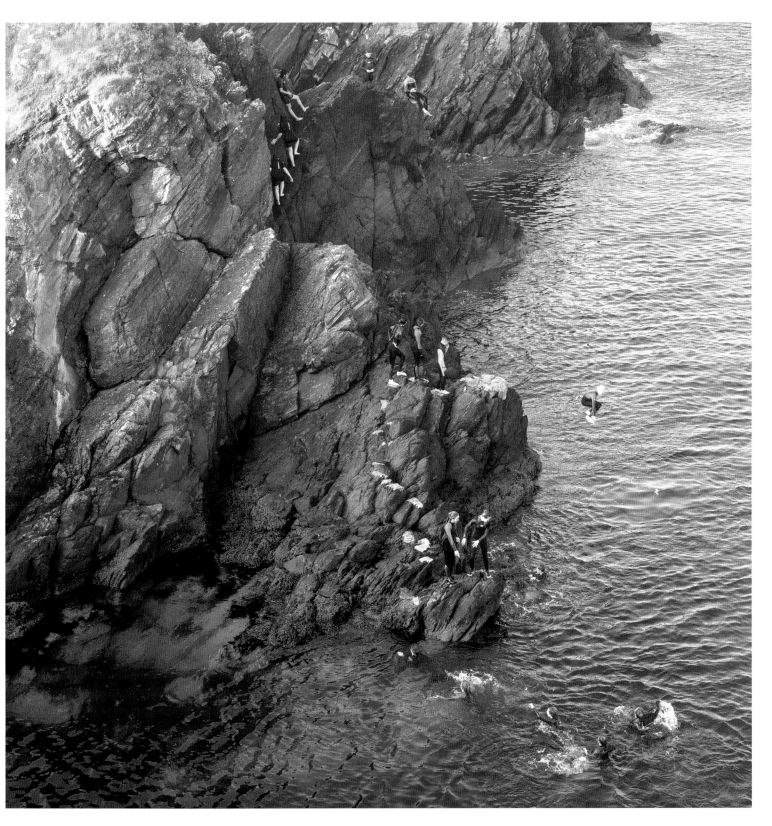

KELLY'S RESORT HOTEL
ROSSLARE, WEXFORD

For 125 years, and through five working generations of
the family, Kelly's has been a benchmark seaside vacation
destination in Ireland's sunny south-east. The family's ability
to maintain and improve their own stellar standards means
that the hotel frequently has occupancy rates north of 99%.
Go once and you will likely find – like countless other
generations – that you will be going back to Kelly's for the
rest of your life. Bill and Isabelle Kelly's art collection is
one of the finest private collections in the country, and the
restaurant wine list – Vincent Avril of Chateauneuf-du-Pape is
Mr Kelly's father-in-law – is a masterpiece. Above all, Kelly's
is characterised by gracious hospitality from the staff, many
of whom have spent their entire working lives here.

FIND | WALK | EAT | SLEEP PAGE 217

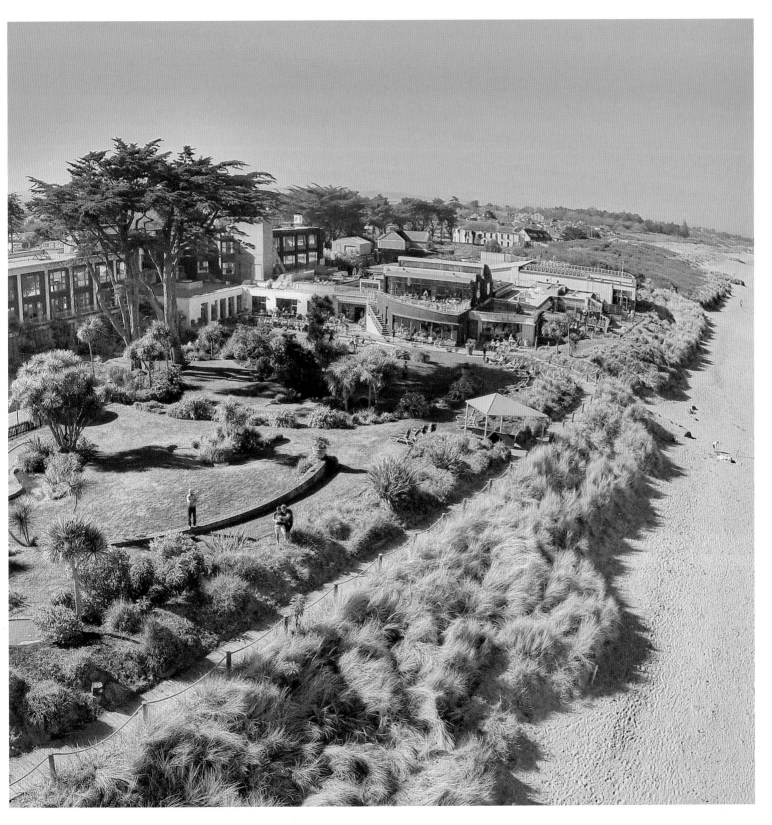

HOOK LIGHTHOUSE
HOOK HEAD, WEXFORD

The Hook Lighthouse is still fully operational 800 years after its construction. The 13th-century medieval lighthouse tower stands four storeys high and has walls up to 4 metres thick, and has 115 steps before you reach the top. The tower was built by William Marshal, a renowned jousting champion, whom the Archbishop of Canterbury declared to be 'the greatest knight that ever lived'. He was also the designer of Kilkenny Castle and St Mary's Church, now the Medieval Mile Museum. Tours of the lighthouse happen all year (weather permitting: when the storms arrive the waves can reach the top of the tower). The Lightkeeper's House Café in the visitor centre has good cooking and baking, and exhibitions by local artists.

FIND | WALK | EAT | SLEEP **PAGE 217**

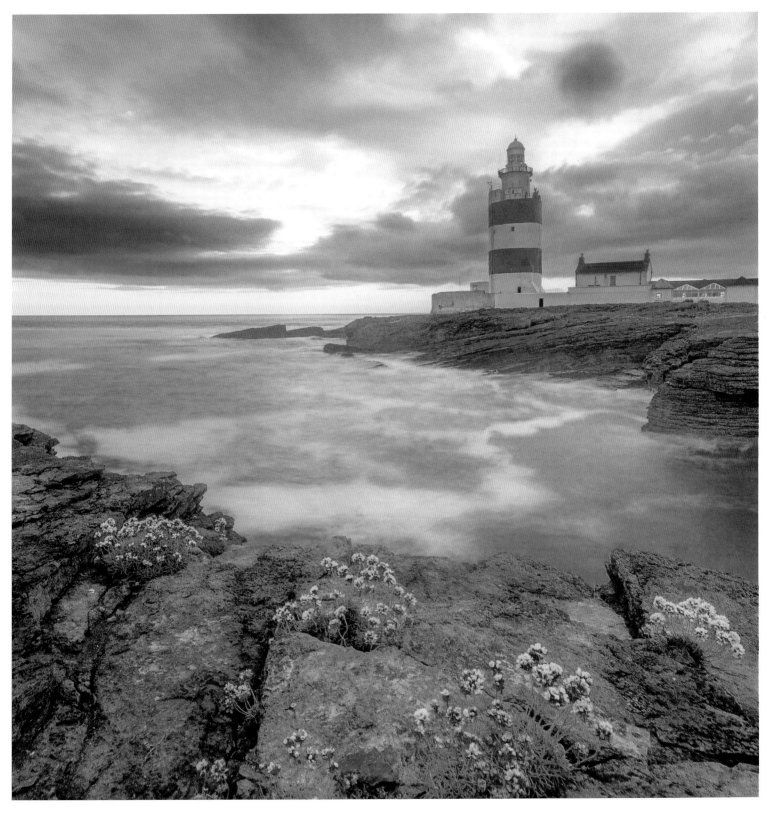

ROCK OF CASHEL
CASHEL, TIPPERARY

Caiseal means 'stone fort' and, hovering dramatically on the hilly outcrop of St Patrick's Rock, the Rock of Cashel overlooking Ireland's Golden Vale is a towering landmark. There are many folk tales as to how the Rock came to be where it is, but there is no argument that it was built around the 12th century. Cormac's Chapel, which dates from the early 12th century, features beautiful details in its arches and corbels, and contains some of the oldest Romanesque wall paintings in Ireland. The great Gothic cathedral, built originally by Donal Mor O Brien, King of Thomond, was set on fire in 1495 by Gearoid Mor Fitzgerald, Great Earl of Kildare, who explained to Henry VII that he did so because he 'thought the archbishop was inside'. The surrounding grounds are home to an extensive graveyard packed with impressive high crosses. Do take time to see the grave of the rapscallion Miler McGrath, an Archbishop known as 'the scoundrel of Cashel', whose offspring allegedly numbered 47, with 'only 9 of these being with his wife.' Brian Boru, most famous of the High Kings of Ireland, was crowned High King in Cashel in 990. He was the only High King to rule the whole island in unity.

FIND | WALK | EAT | SLEEP **PAGE 217**

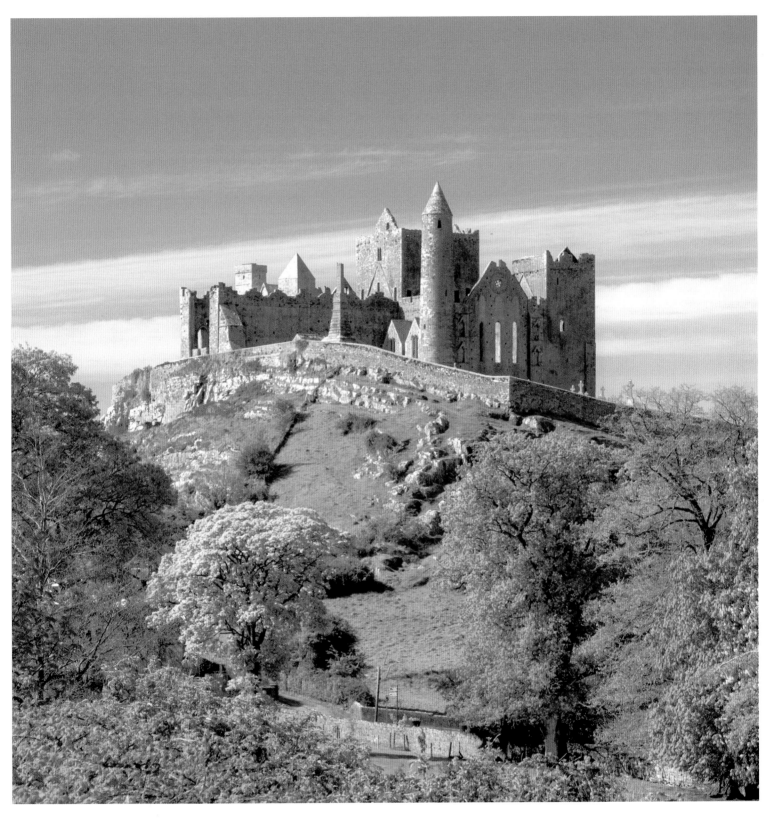

SEAN'S BAR
ATHLONE, WESTMEATH

Pints on the tables. Pipes and guitars in perfect synchronicity. Bar staff moving like elite athletes trying to keep up with the orders. Chatter and laughter amongst the thronged crowd of revellers packed sardine-like into the long, narrow space. The patina of age and the patina of nicotine. There is nothing else quite like a drink in Sean's Bar, on King's Road in the old town of Athlone. Is Sean's the oldest bar in Ireland? Many will say that it is, and some will say it isn't. But what is important about Sean's is that longevity takes second place to authenticity: this is the real deal of a classic Irish pub, with all its harmonious clamour and democratic affability. Away from Athlone, it would likely be a tourist trap. In Athlone, Sean's is simply one of the best bars you can ever find yourself in, a place for drinking, making merry, making music.

FIND | WALK | EAT | SLEEP **PAGE 217**

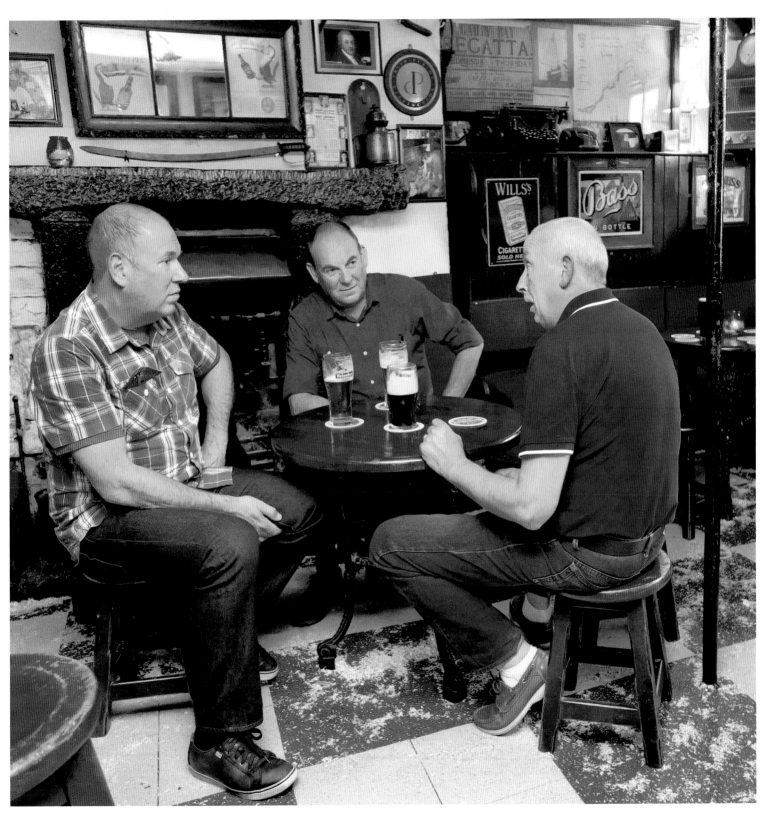

HILL OF TARA
DUNSHAUGHLIN, MEATH

Immortalised by Thomas Moore's melody, *The Harp That Once Through Tara's Halls*, the legendary primeval site features an impressive number of ancient monuments and was an important centre of paganism – a strong streak of which still courses through the veins of residents of County Meath to this day. Tara was the seat of priest-kings, who would symbolically mate with the local earth goddess at a ritual banquet, the Feis Tamrach.

Between 1899 and 1902, a group of British-Israelites dug the hill, and caused significant damage and much outrage, in their quest to find the Ark of the Covenant, believed to be buried at Tara and said to contain the Ten Commandments inscribed on stone tablets. Recent surveys have revealed new insights into the landscape but, unfortunately, no Ark.

Tara is hugely significant in Irish mythology, and while it is not spectacular, it somehow manages to inspire an aura that is powerful and atmospheric. With its multiple histories, it is the very essence of 'Deep Ireland', the place where the pasts collect. From the hill, you can see more than half of Ireland's 32 counties.

FIND I WALK I EAT I SLEEP **PAGE 218**

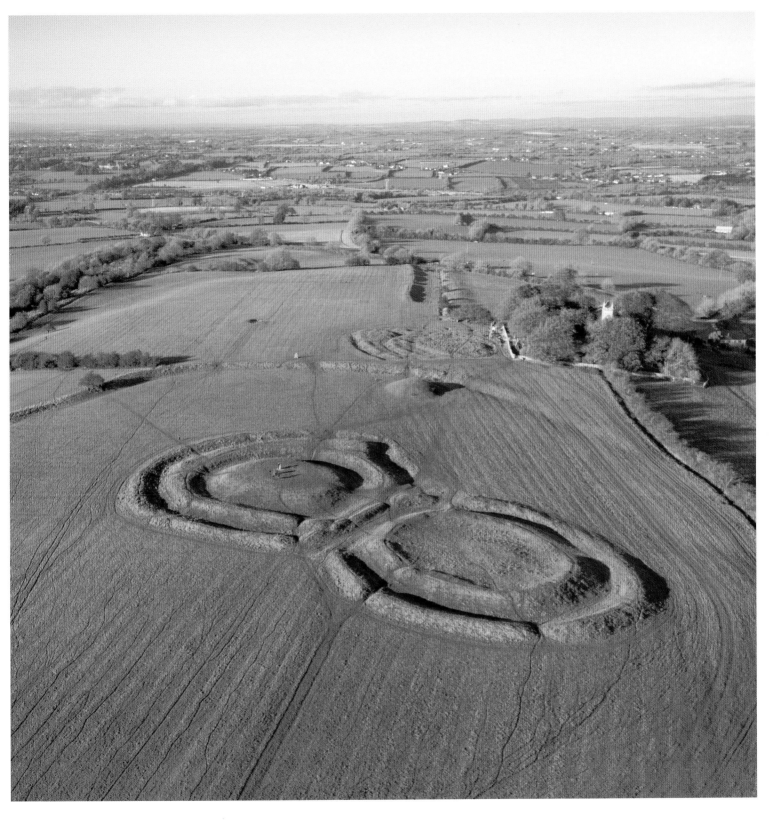

SHERIDANS CHEESEMONGERS
KELLS, MEATH

When the Sheridan brothers' cheesemonger shop in Cornelscourt, in south County Dublin, won the award for Best Cheese Shop in Britain and Ireland in 2019, the recognition paid tribute to the achievement of Kevin and Seamus Sheridan, and also to their unusual way of creating a food business. The brothers began with a wooden cheese stall, made by Kevin, in the Galway Market in 1995. From there they progressed to bricks and mortar stores – in Galway and Dublin – and recently they have begun to open their cheesemongers in supermarkets, whilst establishing a centre in an old creamery building in Pottlereagh, Kells, County Meath, where they hold a brilliant food festival every summer. Their secret is simple: the brothers are artisans, and they think like artisans, and everything they do is delightfully different, from their brown bread cheese crackers to the unique wine bar above their Galway store.

FIND | WALK | EAT | SLEEP **PAGE 218**

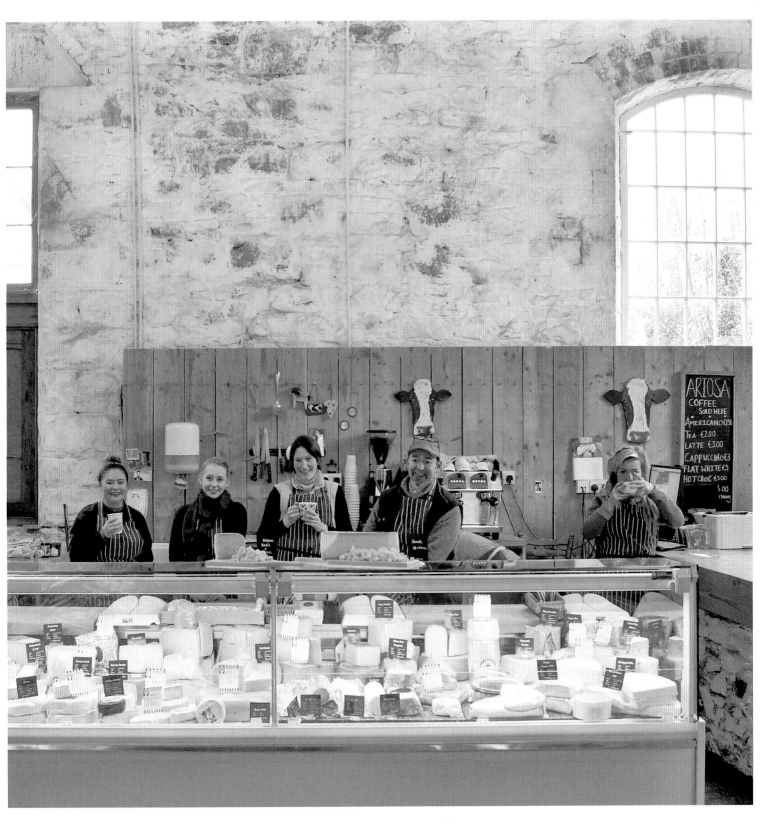

NEWGRANGE STONE AGE PASSAGE TOMB
DONORE, MEATH

One thousand years older than the Pyramids, Newgrange is a Neolithic Ritual Centre and Passage Tomb, the oldest astronomical observatory in Europe, and has remained completely intact since the Stone Age. It is estimated that a workforce of 300 laboured over 30 years to fashion the mound, using 200,000 tonnes of stone which was brought to the valley from elsewhere. The entrance to the tomb was re-discovered in 1699 and, on the morning of the winter solstice, the inner cruciform chamber is illuminated by the rising sun for 17 minutes, an extraordinary example of solar orientation. Newgrange is a UNESCO Heritage site, and one of three extraordinary cairns in the Boyne Valley, the others being Knowth and Dowth. The Passage Tombs speak of a sophisticated and artistic society that valued prestige, and was capable of constructing enormous monuments and precious artworks.

FIND | WALK | EAT | SLEEP PAGE 218

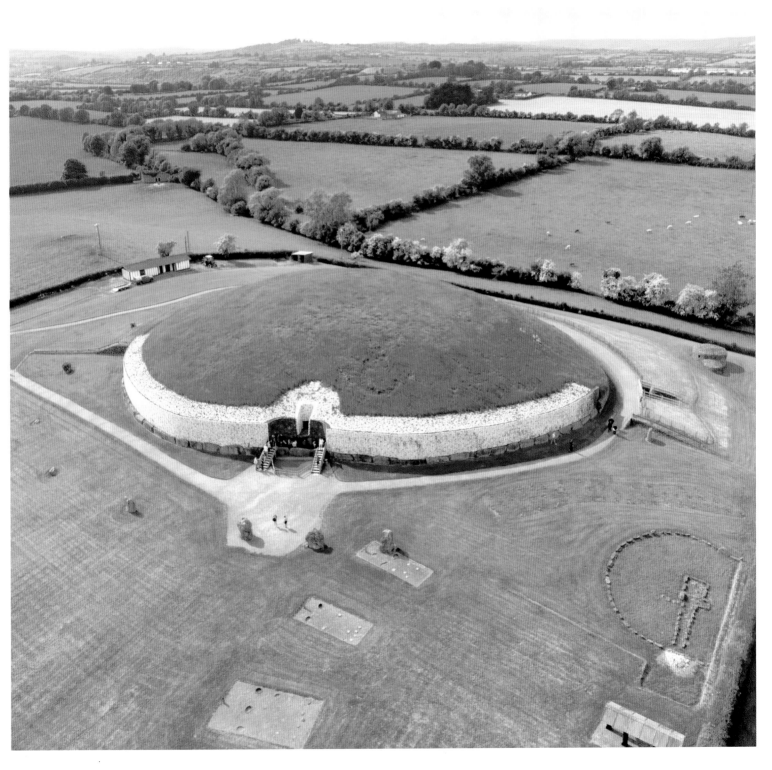

TRIM CASTLE
TRIM, MEATH

The largest Anglo-Norman castle in Ireland, Trim Castle was built in the 12th century by Hugh de Lacy, who had been given the Kingdom of Midhe (Meath and lands west of it) by Henry II. The Castle is regarded as one of the finest examples of medieval military architecture, and took about 30 years to build, but thereafter it was not added to or remodelled during any later period. The fortress was built over a large area of land, next to the River Boyne, so no modern buildings have intruded on its landscape. The castle keep is three-storeys high, with 20 sides, including four towers which flank it. Because the castle has kept its original shape and style, and still dominates the landscape surrounding it, we can appreciate one of the great examples of Norman architecture as it was originally intended. Trim was one of the major strongholds of the English Pale during the Middle Ages, and several Anglo-Norman parliaments met here. In 1447 the parliament was perturbed by the moustache question, and decreed that every man who wished to be accepted as English should shave off his Irish-style moustache and 'have no hair upon his upper lip'.

FIND | WALK | EAT | SLEEP **PAGE 218**

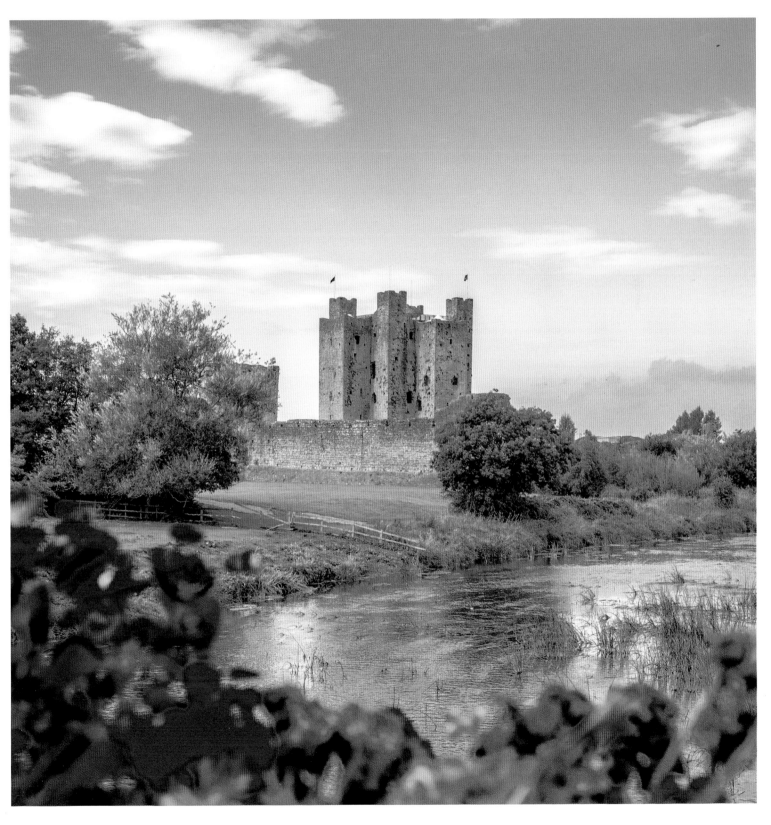

MUIREDACH'S HIGH CROSS
MONASTERBOICE, LOUTH

Three high crosses, and an immense 35-metre-tall High
Tower, are the jewels of this small, spiritual monastic site.
In particular, the South Cross, known as Muiredach's
Cross, is a masterpiece of the Scriptural Group, crosses
that depicted biblical scenes from the Old and New
Testaments for the unlettered. The detail carved into the
cross is simply incredible, and includes Moses smiting the
Rock, the Crucifixion, the Last Judgement, the Ascension,
and much more. The even-taller St Bween's Cross – 7 metres
tall – features Abraham's sacrifice of Isaac, the Resurrection,
David killing the Lion, and much more. The High Tower rises
straight and true into the air, a sublime piece of 10th-century
architecture. The atmosphere of the site is quite magical.

FIND | WALK | EAT | SLEEP PAGE 218

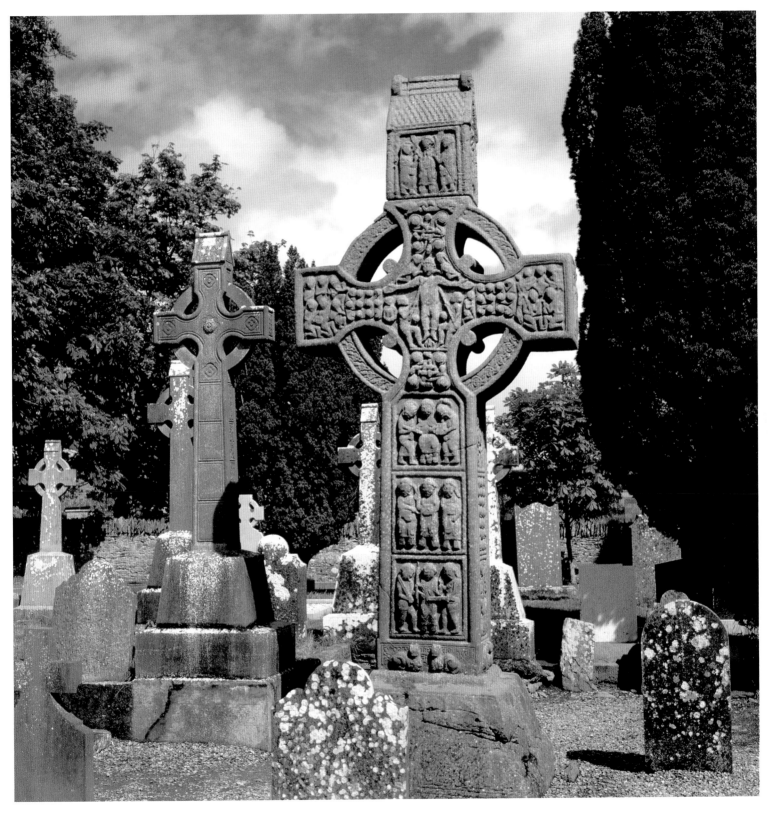

BLACKROCK CASTLE OBSERVATORY
CORK

The iconic riverside castle on the River Lee was built as
a coastal defence fortification on the instructions of Lord
Mountjoy to protect Cork Harbour and Port. To fund its
upkeep, fishing boats had to pay a tariff of a dish of
fish, and the rowdy parties held by the Admiralty Court
were so raucous that major repairs had to be carried
out almost every year of the 18th century. Today, the
castle is a working observatory that smartly explains the
science of space to children. Schools and families use the
castle's interactive astronomy centre and its planetarium
and sundial. It also operates as a lab for astronomical
researchers from Cork Institute of Technology, and the Cork
Astronomy Club bring their telescopes for regular observing
sessions that are open to the public. The building is also
home to the fine Castle Café, and a seat outside on the
courtyard benches on a sunny day is a fine thing altogether.

FIND | WALK | EAT | SLEEP **PAGE 219**

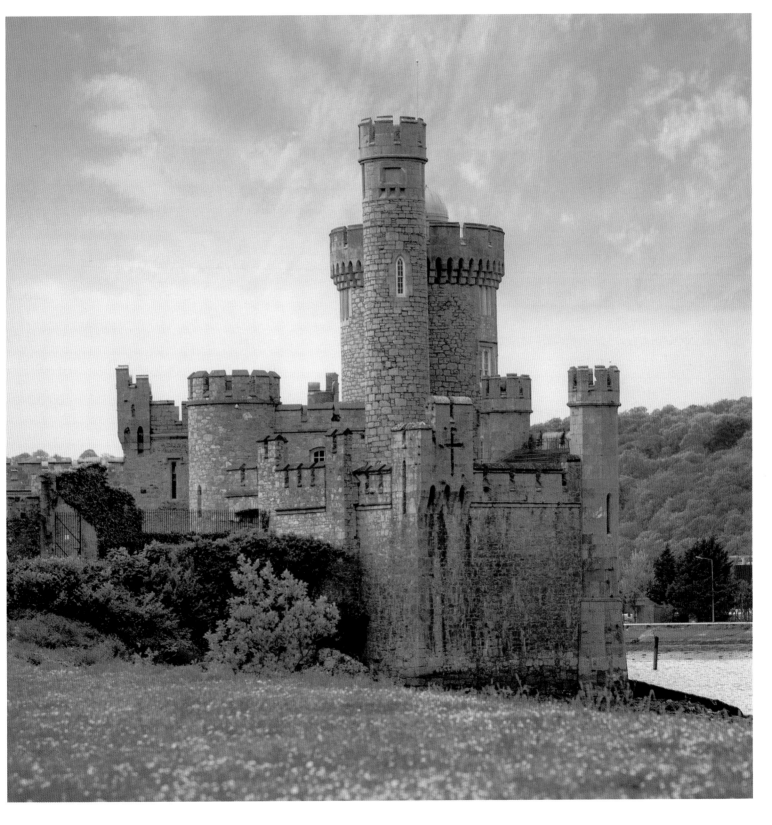

THE BLARNEY STONE
BLARNEY, CORK

The Blarney Stone is a lump of limestone rock built into the battlements of the medieval stronghold, Blarney Castle. One legend suggests that the stone was Jacob's Pillow, brought from the Holy Land by Crusaders. Another says that it was given to the Mac Carthys of Blarney by Robert the Bruce, in thanks for sending troops to fight Edward II. A third legend suggests that the power of the stone to bestow eloquence was pointed out to Cormac Láidir Mac Carthy, who built the castle, by an old woman whom he rescued from drowning. The old woman was, of course, a witch. In order to actually touch the stone with one's lips you have to lean backwards over the edge of the parapet, holding on to iron cross rails. The rock's linguistic blessings don't come that easy, but that doesn't deter the enormous numbers of visitors who make the trek to pretty little Blarney, and kissing the stone is mighty good fun.

FIND | WALK | EAT | SLEEP **PAGE 219**

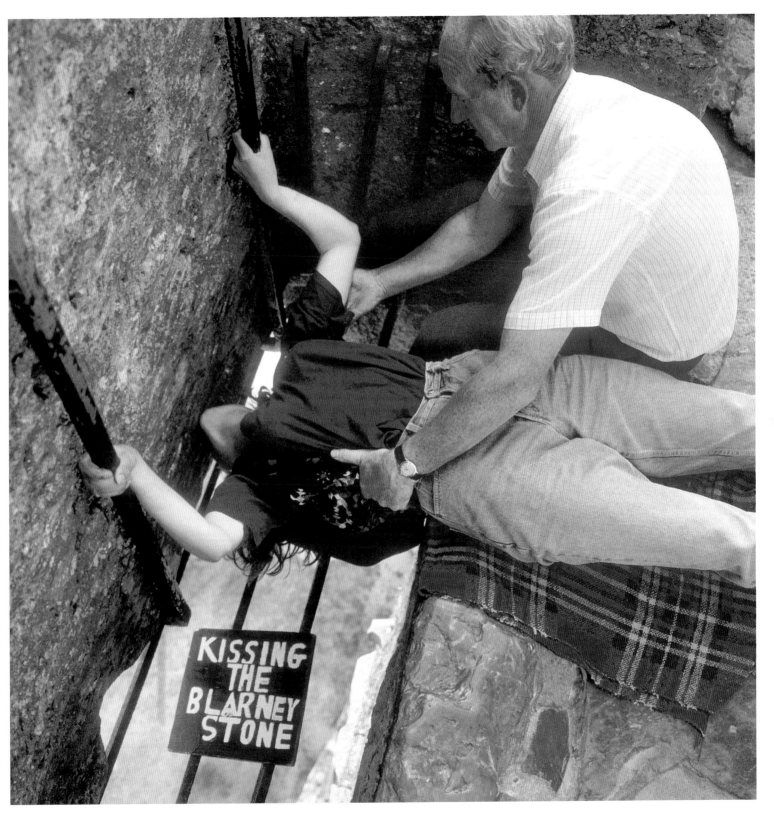

PARADISO RESTAURANT
CORK

Restaurateurs have had more than 25 years in which to copy the signature dishes which Denis Cotter has created in Cork's Paradiso. Mr Cotter has even written a quartet of exceptional cookery books, laying out his methods and techniques of cooking without meat and fish. But the proof of the uniqueness of Paradiso's style is the fact that no one else can copy this food, far less actually cook it. Paradiso is sui generis, and has been since they first opened their doors in 1993. 'The best restaurants are, in all their aspects, expressions of the people who create them', Cotter told us, back in 1997, and Paradiso has played stage to a superlative brigade of talents over the years, anchored by Cotter's belief that cooking is a cultural and cerebral statement, as much as a culinary statement. In its modest magnificence, this simple room with its high-wire cooking has revolutionised the very idea of vegetarian cookery.

FIND | WALK | EAT | SLEEP PAGE 219

THE OGHAM STONES
IN UCC QUADRANGLE
CORK

The collection of ogham stones in the Stone Corridor on the campus of University College Cork is the largest public collection of these rare, inscribed memorials. Whilst ogham stones have been found in both Cornwall and south Wales, they are particularly associated with the south of Ireland, in particular counties Cork, Kerry and Waterford. Ogham is an alphabet of 20 letters, derived from Latin script, which were carved into the edges of quarried stone and are read vertically upwards on the edge of the stone. The stones marked the burial place of a distinguished person, and usually record tribal or personal names. The individual letters are associated with a tree or a plant. Ogham stones are the first inscribed monuments in Ireland, in use between the 4th and 7th centuries AD, and pre-date the arrival of Christianity.

FIND | WALK | EAT | SLEEP PAGE 219

THE ENGLISH MARKET
CORK

Think of Cork's legendary English Market as Cockaigne, the mythical land of plenty, but Cockaigne as designed by Guillermo del Toro, a trawl of riches from the larder and labyrinths of Irish culinary history, slung together surreally and cheek-by-jowl smack in the centre of the city. You come here to find pig's tails, and queer gear like La Poire de Boeuf. You come for the uniquely pungent drisheen – a blood pudding made of sheep's blood – and bottles of 2008 Pommard. The Market's uniqueness lies in the fact that it straddles the ancient and the contemporary of Ireland's food culture, without any tension, which means there is no other food market anywhere quite like it.

FIND | WALK | EAT | SLEEP **PAGE 219**

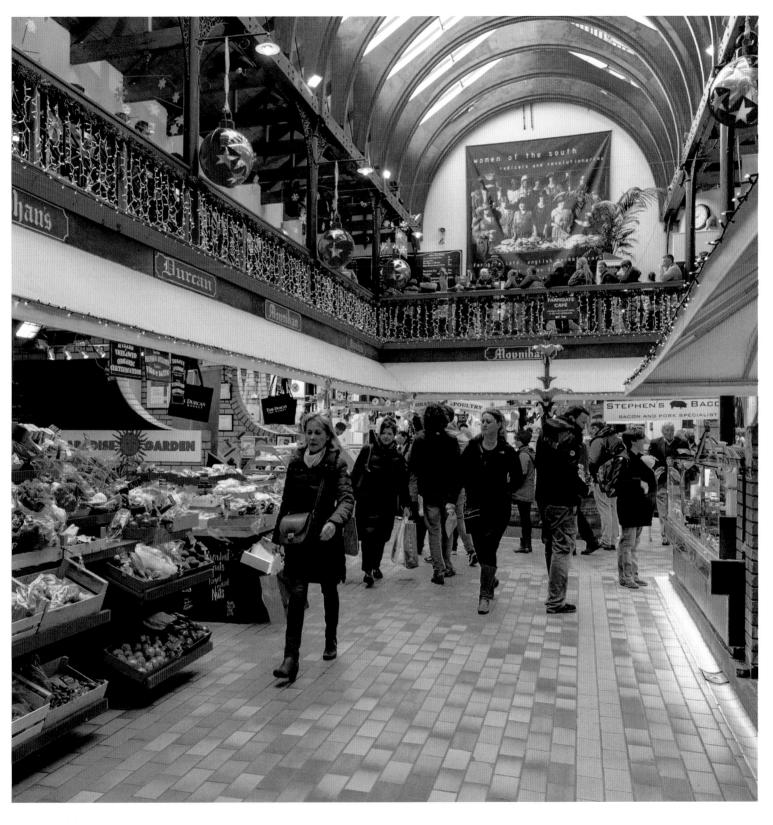

BALLYMALOE HOUSE
SHANAGARRY, CORK

Myrtle Allen created both the modern Irish food revolution, and the country house hotel concept, when she opened the doors of Ballymaloe House to dinner guests in 1964. For Irish food, this was the Big Bang, and every working chef in Ireland remains in debt to Mrs Allen's pioneering and quietly transgressive personality. The house sits at the centre of a working farm, surrounded by landscaped lawns and vegetable beds and, despite its international reputation, Ballymaloe House remains a simple, elegant and understated destination: no bells and whistles, no lifts, no pomposity. The cooking in the house's Yeats Room restaurant is simple and pure, offering flavours that are both elemental and ancient.

FIND | WALK | EAT | SLEEP PAGE 220

KINDRED SPIRITS
MIDLETON, CORK

In 1847, during the time of the Great Famine, an extraordinary contribution was made by the Native American Choctaws, who donated the then substantial sum of $170 to aid the Irish famine-relief. This gorgeously evocative sculpture, by Alex Pentek, commemorates this singular act of generosity, and remembers the story of two separate nations, tied together in suffering – at the time the Choctaw had suffered dreadful hardship having been relocated from their homelands and moved westwards on the Trail of Tears. The statue depicts Choctaw feathers – eagle feathers – made from stainless steel, arranged in a circle, symbolising an empty bowl.

FIND | WALK | EAT | SLEEP **PAGE 220**

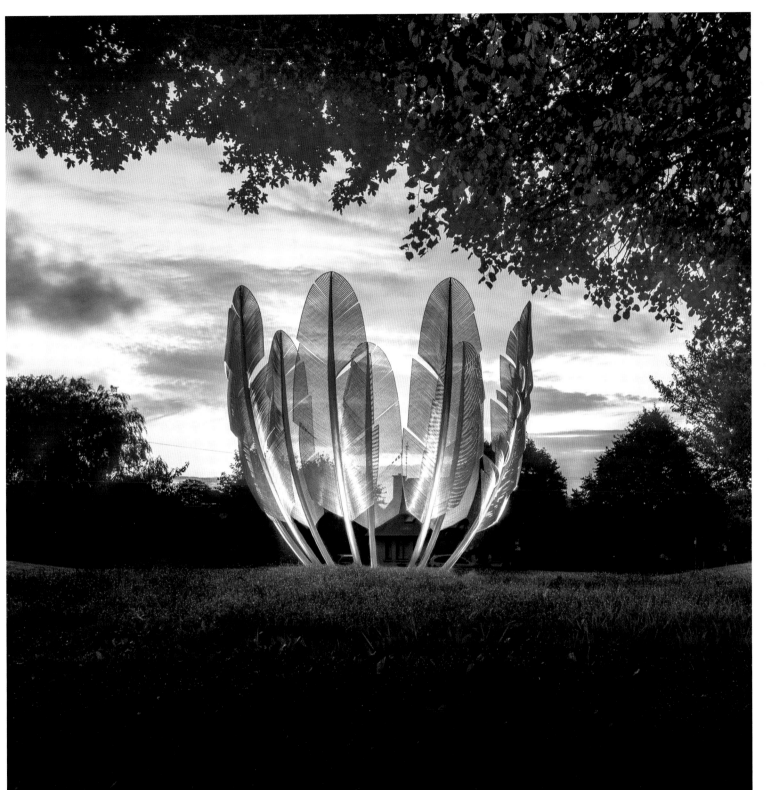

KINSALE
CORK

When a savvy group of food folk banded together to form the Kinsale Good Food Circle, back in the early 1970's, and then organised the town's first Gourmet Festival in 1977, the pretty maritime port of Kinsale proved itself to be a culinary trailblazer, for this was the first ever festival in Ireland organised around food, and the creative work of Kinsale's restaurateurs. More than 40 years later, Kinsale remains a destination for food lovers, and a buzzing, engaged town, where local businesses work well together. We love the apocryphal – and true – story of the night in the early days when the electricity in Heide Roche's Bistro restaurant went on the blink. The chef, who was cooking veal escalopes, quickly bundled up the meat, brought it up to The Vintage Restaurant, run by the great Gerry Galvin, and finished the cooking on the Vintage's gas rings, before bringing the completed dishes back to the Bistro and the hungry, and unsuspecting customers.

FIND | WALK | EAT | SLEEP **PAGE 220**

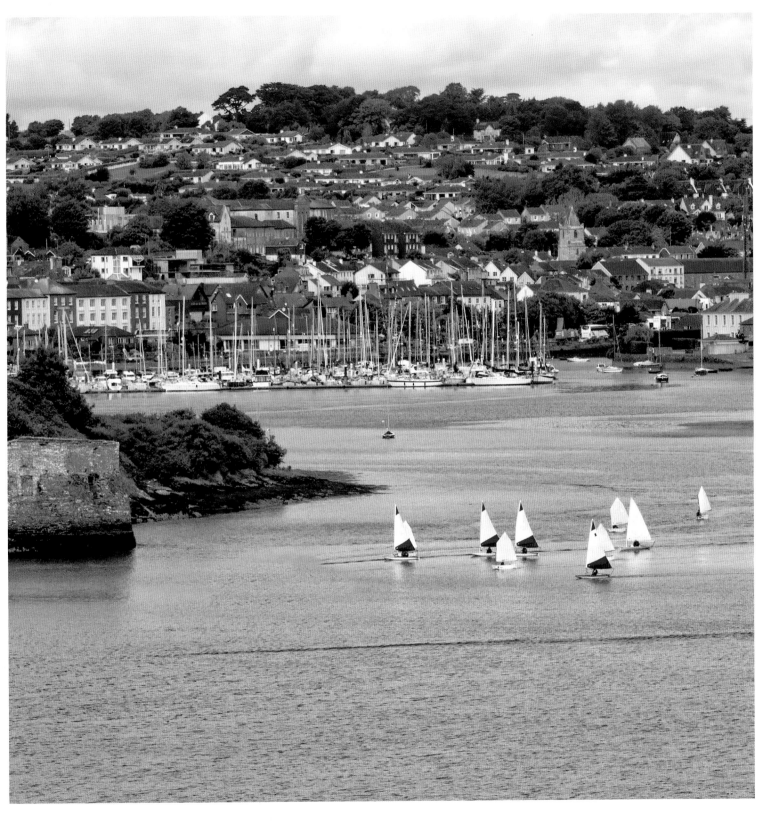

THE BEACON
BALTIMORE, CORK

Known locally as 'Lot's Wife', because of its resemblance
to a pillar of salt, the navigation beacon that overlooks
Baltimore Harbour is an atmospheric circular, freestanding
edifice, built in 1849 on the cliff's edge, and no further
than a good walk from the pretty village. The beacon is
made from rubble stone that has been painted lime-wash
white. It is topped with a slender iron finial cap, which gives
the structure drama and an almost Celtic, sculptural aura.
Practically, it is a distinctive landmark which has guided
mariners for more than a century, although the Algerian
pirates who arrived here in 1639, sacked the village and
took more than 100 inhabitants, likely to sell into slavery,
clearly didn't need any navigational assistance.

Be careful when walking around the Beacon: freak waves
have claimed lives over the years.

FIND | WALK | EAT | SLEEP **PAGE 220**

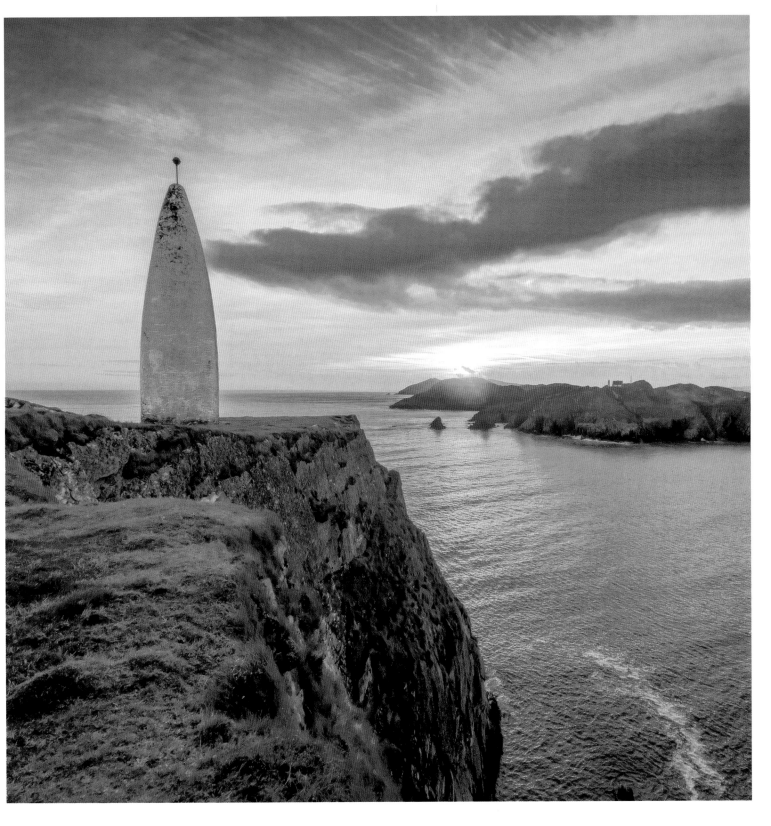

LOUGH HYNE
SKIBBEREEN, CORK

Lough Hyne is an important sea lough, and its marine life has been carefully studied for many years. Around 8,000 years ago, it was a freshwater lake, and the sea level outside the lough was about 15 metres lower than today. Nowadays, it's a saltwater lake, which meets the sea at a narrow passage – the Lough Hyne rapids – which can be flat calm at the turn of the tide, or can run in either direction, depending on the ebb and flow. There is evidence of prehistoric life around the lake, and there are also ruins of four ring forts, suggesting medieval dwellers. The original rapids wall, built in 1847, is what is known as a 'famine wall'.

Today, wild swimmers jump into the water year-round, and kayakers enjoy night paddles hosted by www. atlanticseakayaking.com. Keep your eyes peeled for kingfishers.

FIND | WALK | EAT | SLEEP PAGE 220

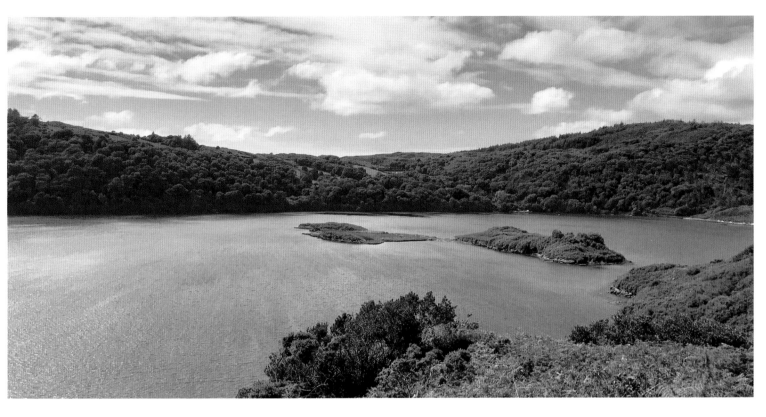

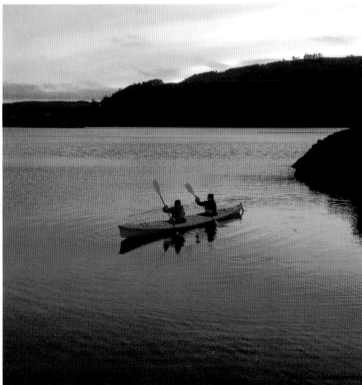

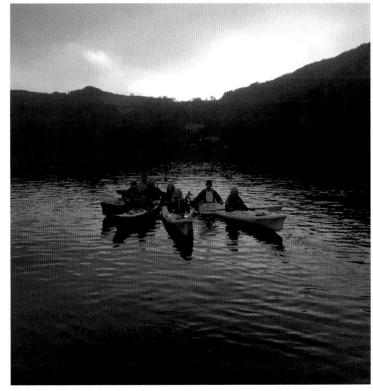

LEVIS CORNER HOUSE
BALLYDEHOB, CORK

Levis is a century-old country pub with a century-old tradition of hospitality, a lovely little place where in recent years Joe and Caroline O'Leary have amplified the hospitality, whilst also creating one of the great music session venues, and a marketplace where you can pick up some organically grown West Cork vegetables. Mixing the traditional with the contemporary means that Joe and Caroline have created a whole new template for the Irish pub, and their inspired work is fitting tribute to Joe's great aunts, Nell and Julia, who ran the pub for many decades. As a singer himself – Joe was frontman for the Cork band, Fred – Joe has an especial sympathy for musicians, which results in unforgettable music sessions.

FIND | WALK | EAT | SLEEP PAGE 220

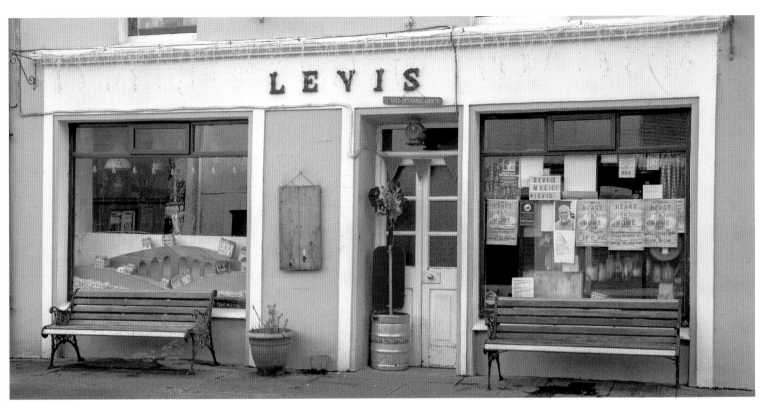

THE SHEEP'S HEAD WAY
CORK

The visionary folk who carved out the Sheep's Head Way took their elemental impetus in creating this EDEN award-winning series of walks from Seamus Heaney's poem, *The Peninsula*: 'things founded clean on their own shapes; water and ground in their extremity.' If you manage to walk the 93km, and complete the 18 loop walks, you will understand those lines implicitly, and know every inch of the Sheep's Head peninsula, the smallest of the five peninsulas that poke out into the Atlantic Ocean. Look out for the peregrines and the choughs, and lose yourself in the peace of this last shard of Europe.

FIND | WALK | EAT | SLEEP **PAGE 221**

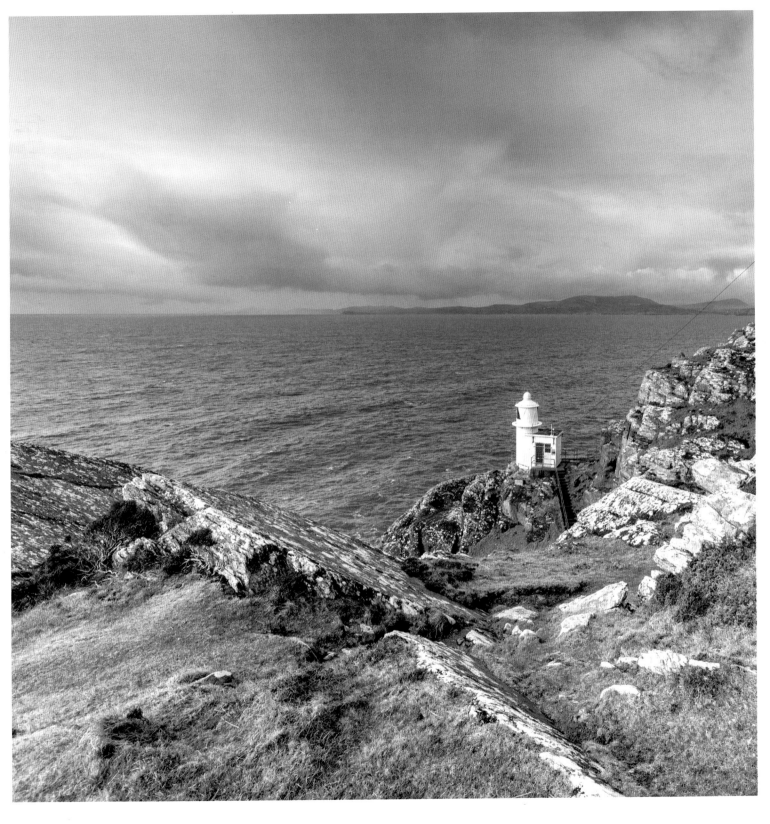

ILNACULLIN
GARNISH ISLAND, CORK

If you should feel a flush of artistic inspiration thanks to the calm beauty of Ilnacullin, then you are not alone, and you are not the first: George Bernard Shaw wrote *St. Joan* here, in 1923, and later described the island, also known as Garinish or Garnish, as 'paradise'. P.L. Travers and Agatha Christie were amongst later guests. The gardens were originally laid out by the legendary Harold Peto and, later, by the Scottish gardener Murdo Mackenzie. The house has been beautifully restored, and the gardens are a thrill, especially the Italian garden, with its Bath stone and Connemara and Carrara marble. Its sheltered setting in Glengarriff Bay means that, over the last century, Ilnacullin is estimated to have enjoyed two centuries of botanical growth. The boat trip, across and back, weaving in amongst the seals, is a joy.

FIND | WALK | EAT | SLEEP **PAGE 221**

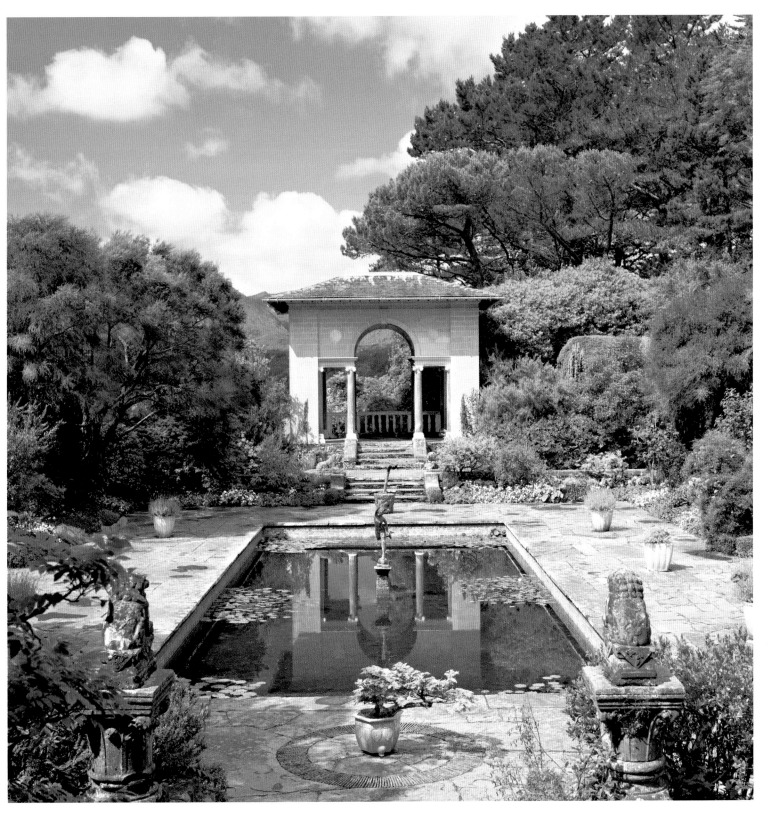

THE EWE EXPERIENCE
GLENGARRIFF, CORK

Sheena Wood and Kurt Lyndorff have created something special in the Ewe Experience. This interactive sculpture garden is a surreal, theatrical, absurd, inspired, political, magical and mystical six acres of mountainy wood pock-marked by Sheena's dramatic sculptures. You are welcomed by a thundering waterfall and, from there on, the thrills continue as if you have entered a dreamscape, and not just taken a little detour off the Glengarriff Road. Sheena Wood has described her work as 'trying to bring out the hidden story' and, in The Ewe, it feels as if she has unearthed a hidden world. Pure enchantment.

FIND | WALK | EAT | SLEEP **PAGE 221**

THE RING OF BEARA
BEARA PENINSULA, CORK

You could drive around the Beara Peninsula, from Glengarriff to Kenmare, and each excursion will seem to be completely different from the last time you toured this other-worldly escarpment of mountain, sea and stone. Everything is always changing, as you head south down to Castletownbere – the major fishing port of the region – then continue up the north coast. Two detours are worth the effort: go as far south as you can and take the cable car over across the water to Dursey Island: the soles of your feet will sweat as you dangle above the waves. And make time to cut across the peninsula via The Healy Pass (R574), an inspiring drive, where the sheep own the road. And don't leave without seeing the Ballycrovane ogham stone, which stands more than 5 metres high looking out over Kenmare Bay, and is the tallest ogham stone in the world, with an inscription that reads: MAQI-DECCEDDAS AVI TURANIAS, which translates as 'son of Deich descendant of Torainn'.

Opposite page: Eyeries village.

FIND I WALK I EAT I SLEEP **PAGE 221**

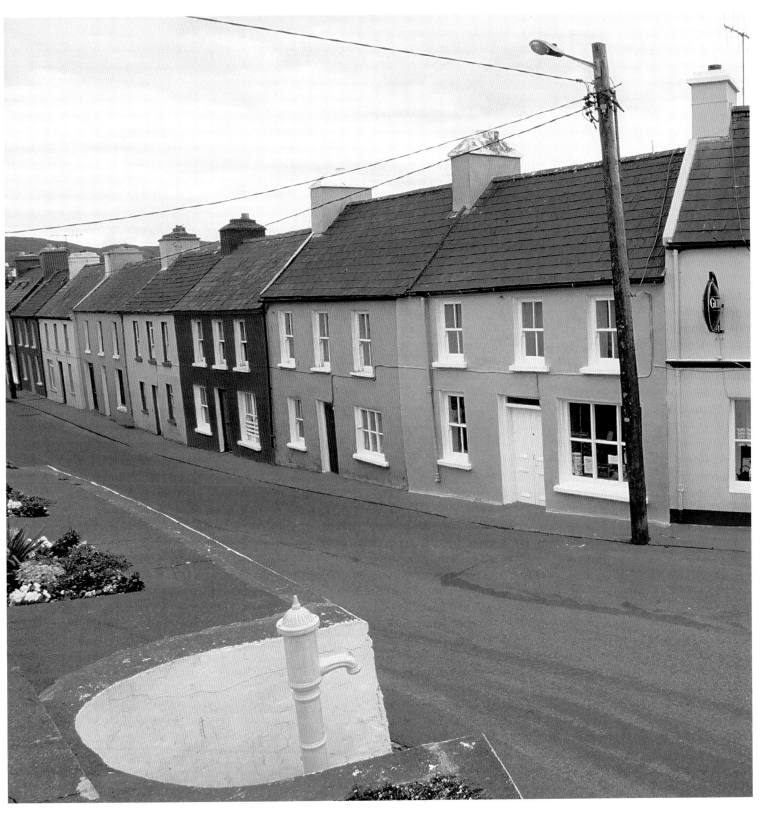

SKELLIG MICHAEL
SKELLIG ISLANDS, KERRY

You step off the boat, prepare to step up the 618 steep steps, and you have arrived at the westernmost outpost of Christianity: Skellig Michael. The Archangel Michael is the patron saint of high places, and you have to imagine that it was an Archangel who led the early Christians to a place where 'half-starved monks crouched against the gales high in the rocky cliffs... and the terrifying beauty of the waters in front of them made them see the sun dance for joy over the Atlantic Ocean, as it celebrated the Lord's Resurrection on Easter Day', writes Diarmaid MacCulloch in his book *A History of Christianity*. Skellig Michael demonstrates the extraordinary determination of the monastic mind: just how did the monks build the Monastery, the Oratory, St Michael's Church, and the incredible beehive-shaped, corbelled dwelling cells, and how on earth did they manage to survive here for centuries? Not only that, but they also managed to invent the medieval church's system of penance. The islands are a UNESCO World Heritage Site.

Opposite page: Photo © Don MacMonagle / macmonagle.com.

FIND | WALK | EAT | SLEEP **PAGE 221**

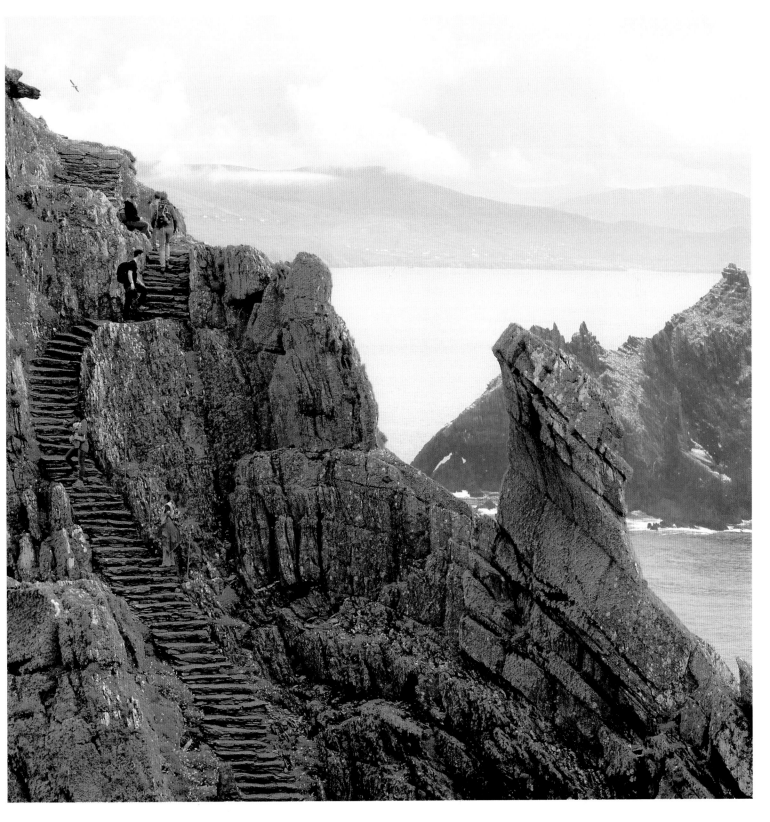

KELLS BAY GARDENS
KELLS, KERRY

Billy Alexander's Kells Bay house and its extraordinary
44 acres of gardens are full of incomparable surprises.
It is home to the longest rope bridge in Ireland, 35 metres
long and 12 metres high over the river. It's a County Kerry
country house, but with a Thai restaurant. Outside there are
dinosaur tree sculptures in a Tasmanian-style forest: artist
Pieter Koning designed these massive creatures to fit their
jungle-type setting. It's all here, in this beautiful Gold-medal-
winning garden. The tree ferns are astonishing – 3.6 metres
tall, and all descended from one 120-year-old tree fern –
and Kells Bay is the largest fern forest in the northern
hemisphere. The nursery has also won an international
reputation, and Mr Alexander has been invited to exhibit
in the Chelsea Flower Show's Great Pavilion. You can
stay in the house, as well as enjoying their terrace and
conservatory cafes.

FIND | WALK | EAT | SLEEP **PAGE 221**

MUCKROSS ABBEY
KILLARNEY, KERRY

Founded in 1448 by Daniel McCarthy Mor, the most dramatic sight in the Abbey is the extraordinary yew tree, which twirls loftily in the very centre of the building. The yew tree in Muckross is said to date from the year the Abbey was founded, making it more than 600 years old. The church itself, and the graveyard around it, are alleged to have inspired Bram Stoker, when he was writing *Dracula*, though this is highly speculative. It's an essential stop on a tour of Muckross Lake and Muckross House, Ireland's first National Park extending over 8,000 acres, and gifted to the State in 1932 by the Bowers Bourne family.

FIND | WALK | EAT | SLEEP **PAGE 222**

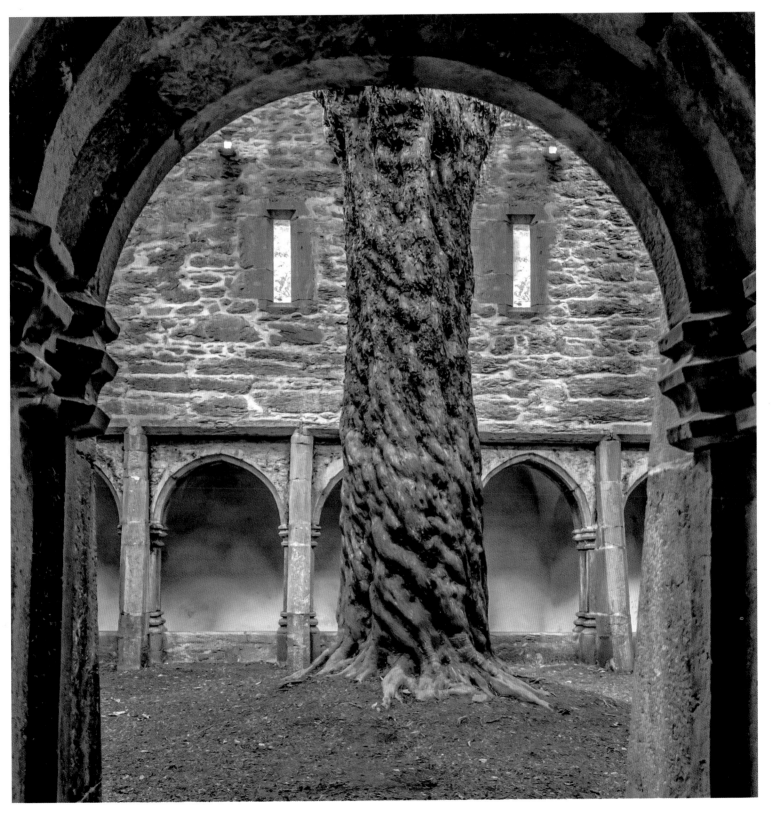

DINGLE WREN
DINGLE, KERRY

December 26th is Wren's Day in Dingle, when groups of boys and men take to the streets of the town dressed in suits and hats of straw, led by a pantomime-style hobby horse. In times past, a wren would be hunted and nailed to a pole to head the procession, for whilst the wren may be the king of the birds, its reputation is ambiguous, and it is associated with treachery. It was also considered bad luck to kill a wren any day other than at Christmas. The Wren boys sing and play music, and visit houses to solicit contributions to be spent on refreshments at the later Wren party. The Wren parades have vanished throughout Ireland, but in Dingle they hold fast to a tradition that dates from the Middle Ages, parading down Goat Street.

The Wren is one of three lovely festivals held in Dingle each year, the others being their buzzing annual food festival and the cult and charismatic Other Voices. It's also a great New Year's location.

Opposite page: Photo © Don MacMonagle / macmonagle.com.

FIND | WALK | EAT | SLEEP **PAGE 222**

SLEA HEAD DRIVE AND DUNQUIN PIER
SLEA HEAD, KERRY

The vertiginous drama of Dunquin Pier, and its endless ability to supply the wandering photographer with dramatic sunsets out over Great Blasket Island, means that there may be a phalanx of folk with tripods and SLRs already in situ when you arrive at this dramatic destination on the Slea Head Drive. But Dunquin is only one of many special places to explore on the Drive, so don't miss the stone beehive huts around Fahan, pay a visit to the Blasket Centre, and to Smerwick Beach and Wine Strand, have a bottle of craft beer at Tig Bhric, and make your own piece of pottery at Louis Mulcahy's studio.

FIND | WALK | EAT | SLEEP **PAGE 222**

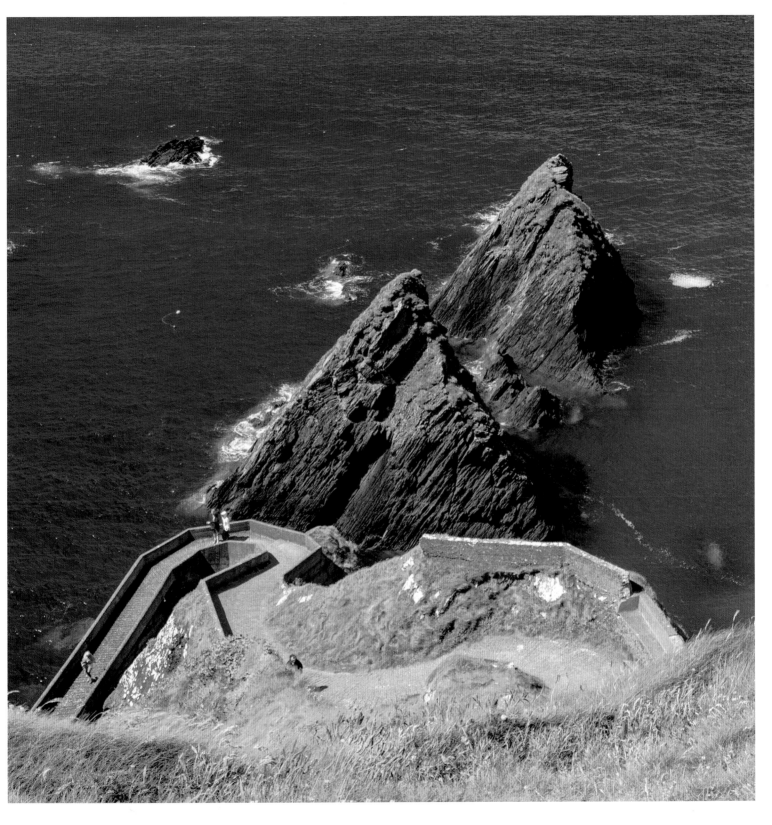

GALLARUS ORATORY
SLEA HEAD, KERRY

Taking the shape of an upside down boat bow, the corbel-roofed Gallarus Oratory is a beautiful dry-stone chapel that to this day remains waterproof. There are divisions about exactly when it was built and what it was for: some call it a chapel, others a shelter for pilgrims, or even a funeral chapel. What is beyond doubt is its beauty, and its utility, and the fact that the area around the Oratory is rife with antiquities. The oratory stands at the foot of Mount Brandon, and overlooks the harbour at Ard na Caithne, scene of a massacre in 1580 when 600 troops were slaughtered in cold blood. Visitors' centre only open during the summer, but access to the Oratory is available all year.

FIND | WALK | EAT | SLEEP **PAGE 222**

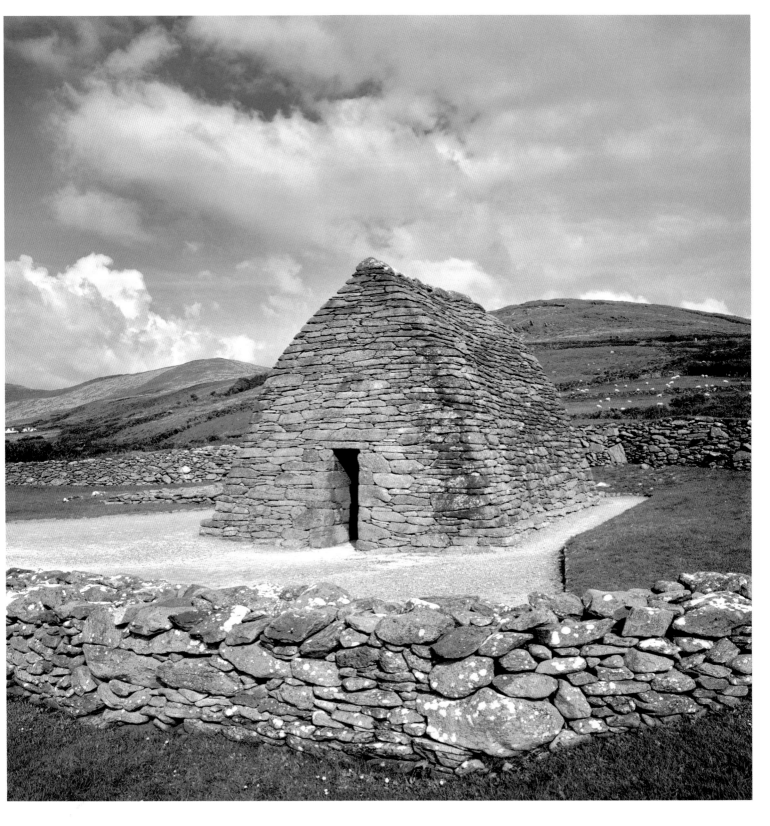

BALLYBUNION BEACH
BALLYBUNION, KERRY

Alfred, Lord Tennyson, visited the caves in the sea cliffs at
Ballybunion, way back in 1842, but today Ballybunion, a
quaint seaside town, is best known for having no fewer than
three dramatic beaches, and the caves have ceded their
popularity to swimmers and sunbathers enjoying the shiny
white sands. 'Ladies Beach' and 'Men's Beach' are divided
by a steep cliff, on which stands a ruined castle and they
are overlooked by the famous golf links. The third beach is
known as Nun's Beach, and is tricky to access. Surfers have
recently unearthed new discoveries amongst the caves, so
expect a fresh wave of poets to begin arriving in the town.

FIND | WALK | EAT | SLEEP **PAGE 222**

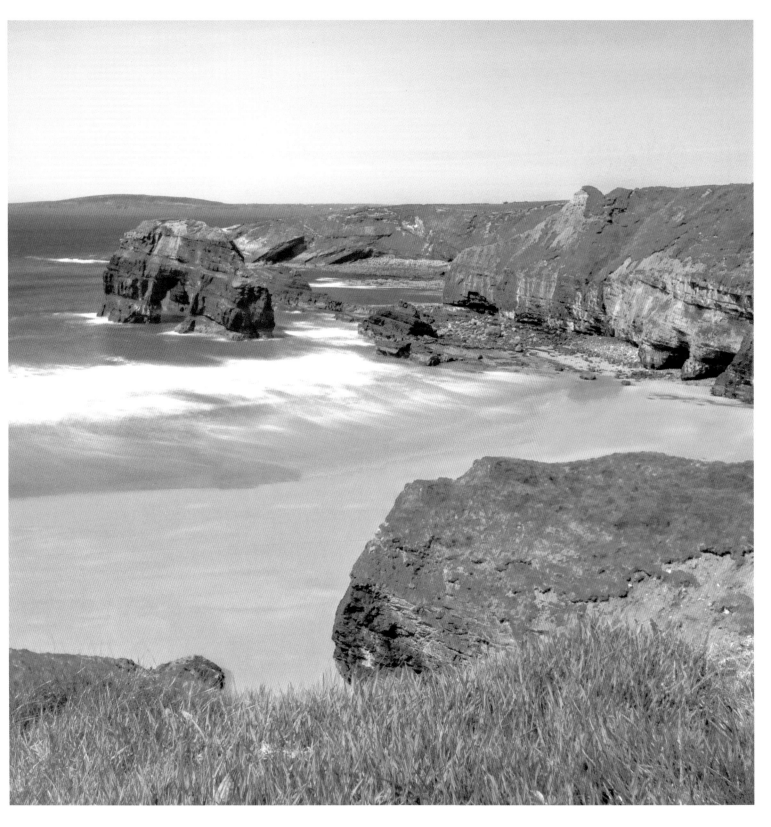

LIMERICK MILK MARKET
LIMERICK

One cold and wintry Sunday morning when we were in the Limerick Milk Market, the upstairs mezzanine was packed with people doing some not-too-serious yoga moves. From *Angela's Ashes* to Vinyasa Yoga. But that's the thing about Limerick city, and Limerick city food, and the city's iconic Milk Market: Limerick is a changed place, and all for the better. The Milk Market is where you head to for some of the best eating and shopping in town. The Market got itself a serious makeover a few years back, and in the process a great space for foods, crafts and culture was created. Whether you fancy sushi or some wet fish, a flat white or a bacon sandwich, a slice of lemon meringue pie or a glass of apple juice, it's all here, sold by a charming bunch of stallholders and shopkeepers.

FIND | WALK | EAT | SLEEP **PAGE 222**

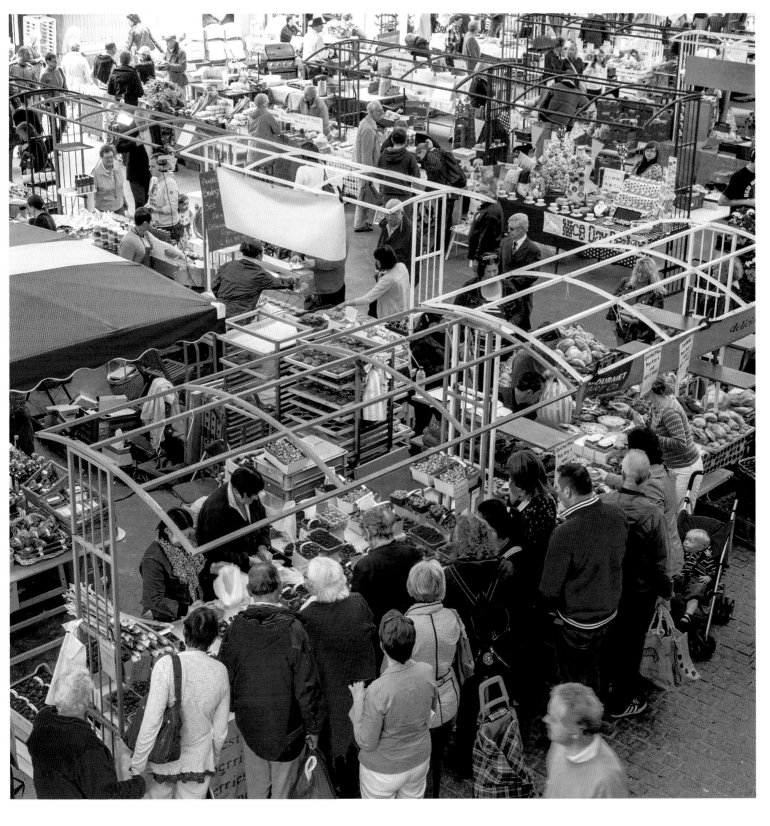

LOOP HEAD
KILKEE, CLARE

The myth that locals will tell you when you are on Loop Head, in south County Clare, is that there is a hidden city – Cill Stuifín – which was submerged in an earthquake some time ago, round about the 5th century.

Only Loop Head could claim to have a hidden, submerged city all to itself. But, in the style in which you come to expect things in south County Clare, it seems that Cill Stuifín can be glimpsed every seven years. Except you don't want to gaze at it, because doing so will bring you bad luck.

Only Loop Head could claim to offer you the most spectacular, incredible vision known to man, but then tell you not to bother looking at it.

This sort of phantasmagorical craic, this audaciousness, is one of the reasons so many of us love Loop Head. It's different. It's mythic, and the people down here have the brass neck to make their own myths, when they aren't cooking great food, and working together to bring the zone to deserved prominence.

FIND | WALK | EAT | SLEEP **PAGE 223**

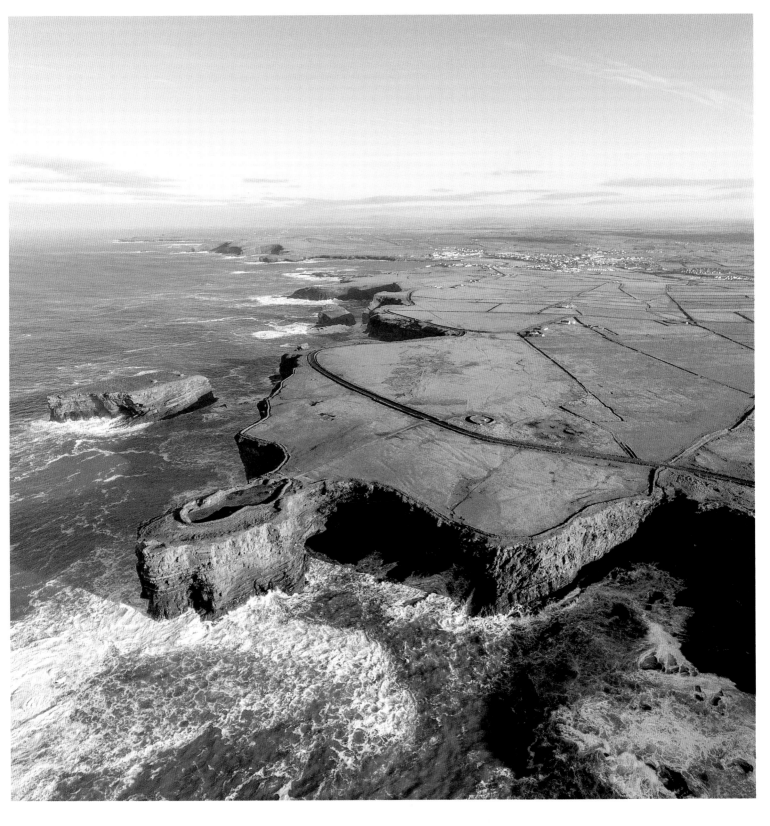

THE BURREN
CLARE

The Burren region in County Clare is the great Irish paradox. When you see it first, one word comes to mind: barren. And yet, it is uniquely fertile. 'Plants normally found in regions as far apart as the Arctic and the Mediterranean occur together in the Burren', the naturalist Gordon D'Arcy has written. Come here between April and June, when the Spring gentian is in flower, and marvel at how it grows on the limestone, all the way down to sea level, fragile, yet intense. The word Burren is derived from the Irish term boireann: a rocky place. But, here's the other paradox: the secret of the Burren is not rock, but water. Under the limestone karst there are countless caves and, in time, it is water that will destroy the Burren, just as it was water that created it.

FIND | WALK | EAT | SLEEP **PAGE 223**

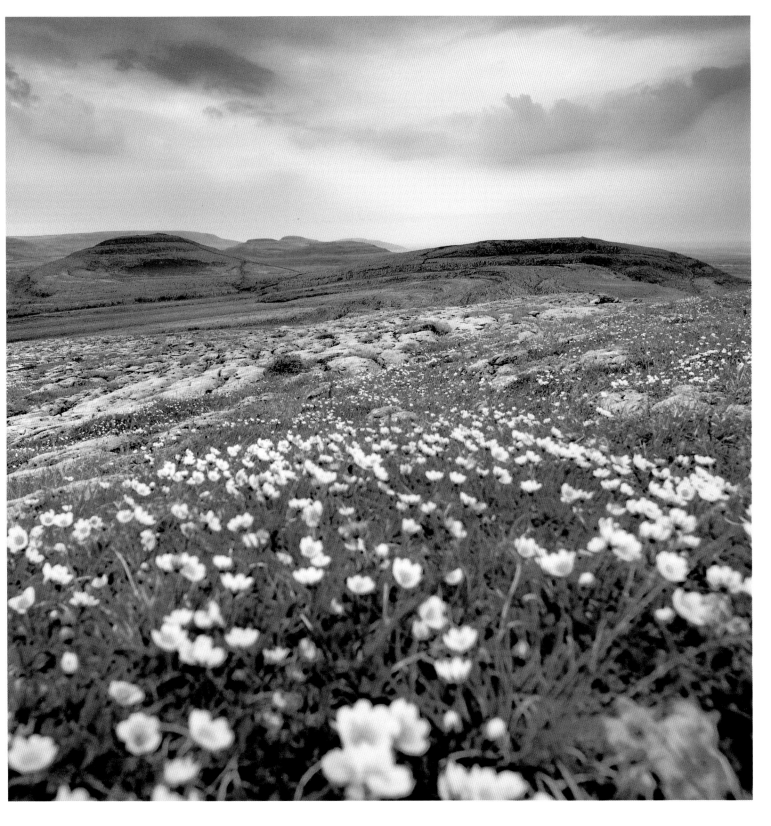

POULNABRONE DOLMEN
BALLYVAUGHAN, CLARE

The Stone Age tomb at Poulnabrone is a portal dolmen understood to date from around 2500BC, and excavations in the 1980s uncovered the bones of 14 adults and 6 children. Neolithic builders also constructed court, passage, and wedge tombs, in addition to portal tombs. The simple but awe-inspiring collection of enormous stones poses an unanswerable question: how on earth did they raise the massive capstones, and place them on the side-stones and back-stone? The dolmen makes a vivid outline on the landscape, and Poulnabrone is an iconic structure that is one of the most photographed monuments in all of Ireland. The name has been translated as 'Hole of Sorrows'.

FIND | WALK | EAT | SLEEP **PAGE 223**

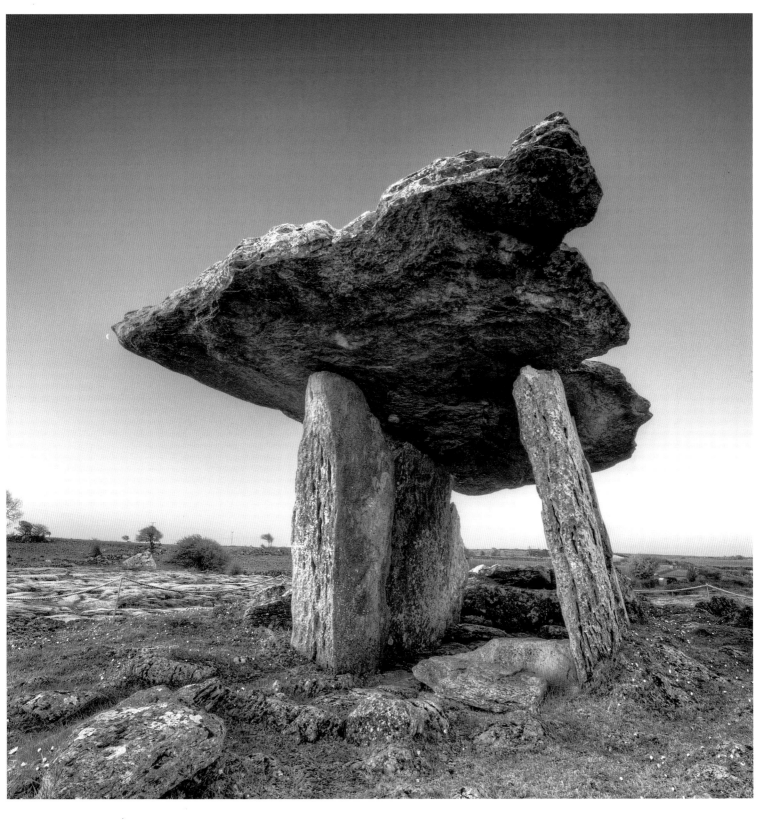

GREGANS CASTLE
BALLYVAUGHAN, CLARE

For many food lovers, Gregans (there is no apostrophe) Castle, on the winding Corkscrew Hill in the heart of the Burren, offers the finest country house experience in Ireland. Simon and Freddie Haden's house is a tone poem of elegant design, and a statement of feng shui: everything is exactly where it needs to be in order to construct a feeling of idyllic repose. This repose, of course, is an ironic counterpoint to the harsh karst landscape which surrounds you on all sides.

FIND | WALK | EAT | SLEEP PAGE 223

DRUID THEATRE
GALWAY

Galway's Druid Theatre is such a phenomenal production powerhouse that today it gets equal billing with its star playwrights. A daylong presentation of John Millington Synge's six plays acts out as DruidSynge. A trio of Tom Murphy plays become DruidMurphy. *The Henriad* is DruidShakespeare, six-and-a-half dramatic hours of the Bard which we saw in the Town Hall in Skibbereen, West Cork, after which the production decamped to… Broadway. Created in the mid-1970's by director Garry Hynes and actors Mick Lally and Marie Mullen, the Druid team has won every imaginable award, from the Tony to the Olivier to the Obie. Yet their hunger remains unabated, which means you await every new production with hungry expectation, keen to see how Mr Hynes and Ms Mullen – the much-loved Mr Lally has passed on – have decided just how they will detonate your expectations.

The theatre building itself – The Mick Lally Theatre on Druid Lane – was once a tea storehouse. The lane was renamed to celebrate the theatre in 1996. It is a venue of intense character, almost like another character in the billing.

FIND | WALK | EAT | SLEEP **PAGE 223**

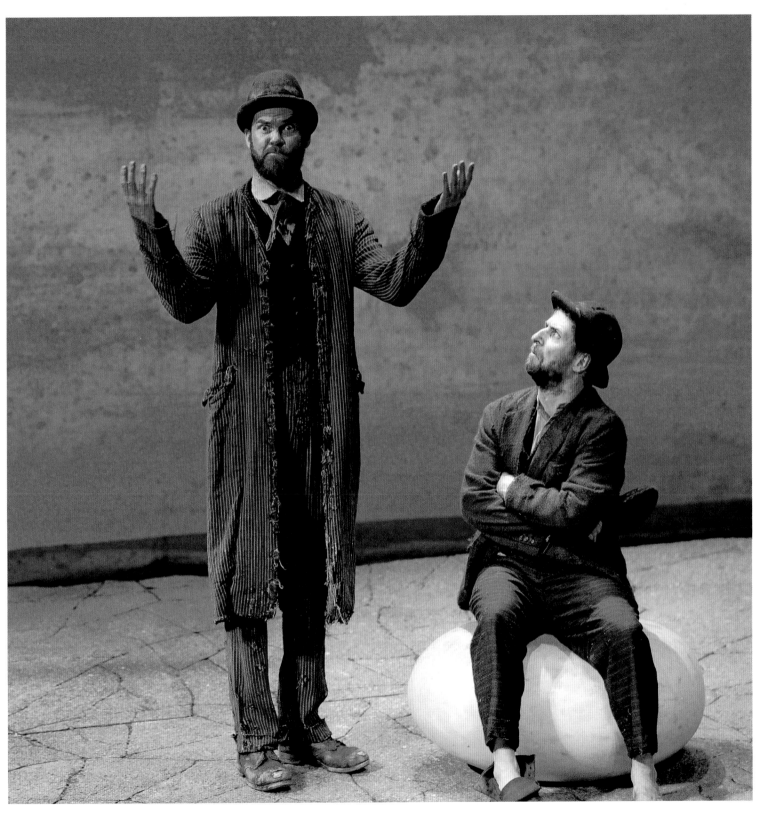

THE KINGS HEAD
GALWAY

Galway has many splendid pubs, but none has a story quite like The Kings Head.

In early 1649, as King Charles I awaited execution, emissaries scoured Ireland, Scotland and Wales in order to find an executioner, in order that the task not be carried out by an Englishman. In Galway, two soldiers, named Gunning and Dean, volunteered. On 30 January, legend has it that Gunning, masked in black, did the deed. His reward was to be gifted, by a grateful Parliament, the building that is today the Kings Head.

However, new research suggests that the executioner was more likely a trusted henchman of Oliver Cromwell, Col. Peter Stubbers. After the execution, Stubbers came to Ireland with Cromwell's army and laid siege to Galway. Stubbers would become military Governor and, after he had ousted the Mayor, he seized his fine house on High Street, which we know today as The Kings Head.

Today, the pub brews its own Blood Red Ale, and the fireplace, dating from 1612, burns brightly every day.

FIND I WALK I EAT I SLEEP **PAGE 224**

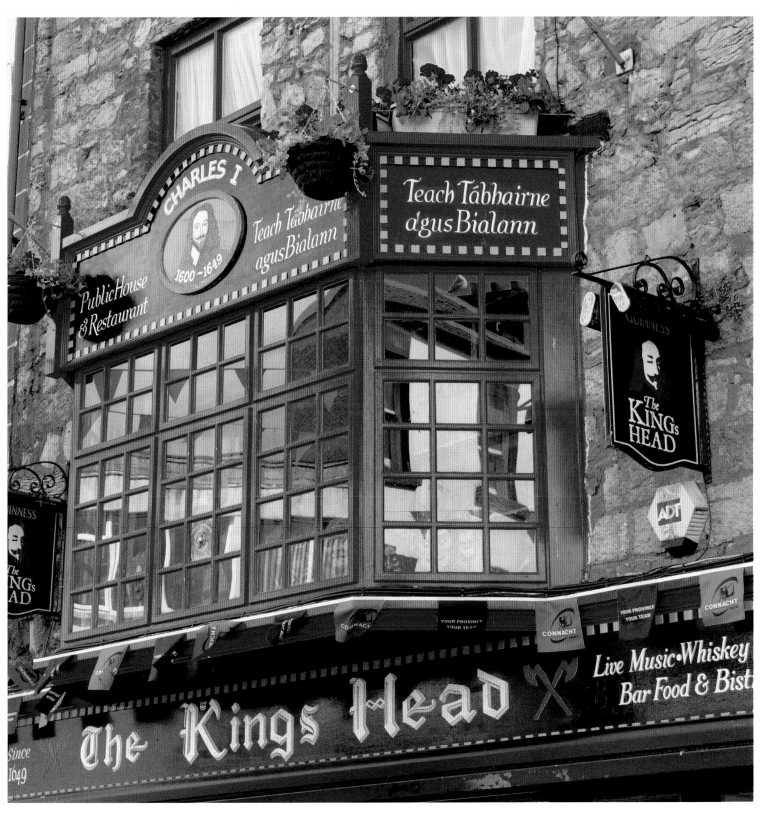

SPANISH ARCH
GALWAY

In Galway, they do things in public. You can walk down Shop Street at 2am in the morning and a sea of happy human beings will swarm all around you, as if they have lapped up from the River Corrib. And when the sun shines, then everyone, but everyone, heads to Spanish Arch to sit on the grass and bask in the rays that swamp the fields between the bay and the river mouth. Galway's public culture is unique in Ireland, where every other city pays lip service to the rivers and waterfronts that are the very reason for their existence.

The famous Arch was built as part of the city walls, a defensive structure erected in the 16thC, built on the site of a 12thC Norman battlement. The Spanish misnomer was probably in reference to the European traders and trawlers that docked here (including Christopher Columbus). In the tsunami that followed the Lisbon earthquake of 1755, the arch was damaged.

FIND | WALK | EAT | SLEEP **PAGE 224**

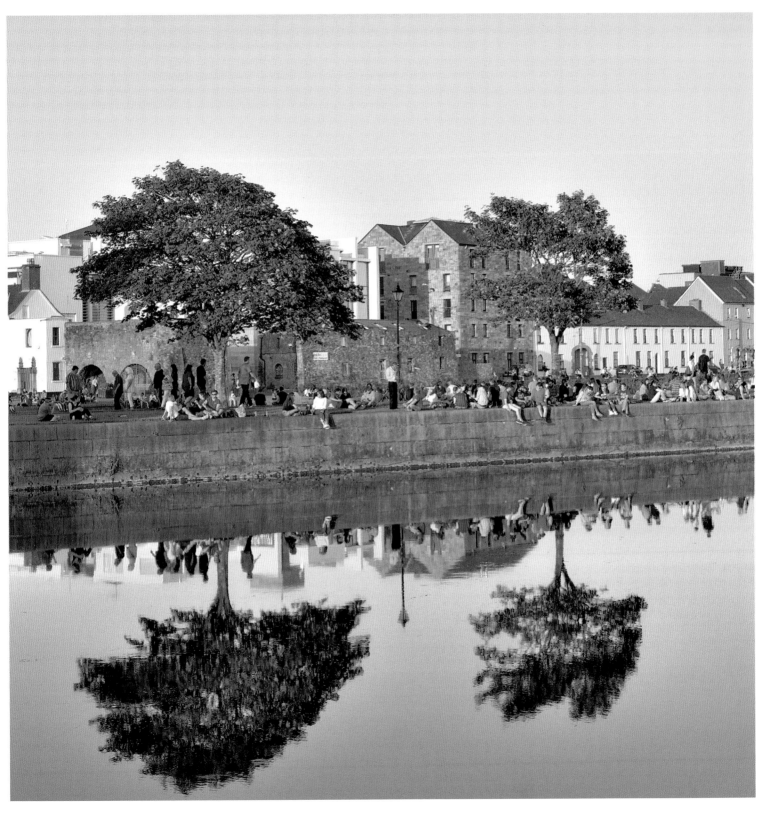

MACNAS HALLOWE'EN PARADE
LATIN QUARTER, GALWAY

For more than three decades, Galway's Macnas has been showing people that madness is magnificent. A street theatre company that taps deeply into the anarchic creativity of the city, Macnas take your dreamscapes and make them real, in street parades that take Germany's Karneval and Arizona's Burning Man and make them into a unique Irish mash-up. The annual Hallowe'en parade shows their mastery of costume, music, pyrotechnics and staging as it wends its way through the medieval streets of the city's Latin Quarter. Macnas have taken their productions all over the world, but it's back home in Galway that their astonishing events unveil the true nature of the city.

FIND | WALK | EAT | SLEEP **PAGE 224**

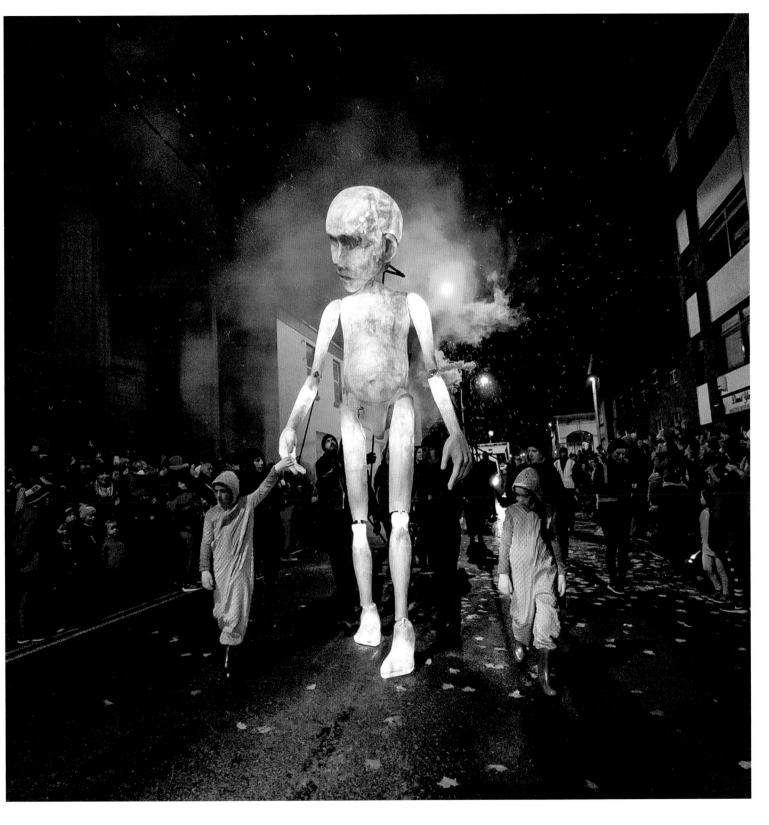

POLL NA BPEIST
INIS MÓR, ARAN ISLANDS

Known as 'The Worm-Hole', Poll na bPeist is an
extraordinary straight-sided rectangle, measuring some
6m by 15m, which has been cratered in the limestone
on the southern edge of Inis Mór, close to the fort at Dun
Aonghasa. It is the largest of the 'puffing holes' on the
island, subterranean passages that connect the sea to the
land. It is somewhat strange that the island's most striking
natural curiosity doesn't have an attendant myth, though
modern writers tend to extrapolate the work *péist* to mean
'serpent', rather than 'worm'. Get close to it on a stormy
day and the sound of the roaring water will terrify you.
Divers use it for competitions, bless 'em.

FIND | WALK | EAT | SLEEP **PAGE 224**

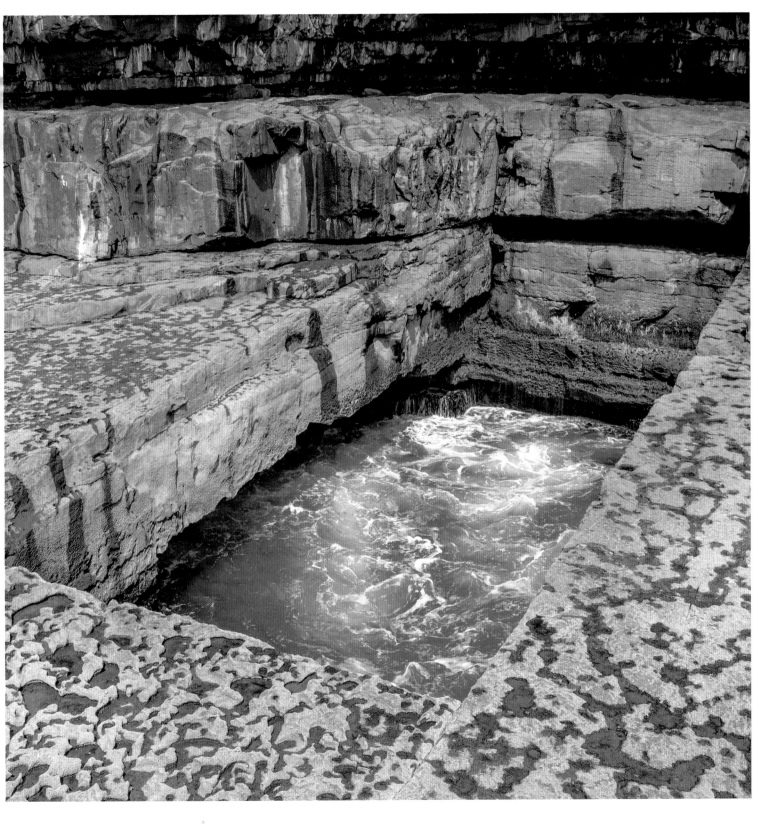

TEACH SYNGE
INIS MEÁIN, ARAN ISLANDS

The house where J.M. Synge stayed when he visited the
Aran Islands, between 1898 and 1902, has been restored,
and is a splendidly authentic tribute to the great playwright.
Synge himself took two fine photographs of the cottage,
one with an islander leading his donkey who is laden down
with rye straw standing in front, the second showing a child
outside the front door next to a stout pig, and both feature
in his book, *The Aran Islands*, first published in 1907. The
family who looked after Synge still own the cottage, and
maintain it beautifully, and the small admission charge goes
towards the upkeep of the cottage. Sitting on the pier at Inis
Meáin one night, Synge wrote that 'The sense of solitude
was immense. I could not see or realise my own body, and
I seemed to exist merely in my perception of the waves and
of the crying birds, and of the smell of seaweed.' Aran will
do that to you.

FIND | WALK | EAT | SLEEP **PAGE 224**

MV PLASSY
INIS OÍRR, ARAN ISLANDS

The *MV Plassy* was a 530-tonne steam trawler that sank
in a storm on 8 March 1960. All the crew members were
saved, thanks to the bravery of the islanders of Inis Oírr.
The boat was swept up onto the shore above the tide line,
and has stayed there ever since, though it was shifted first in
1991 and later by Storm Christine in 2014. The rusty hulk
became the image of Craggy Island in the television show,
Father Ted, and is now world famous. The painter Hughie
O'Donoghue has used the image of the rusting *Plassy* wreck
in his paintings on many occasions.

FIND | WALK | EAT | SLEEP **PAGE 224**

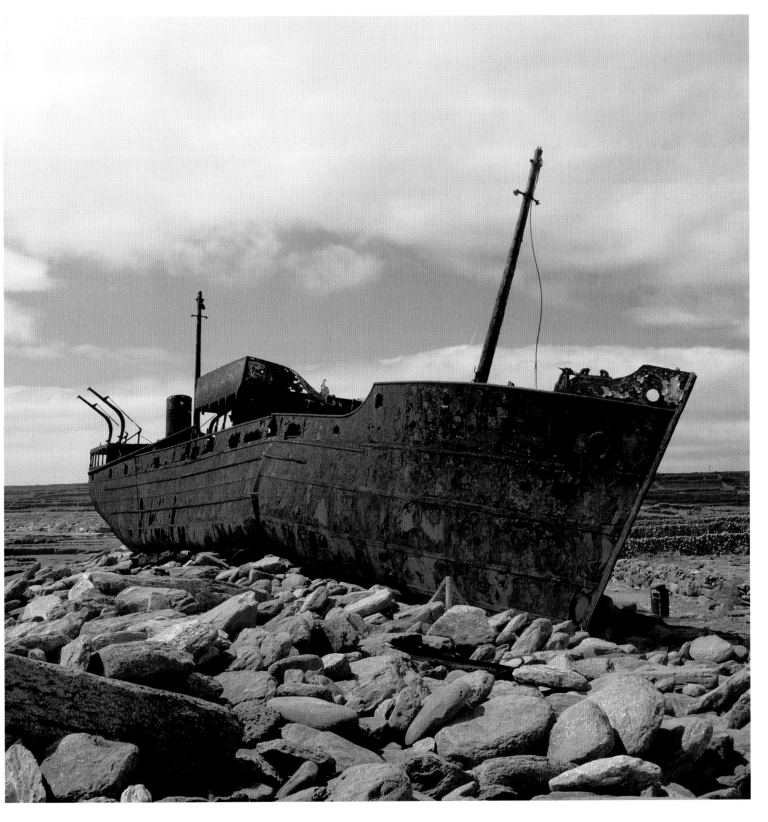

TWELVE BENS
CONNEMARA, GALWAY

Na Beanna Beola – Beola's Peaks – are today better
known as the Twelve Bens, or sometimes the Twelve Pins.
The stark quartzitic peaks make for good climbing and
hiking – the highest is Benbaun at 729 metres – for those
with strong boots and stout hearts. The biggest challenge
the Bens present is simple: just try to describe them without
your prose turning a deep shade of purple. 'Connemara
is the land that looks upon the Twelve Bens, that close-knit,
mandala-like mountain range, as its stubborn and reclusive
heart', writes the region's great cartographer, Tim Robinson,
who notes that 'Fittingly, there is no official boundary to
the land under the spell of this name.' Call it the wild west,
bound only by your imagination.

FIND | WALK | EAT | SLEEP **PAGE 225**

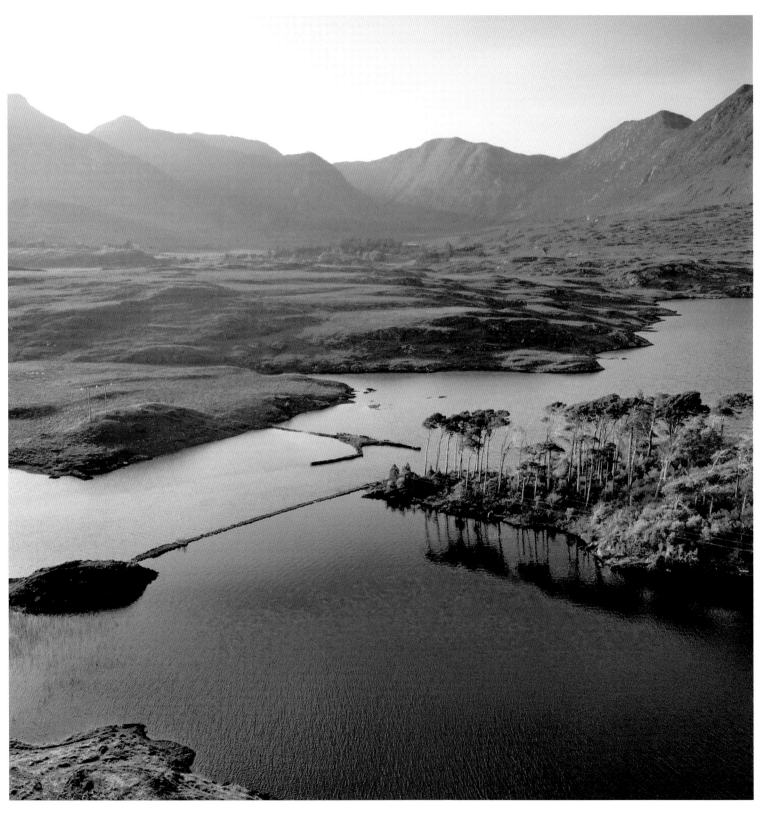

KYLEMORE ABBEY
CONNEMARA, GALWAY

Kylemore Abbey is the Taj Mahal of Ireland: a building built for love.

And when you see it first, Kylemore is a place that takes your breath away.

Mitchell Henry built the Castle for his wife, Margaret. His affection manifested itself on an enormous scale: at one time, the greenhouses of the 6-acre walled garden at Kylemore were so vast they were compared to Kew Gardens in London, and 40 gardeners toiled here in an ordered ornamental brocade that contrasts vividly with the magnificent wildness of Connemara. The perfect siting of the Castle, overlooking and reflected in Lake Pollacappul was no accident: the sound of dynamite was heard for the first time in Connemara when the hills were blasted to create the ideal site for the construction.

And then, reader, she died.

Mitchell Henry paid her another tribute in stone: the neo-Gothic chapel, which is close to the main house.

Today, Kylemore Abbey is a busy place, run by Benedictine Nuns and swarming with tourists and travellers exploring the house, gardens and grounds. Busy staff serve food, make chocolates, and gardeners bravely try to hold back the encroaching rhododendrons.

FIND I WALK I EAT I SLEEP **PAGE 225**

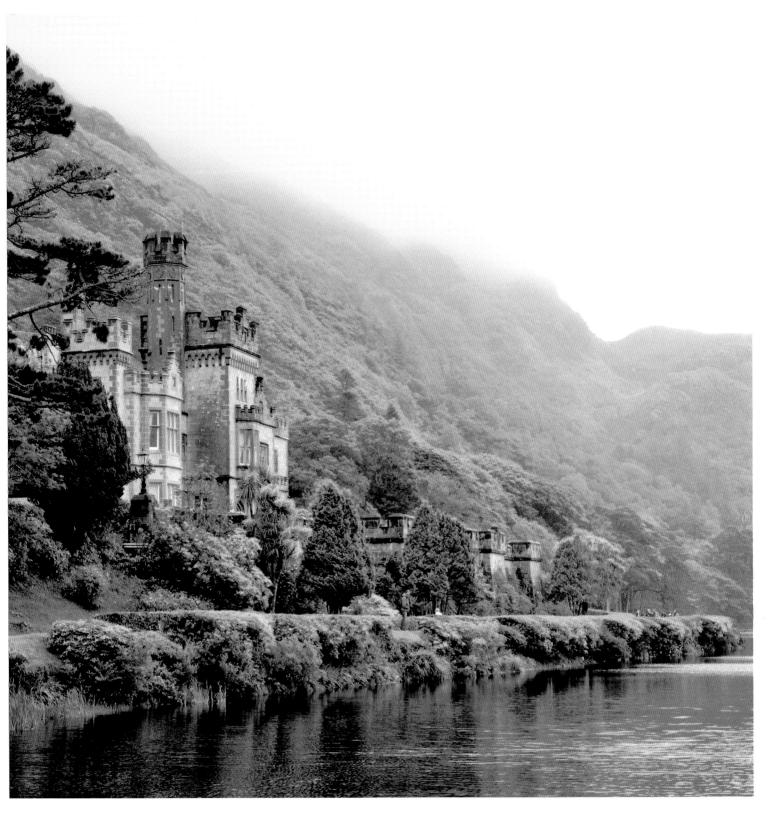

DERRIGIMLAGH BOG
CLIFDEN, GALWAY

By extraordinary coincidence, the wireless station where Guglielmo Marconi transmitted the first wireless messages to America is the same blanket bog where Alcock and Brown crash landed after the first non-stop Atlantic flight. Their journey was a harrowing one, with both men having to leave the cockpit and manually clear the ice from parts of the aircraft after the controls began to freeze. Mistaking the bog for a landing strip, the nose of the plane sunk into the bog, but neither pilot suffered injury. They received a reward of £10,000 from the *Daily Mail* and a triumphant journey from Clifden to London, where they were knighted by King George V. In 2016 the Derrigimlagh looped walk opened – a 5km boardwalk cutting through the bog. The Monument – an aircraft tail – is on the hillside that overlooks the bog.

FIND | WALK | EAT | SLEEP **PAGE 225**

CROAGH PATRICK, HOLY MOUNTAIN
WESTPORT, MAYO

The holy mountain of St Patrick, Croagh Patrick, just outside the village of Murrisk in County Mayo, is 764 metres high, and fairly easily scalable, though at the summit it becomes steep with free-falling rocks that move disconcertingly under your feet as you edge forward, sometimes on all fours. There is an annual Pilgrimage up the mountain on what is known as Reek Sunday, the last Sunday in July, when 25,000 pilgrims will make the ascent all the way up to the chapel at the summit. The National Famine monument, an eerie and affecting sculpture by John Behan, of a coffin ship with a rigging of skeletal bodies, is just across the road at the foot of the mountain.

FIND | WALK | EAT | SLEEP PAGE 225

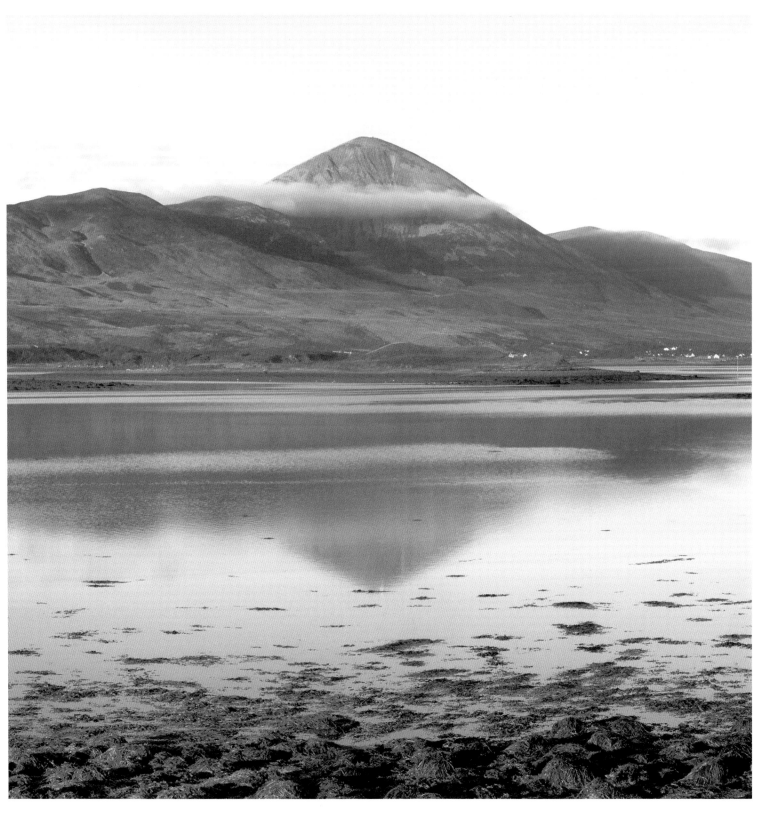

GREAT WESTERN GREENWAY
WESTPORT TO ACHILL, MAYO

The Greenway is the longest off-road trail in Ireland, extending from Westport to Achill Island, and it's a splendid route for cycling or walking. The true secret, however, is the fact that the Greenway is dotted with some of the finest food artisans on the West Coast, so the route offers an aesthete's indulgence, rather than an ascetic scourge. As you tick off the miles, make sure you tick off the culinary signatures: black pudding; Croagh Patrick oysters; Achill sea salt; blackface mountain lamb; Belgian-style beers; blue salmon. The Greenway may be the only cycle route that offers the chance to put on weight.

FIND | WALK | EAT | SLEEP **PAGE 225**

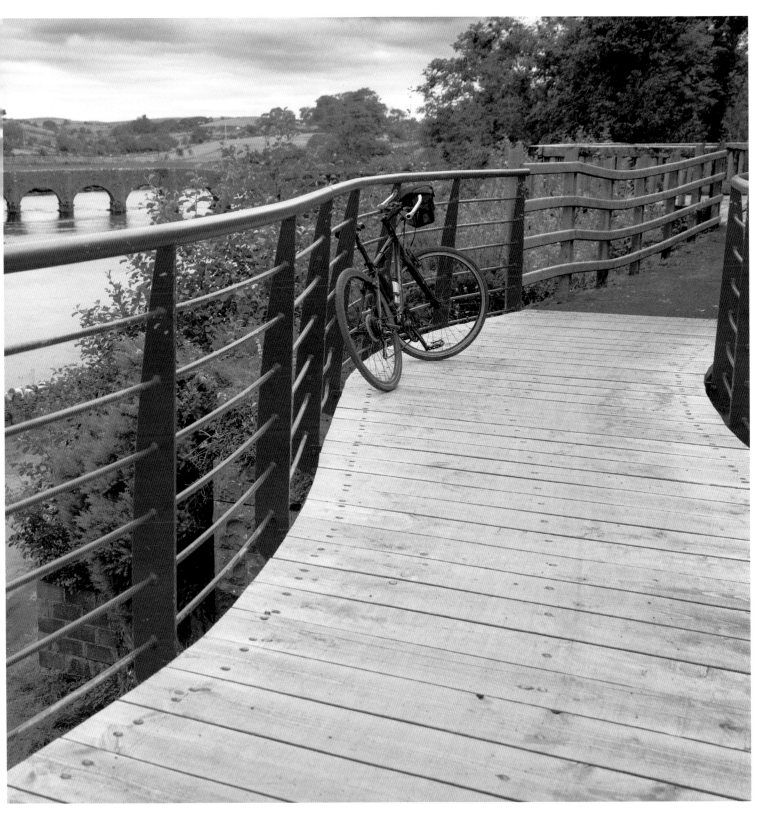

THE DESERTED VILLAGE
ACHILL ISLAND, MAYO

The deserted village of Slievemore is eerie, ghost-like.
The settlement dates to around 1750, and numbered
137 houses in the Ordnance Survey of 1838. But the
villagers emigrated, beginning in 1848 during the Famine,
with others leaving in the early 1850s. There were,
however, villagers still living here as late as 1915, as a
famous image from National Geographic Magazine, of
a young girl on a horse who is carrying baskets of turf,
revealed. It is likely that these were byre houses, where
animals were kept at one end during the winter, and
some continued to be used as booley houses during the
20th century, when the islanders practised transhumance,
and moved their animals up to Slievemore for grazing.

FIND | WALK | EAT | SLEEP PAGE 225

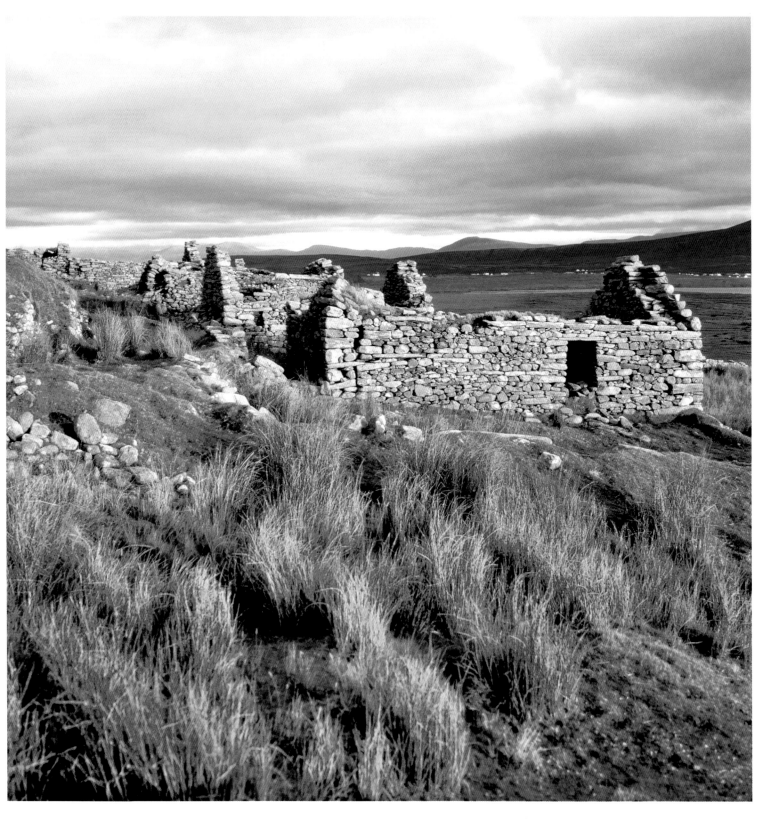

NATIONAL MUSEUM OF IRELAND – COUNTRY LIFE
CASTLEBAR, MAYO

A suitcase made of cardboard. Little boats made of sticks and cowhides. Tea pots made of tin. Nests and cloaks made of straw. Much of the content of the Country Life museum is composed of simple things. How, then, to explain the raw power of these objects, and their ability to move the viewer to the point of tears? The museum's exhibitions reveal that the past, in fact, is not a foreign country, and Irish people didn't do things so differently there. They were the same people, responding with artful spontaneity to the challenges around them.

FIND | WALK | EAT | SLEEP PAGE 226

MARSHALL DORAN COLLECTION
BELLEEK CASTLE, MAYO

Somebody will make a movie about Marshall Doran, someday soon. The content is there: a mysterious identity, a thirst for travel, sailing and collecting, shipwrecks and salvage, suits of armour and executioner's swords, the bed of a pirate queen, then the purchase by Mr Doran, in 1961, of a neo-Gothic pile, Belleek Castle, that was fast fading into ruin. Errol Flynn would have been perfect as Marshall Doran, though one can also imagine Kirk Douglas giving it his all. Mr Doran collected precious fossils and armaments, weapons and artefacts, and brought them to Ballina, and you can see them at close-quarters, downstairs in the dungeons of this friendly, charming castle, where you can also stay overnight, and eat dinner.

FIND | WALK | EAT | SLEEP PAGE 226

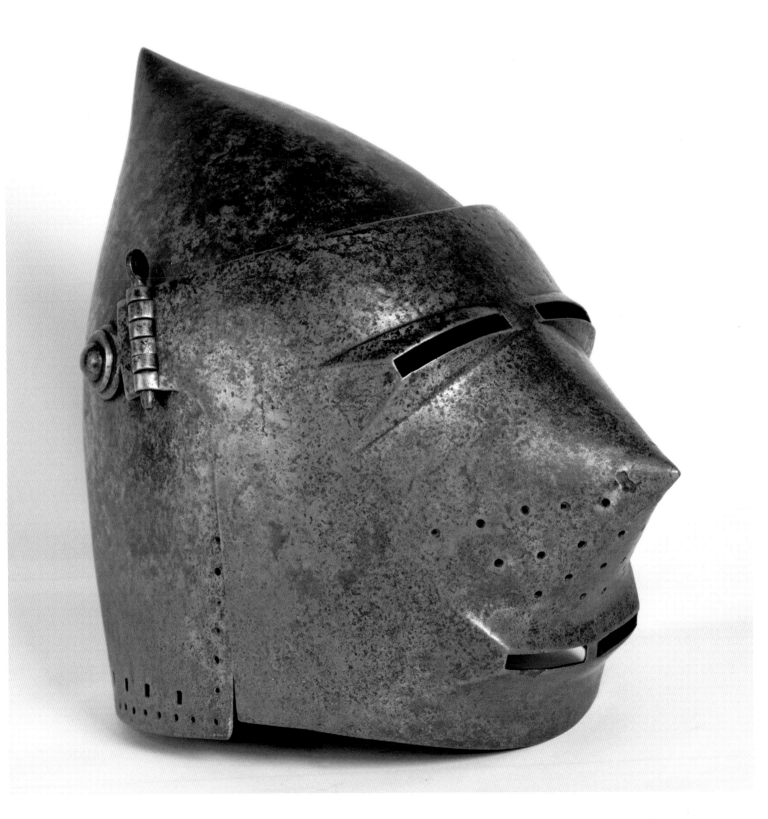

CÉIDE FIELDS
BALLYCASTLE, MAYO

The Stone Age people who cleared the forests and divided
the land between Ballycastle and Belmullet into regular
field systems for cattle rearing were a peaceful community
of farmers, builders and craftspeople. The field systems on
which they lived and worked remained covered by blanket
bog for 6,000 years, until the system was uncovered by
father and son, Patrick and Dr Seamus Caulfield, who noted
that the buried stone walls predated the bog, which was
being cut for turf. The interpretative centre that is now built
over part of the bog features a stunning, award-winning
building, and the museum uncovers not only Stone Age life,
but also the life of the bog that covers it.

FIND | WALK | EAT | SLEEP PAGE 226

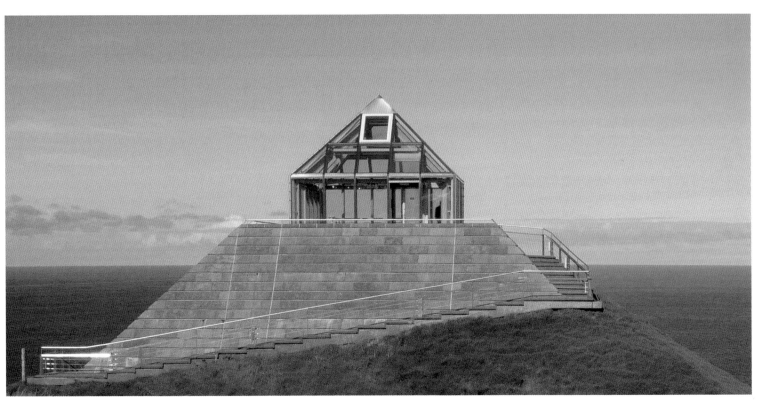

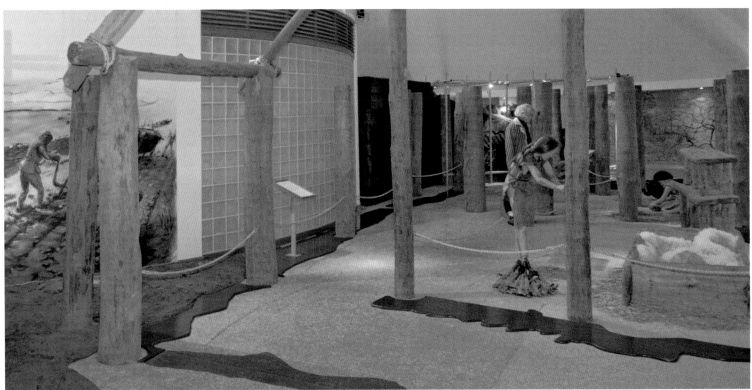

ENNISCRONE SURF
ENNISCRONE, SLIGO

The 5km sandy beach at Enniscrone in West County Sligo is one of the most celebrated destination beaches for surfers, known for long rolling waves that suit beginners, whilst serious surfers come here for the different breaks that occur when there is a good swell. Enniscrone has also become popular for winter surfing when it offers monster waves for the brave. The village is also home to the Victorian-era Kilcullen's seaweed bath house, where you float in baths of hot, lubricious seawater. Drinks afterwards in The Pilot Bar.

FIND | WALK | EAT | SLEEP **PAGE 226**

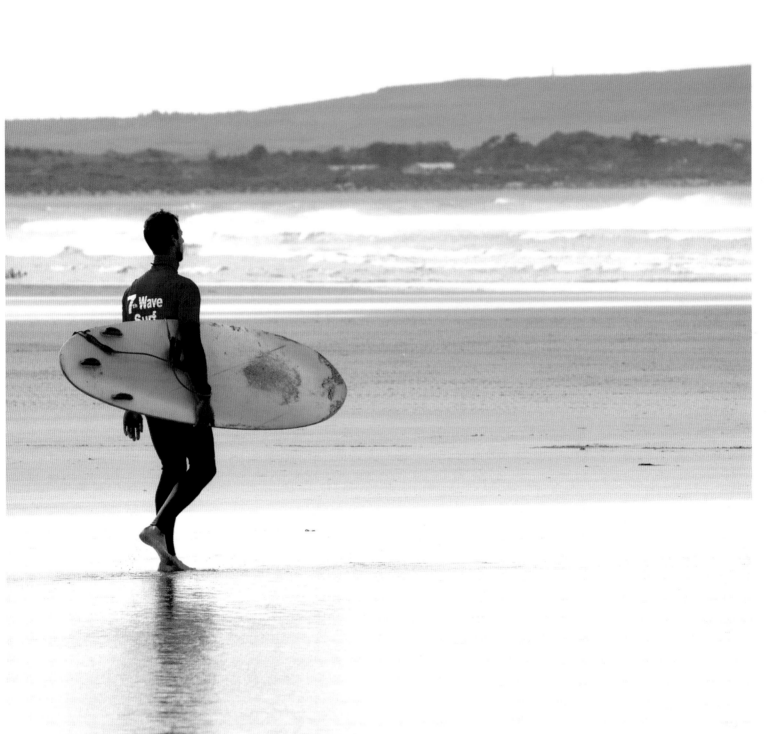

BENBULBEN AND YEATS COUNTRY
SLIGO

'The place that has really influenced my life the most is Sligo,' W.B. Yeats wrote to his close friend, Katharine Tynan. The poet's love of Sligo was handed down by his mother, Susan, with whom 'it was always assumed between her and us that Sligo was more beautiful than other places.' Whether up on the coast near to his grave at Drumcliff, or marvelling at the brute elementalism of Benbulben – best seen from the north-west coastline – or exploring inland amongst the lakes, Yeats is always with you in Sligo, amidst the silver apples of the moon, the golden apples of the sun.

FIND | WALK | EAT | SLEEP PAGE 226

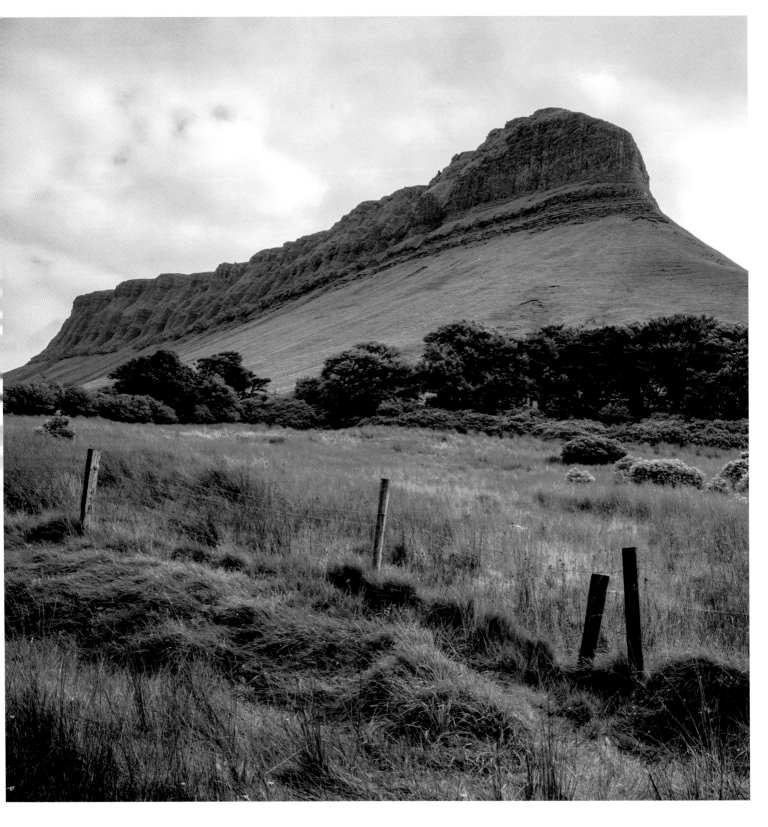

BALLYMASTOCKER BEACH
MAGHERAWARDAN, DONEGAL

Ballymastocker is a beautiful beach of more than a mile of pristine white sand, and is recognised as one of the most serenely beautiful beaches in the world, not just in Ireland. It is also known locally as Portsalon Beach, and *The Observer* once voted it the second most beautiful beach in the world, which any Donegal man or woman will tell you is utter nonsense. But, be warned: in wintertime the winds here are so severe that they are known locally as a 'lazy wind': too lazy to go around you, they simply go straight through you. You've never felt a chill like it. The prize, however, is that this is one of the most idyllic beaches in Ireland and, believe it or not, on many occasions you can have it all to yourself.

FIND | WALK | EAT | SLEEP **PAGE 226**

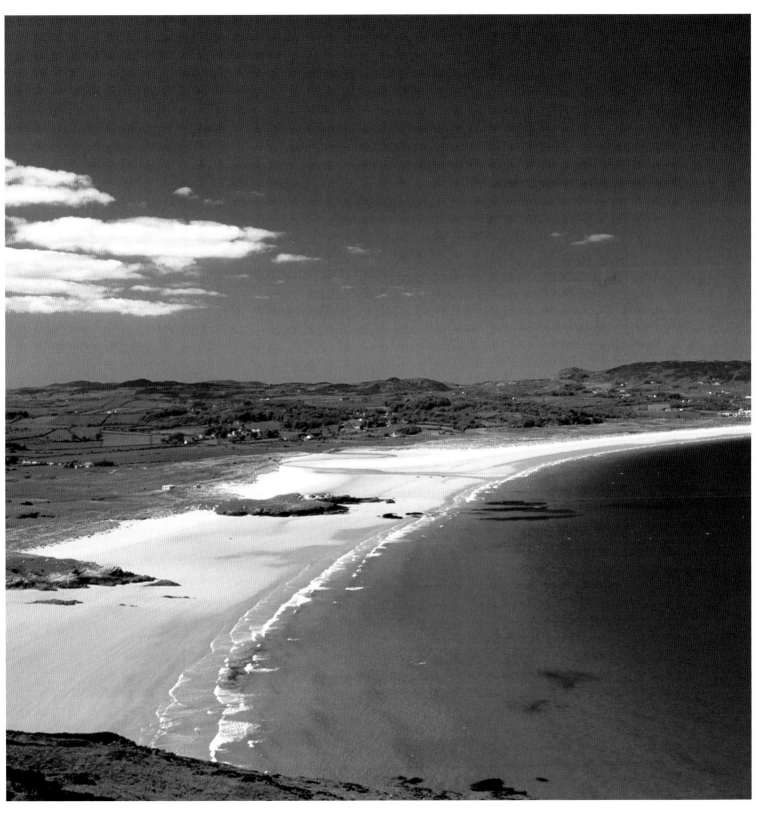

EAGLE'S ROCK
GLENADE, LEITRIM

Eagle's Rock is a 300-metre-tall exclamation mark of limestone, shooting up out of the Glenade Valley, near to the road running between Manorhamilton and Kinlough, and silently telling the story of 340 million years of history, beginning at the Carboniferous period. There were bears living in the caves up here as recently as 2000BC but today, despite its name, there aren't any eagles perched proudly scanning the valley, even though the rock towers are a movie director's idea of exactly where eagles would nest. Whilst it is known locally and nationally as Eagle's Rock, that name seems properly to belong to a cliff face over at Tievebaun, Leitrim's second-highest mountain, and the OS maps record the correct name as Croontypruglish. All around the series of peaks, towers and pillars are fields of boulders, left behind 12,000 years ago as twin glaciers gouged out the horizontal beds of limestone. Only a handful of rock climbers have made the ascent to the summit, which presents both a scary climb and a scary abseil.

FIND | WALK | EAT | SLEEP PAGE 227

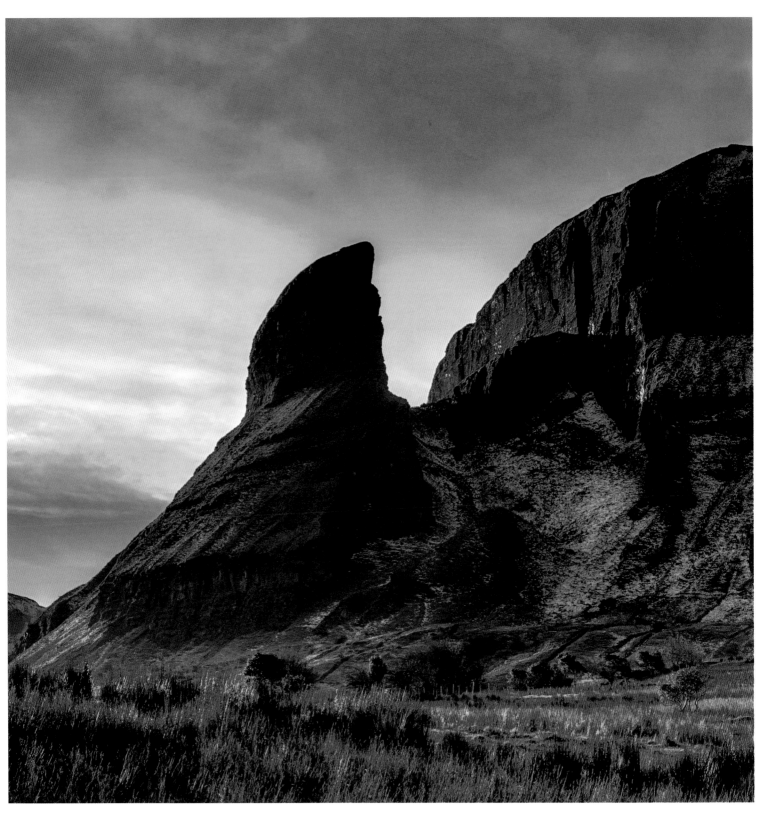

ST AENGUS CHURCH
BURT, DONEGAL

Architect Liam McCormick built seven churches in County Donegal between 1961 and 1977. For the church at Burt, he drew inspiration from the ancient stone fort of Grianán an Aileach, which sits further up the hill, creating a circular church which had never been attempted before in Ireland.

McCormick took both Christian and pagan symbols – a Celtic cross; a Minoan maze; a solar disc – and alchemized them in a series of concentric circles that are washed with the light from the stained glass windows. The copper roof rises upwards like a wave from the landscape, whilst the interior is strikingly pagan: it is difficult to believe that McCormick managed to build this Catholic church in 1960's Ireland. Light pours into the church from the lantern in the spire – echoing the Pantheon in Rome – showcasing the outstanding church art features. The sculptures on the screen wall by Oisin Kelly, near to the porch, are a sublime complement to McCormick's masterpiece.

FIND | WALK | EAT | SLEEP PAGE 227

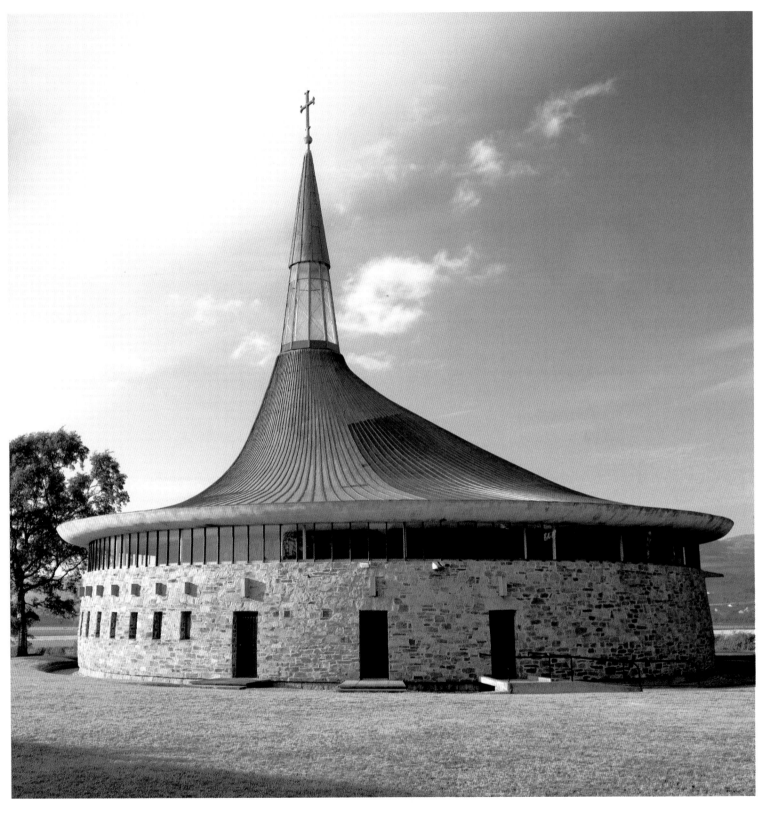

GRIANÁN OF AILEACH
INISHOWEN, DONEGAL

It's hard to decide which is more impressive: the enormous
Iron Age stone fort of the Grianan, or the views you enjoy
when you climb to the top of the enclosure, from where,
on a good day, you can see fully five counties. The simple
circular shape, built on the summit of Greenan Mountain
and up the hill from the Church of St Aengus, is incredibly
pleasing, with an encircling wall that measures around 23m
in diameter. The entrance passage reveals the depth of the
structure and why it has lasted so well. The cashel was likely
constructed around the 8th or 9th century as the chief fort
of the Ui Neill, and was the capital of the over-kingdom
of Aileach, but there are remains on the site that link this
hillside to a structure dating from 1000BC.

FIND | WALK | EAT | SLEEP PAGE 227

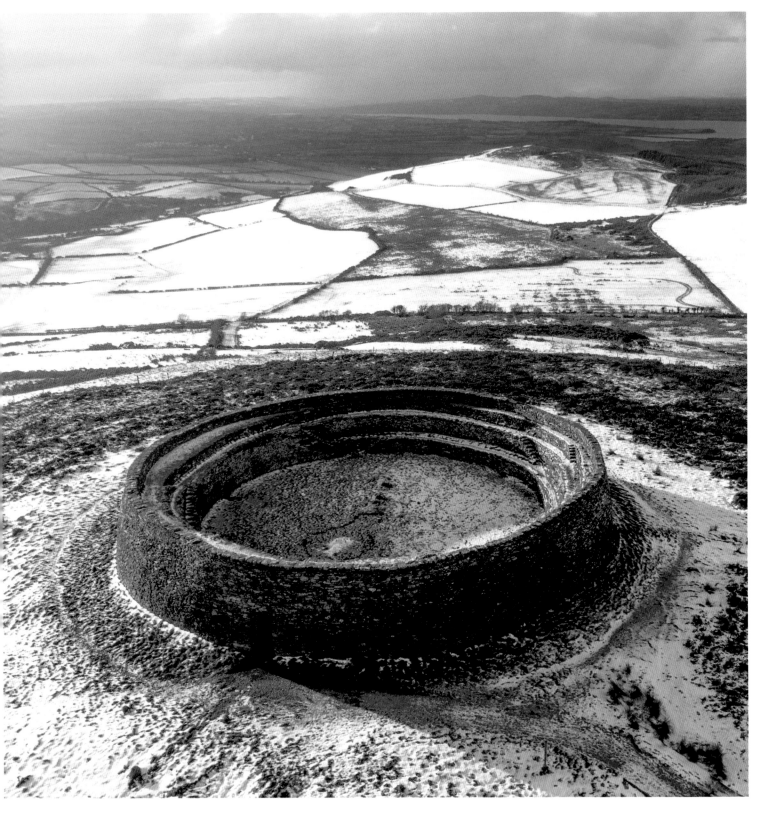

GLEBE HOUSE AND GALLERY
CHURCHILL, DONEGAL

The painter Derek Hill gifted his house, his priceless art collection and a 25-acre wooded garden to the State in 1982. The house is as Mr Hill left it, 'as if Hill himself had just gone out for a walk', said *The Irish Times*. The artworks collected by Mr Hill during an itinerant life, which saw him visiting huge parts of the globe, are stunning: Giorgio Morandi; Stanley Spencer; Camille Souter; Picasso; Hokusai; Le Brocquy; James Dixon; Evie Hone are just some of the artists whose work Hill loved.

FIND I WALK I EAT I SLEEP **PAGE 227**

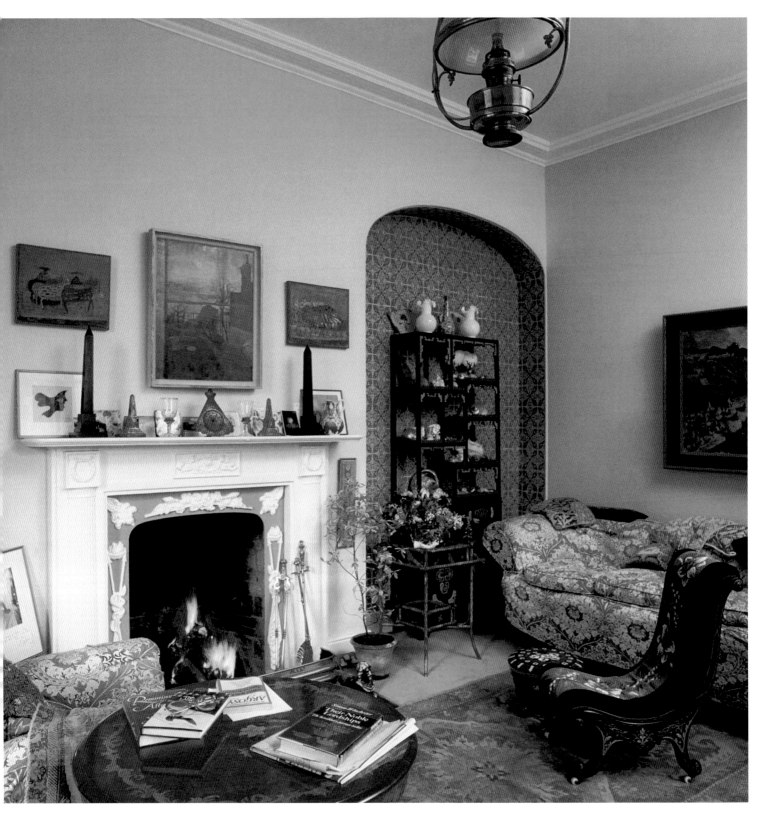

DERRY CITY WALLS
LONDONDERRY

1.8 miles long, 12 metres high, and 9 metres wide, the ancient granite and basalt Walls of Derry form a complete circular walk around the inner city, and encapsulate the tumult of Ireland's history. Whilst the historical stories incarnate the pathos of Northern Ireland's past, it is possible today to appreciate the walls as an aesthetic delight, as the city was actually laid out according to Renaissance town-planning concepts, and the original Plantation layout, finished in 1618, largely survives. And do make sure to step outside the Walls at the bottom of Shipquay Street to explore the magnificently restored Tudoresque Guildhall.

FIND | WALK | EAT | SLEEP PAGE 228

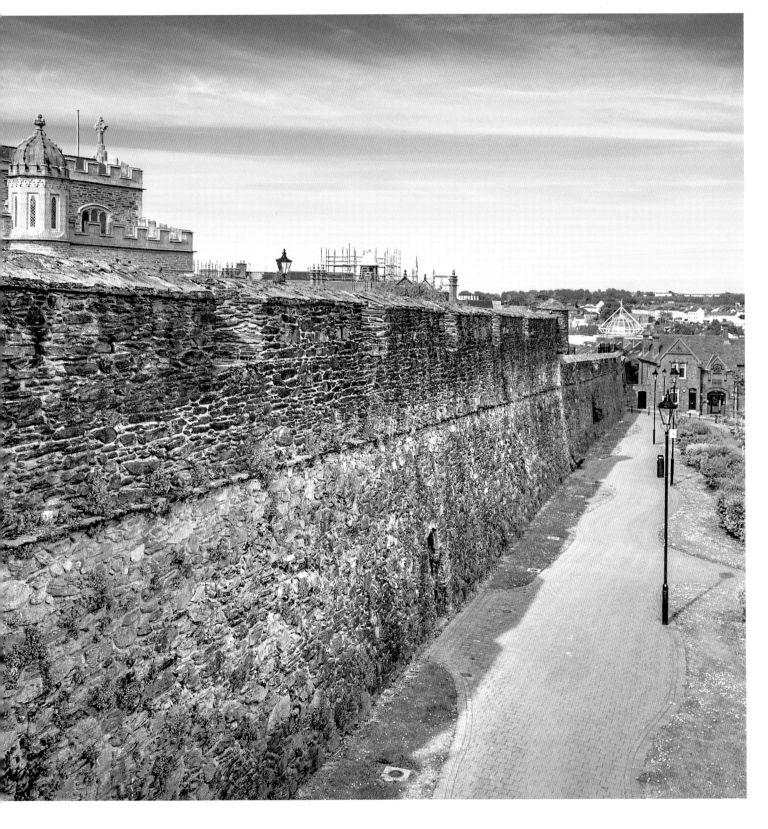

FREE DERRY CORNER
DERRY

Whilst a commemorative stone near the site says that John 'Caker' Casey painted the slogan 'You Are Now Entering Free Derry' on the gable wall of a house in the Bogside, the first iteration of the famous slogan was actually painted by Liam Hillen, on 5 January 1969. Hillen recalled asking the veteran civil rights campaigner and journalist, Eamonn McCann, who had suggested the slogan, 'Is there one or two rs in entering?' The phrase and the gable painting has become an iconic modern image, but it is one that has the confidence to allow itself to be altered: on our last visit the slogan read: 'You Are Now Entering Fairtrade Derry.'

FIND | WALK | EAT | SLEEP **PAGE 228**

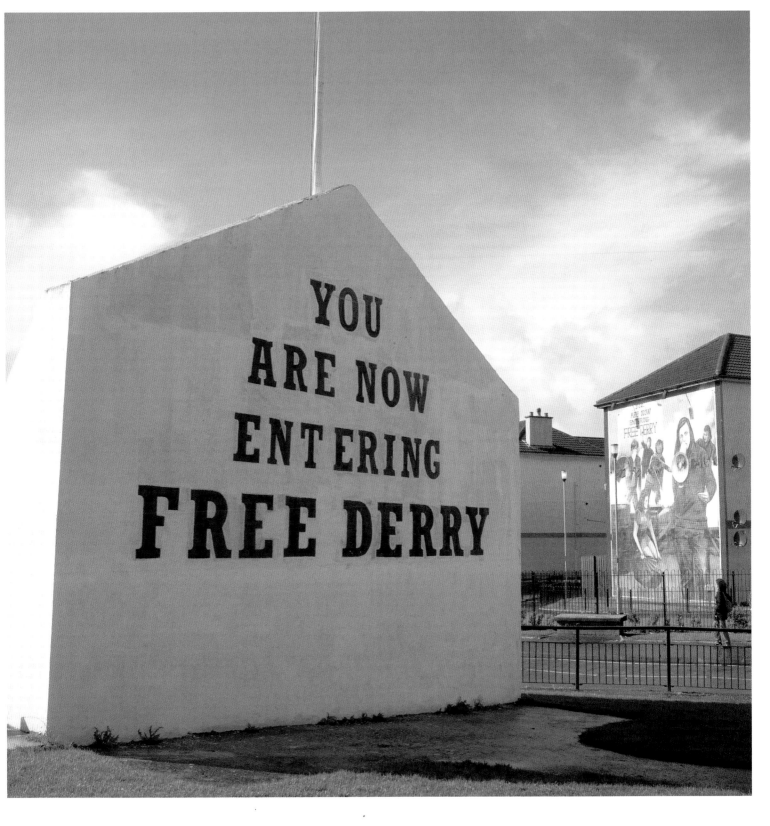

THE PEACE BRIDGE
RIVER FOYLE, DERRY/LONDONDERRY

Opened on 25 June 2011, the Peace Bridge which spans the River Foyle is a cycle and pedestrian bridge that symbolically, and practically, joins the two communities on either side of the River Foyle in Derry/Londonderry. On one side, the Unionist Waterside, on the other, the Nationalist Cityside, with the bridge as an S-shaped artery connecting them. It's an elegant bridge, 235m long, designed by Wilkinson Eyre architects who also designed the Sutong Yangtze River Bridge and Gateshead Millennium Bridge. Derry has been transformed by the building of the bridge, its creation seemingly unleashing a latent, dynamic creative spirit, and the city has been flourishing ever since.

FIND | WALK | EAT | SLEEP PAGE 228

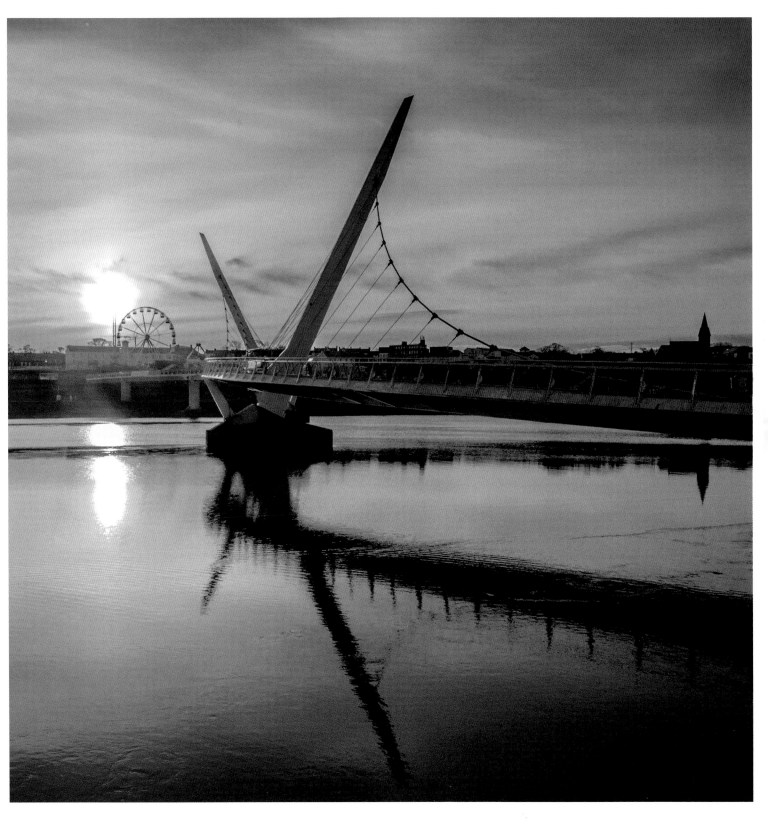

DUNLUCE CASTLE
BUSHMILLS, ANTRIM

The past feels ever-present at Dunluce Castle. It's a simple matter, as you walk through the remains of the 13th-century castle and its ruined gatehouse and loggia, perched precipitously on the extreme edge of a basalt rock face that falls down to the sea, to imagine the MacDonnells and their entourage working and cooking and entertaining and scheming within the walls, and to picture sailing ships off the coastline. The castle is a key element of the extraordinary historical and geological riches of the North East coast, and make sure to take in the Downhill Demesne and the magnificent Mussenden Temple, just a few miles west. There is a ghoulish old myth about Dunluce that part of the domestic quarters, and some kitchen staff members, fell into the sea as part of the castle crumbled. Good story, shame it's now believed not to be true. A true story, however, is that the castle had its own gallows. An image of the castle was used on the inner sleeve of the Led Zeppelin LP, *Houses Of The Holy*.

FIND | WALK | EAT | SLEEP PAGE 228

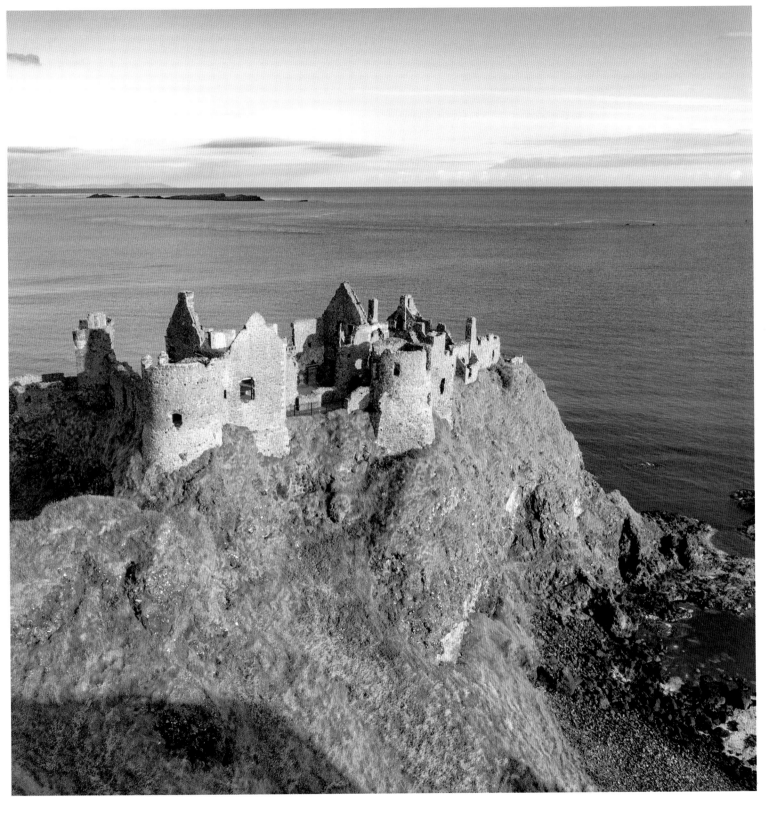

GIANT'S CAUSEWAY
BUSHMILLS, ANTRIM

The Giant's Causeway is an extraordinary geological phenomenon. Today a World Heritage Site, it is a rocky shoreline made from over 40,000 interlocking polygonal basalt columns, like a rock formation designed by M.C. Escher. Before the results of recent scientific experiments the ambiguity as to how the causeway was created pleasingly left open the opportunity to believe that there might be a mystical reason why the columns stand as they do. Enter the giant, Finn McCool, and all the folklore that comes with his story. Today, it is believed that basalt magma fractures at temperatures between 840-890°C, forming the geometric pavement. Visiting the shoreline starts at the National Trust visitors' centre, a stunning building designed by Róisín Heneghan, with exhibitions and explanations and, if you like, you can pick up an audio guide. Walk, or shuttle bus down the hill.

FIND | WALK | EAT | SLEEP PAGE 228

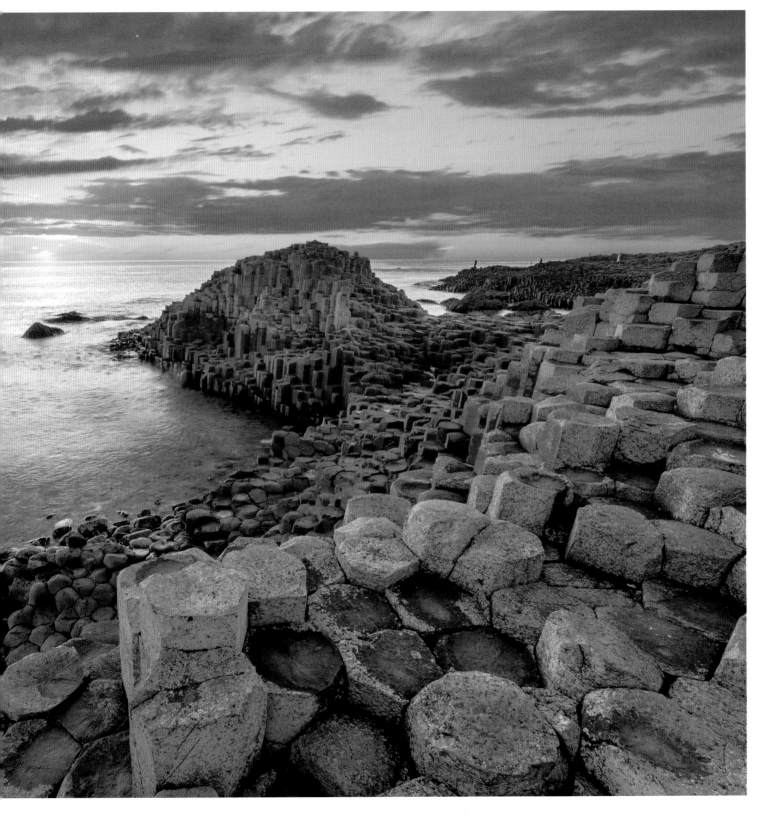

CARRICK-A-REDE ROPE BRIDGE
BALLYCASTLE, ANTRIM

Carrick-a-Rede is one of those sites where it pays to go early, or late, as only a few people are allowed on the bridge at any one time and, even in quiet periods, you'll probably have to queue, and be aware that they sometimes close the bridge if it's blowing a westerly. How different it all is now to 1755 when the brave salmon fishermen threw a rope between the mainland and the nearby rocky island, and used it as a bridge, and then launched their boats from the island into the sheer rocky bay below. In early spring or late autumn, when there aren't too many people, it is a magical place to see guillemots. The walk down to the bridge takes about 15-20 minutes.

FIND | WALK | EAT | SLEEP **PAGE 229**

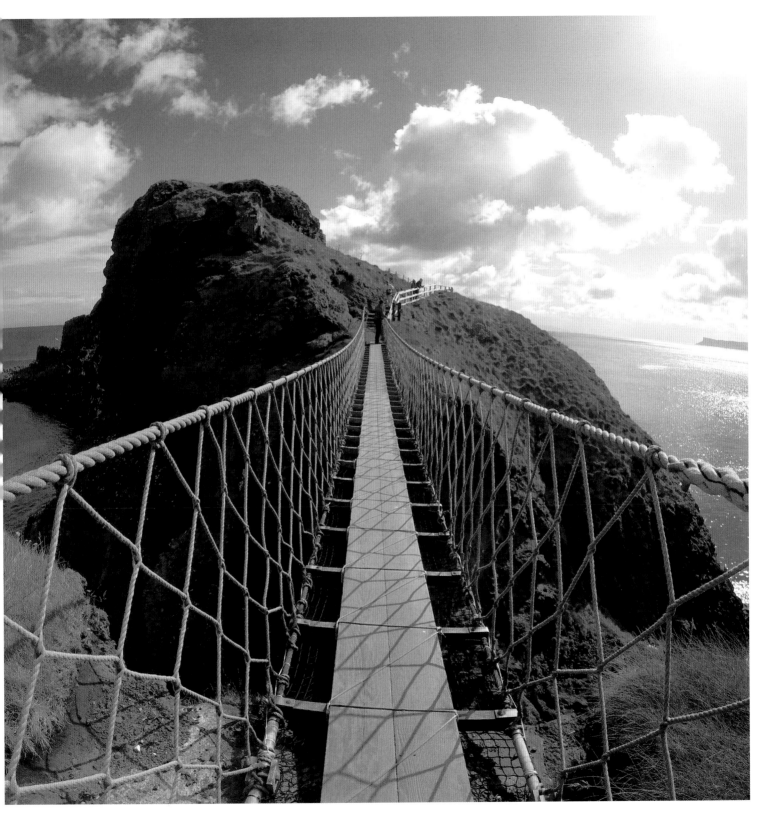

OLD BUSHMILLS DISTILLERY
BUSHMILLS, ANTRIM

'One of the world's most interesting distilleries' is how the drinks writer Michael Jackson described the elegant Bushmills Distillery. The association with distilling dates back to 1276, and the first licence to any distillery was granted to Bushmills in 1608, allowing them to claim to be the world's oldest distillery. The distillery tours are excellent: fun; enlightening; humorous; and not to be missed, and the range of whiskeys that can be bought and tasted on site is impressive: look out for the Distillery Exclusive, and you can even get a bottle of Distillery Reserve printed with your choice of name.

FIND | WALK | EAT | SLEEP PAGE 229

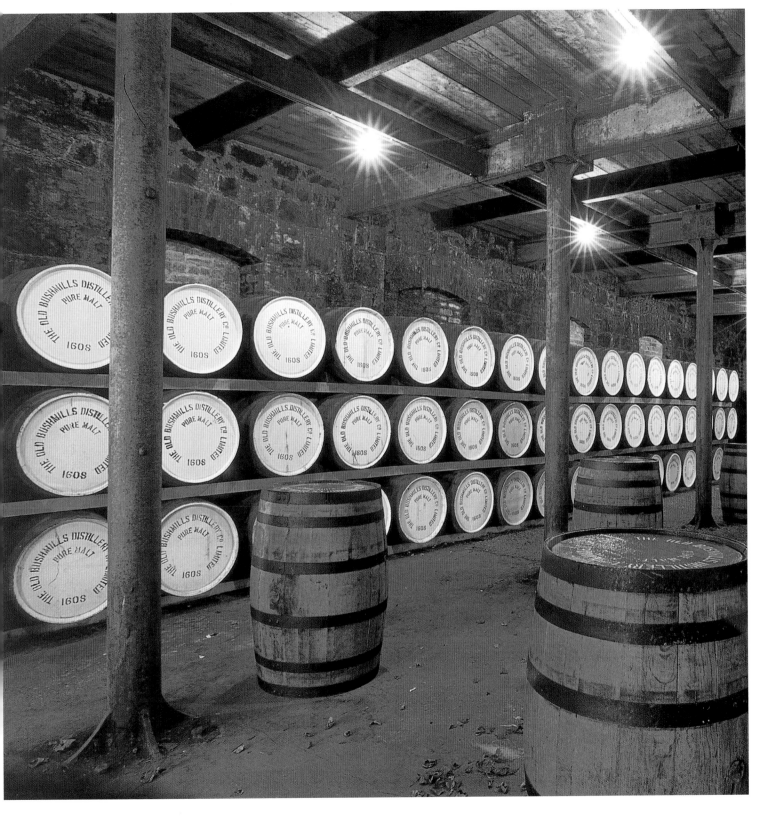

BUBBLE DOMES
FINN LOUGH, FERMANAGH

In the middle of the night, lying in bed, you feel that you need only stretch your arm up, and you could take charge of The Plough, and cut a swathe through the Milky Way. That's the feeling you get on a clear, starry night, as you exult in the comfort and the concentrated viewscape of a bubble dome at the Finn Lough estate, in west County Fermanagh. With their clear, plastic ceilings, housing a four-poster bed, a table and a couple of chairs, the bubble domes are glamping gone lunar, places to stay that are – literally – stellar. There is nothing else quite like the experience of staying at Finn Lough, and the delight of the domes is amplified by excellent, multinational staff and rock-steady cooking.

FIND | WALK | EAT | SLEEP PAGE 229

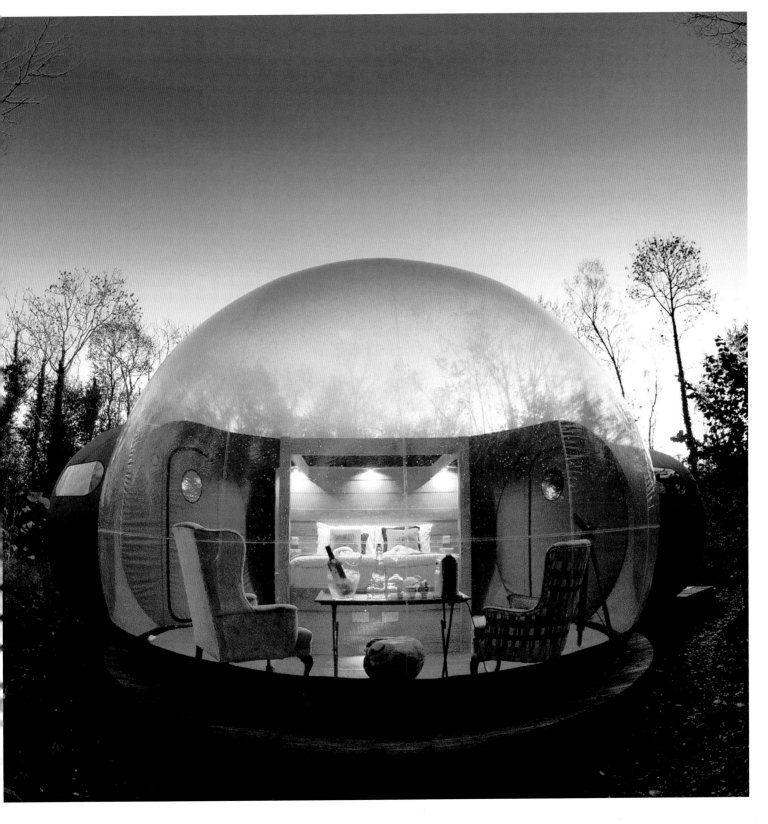

LEGNABROCKY BOARDWALK TRAIL
CUILCAGH MOUNTAIN, FERMANAGH

By turns achingly lonely, and impossibly dramatic, the Cuilcagh Boardwalk, part of the Legnabrocky Trail and the Marble Arch Caves Global Geopark, has become a popular phenomenon, but be warned: the trail is a serious hike, and you need to be fit, and correctly provisioned, before setting out to cross the blanket bog. The 450 steps of the boardwalk has become known as the 'Stairway To Heaven' and extends for 1 mile, following a lengthy limestone track, whilst the complete circuit there and back, extends to 7.5 miles and needs a good few hours of solid walking. Stunning views from the summit, when you will be over 600 metres high.

FIND | WALK | EAT | SLEEP PAGE 229

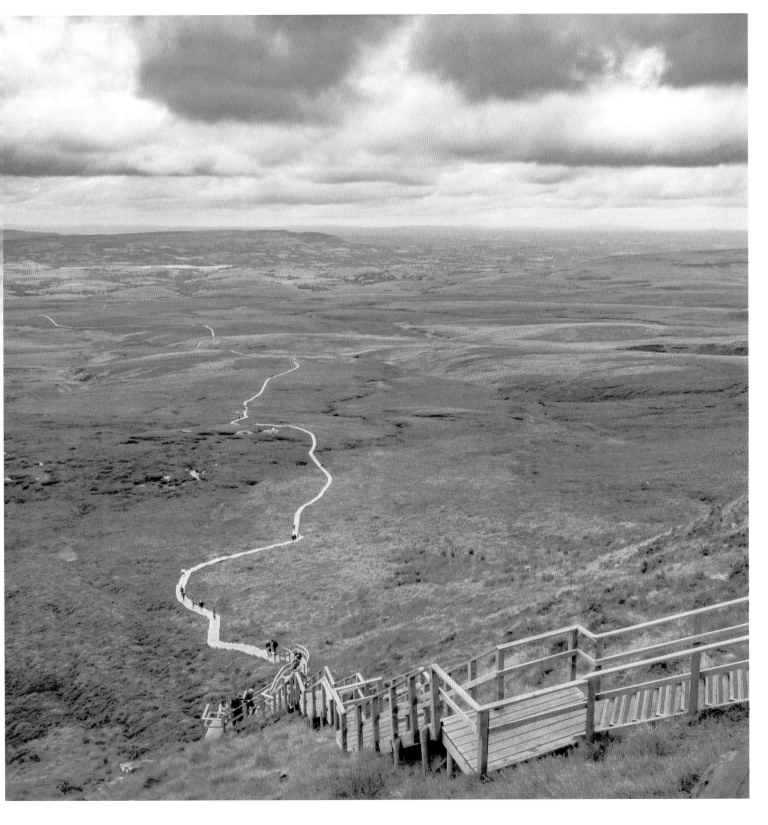

ST GEORGE'S MARKET
BELFAST

There are three distinct markets held under the canopy of the beautiful St George's Market arcades. On Fridays, there is a living echo of the old fish market which stretches back decades in the city's history, enhanced by other stallholders selling all manner of bric-a-brac. Saturday brings out the modern Irish food artisans. This is the day for serious food shopping and for good eating from the myriad of cooked food stalls. On Sundays, there is more cooked food, and lots of music as the Market chills out and, given that little – if anything – happens in Belfast on a Sunday morning, the St George's Market has become the go-to destination.

FIND | WALK | EAT | SLEEP PAGE 229

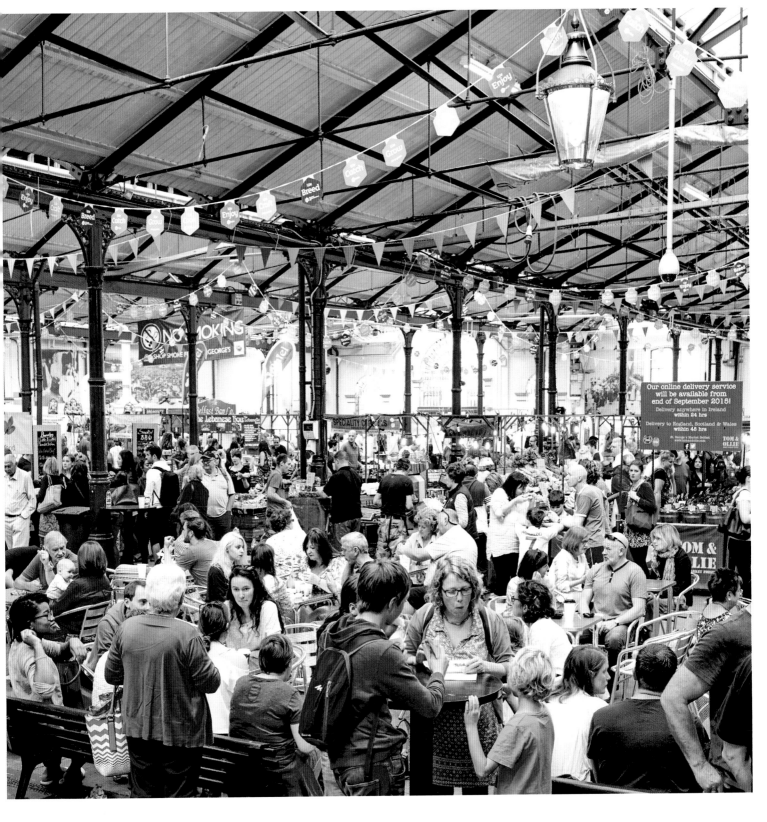

BELFAST WALL MURALS
BLACK TAXI TOUR, BELFAST

The power of the fabled Belfast wall murals comes from the fact that they are ever-changing, with new paintings reflecting current global political events, whether expressing solidarity for Catalonia, or arguing for an Irish language act. The murals are vivid, a unique form of street art, protest, and act of historical remembering. If you can snare a good black taxi driver who knows the history of the Falls Road and the Shankill Road, then the area becomes alive, despite the melancholy of the stories. Archbishop Oscar Romero is quoted on the mural of his image: 'There are many things that can only be seen through eyes that have cried.' Too many tears.

FIND | WALK | EAT | SLEEP **PAGE 229**

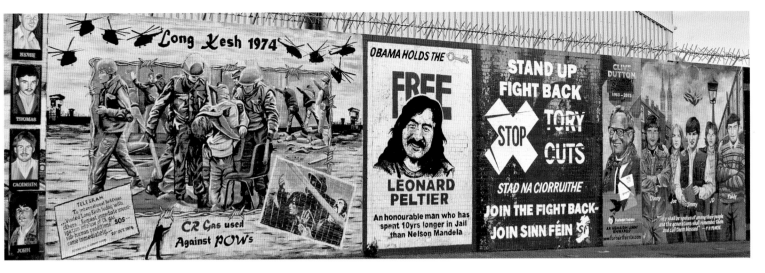

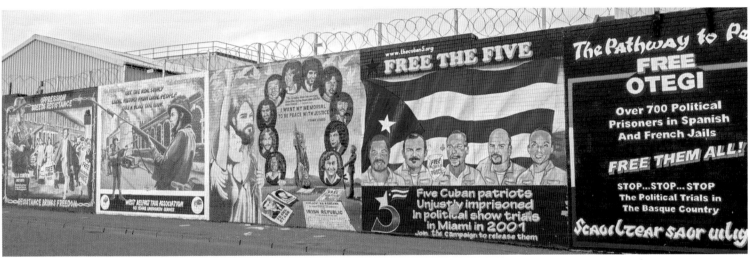

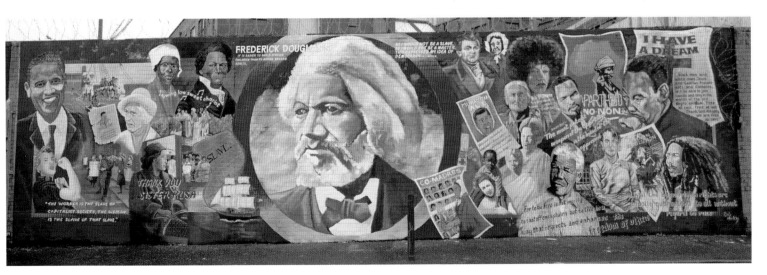

THE CROWN LIQUOR SALOON
BELFAST

The Crown features in every tourist's Belfast bucket list, but don't let that deter you from enjoying this pub's crazed Victorian Gothic interior. Owned by the National Trust, it was established in 1826 and the major embellishments took place – at the hands of Italian craftsmen – in 1885. A facelift in 1981 buffed up the phantasmagoric level of detail etched into every corner: frankly, you need a drink or two to sober up from the orgy of design. Exquisite snugs are the place to be on an afternoon when sunlight through the stained glass casts a benediction on the perfect gloom of the interior.

FIND | WALK | EAT | SLEEP **PAGE 230**

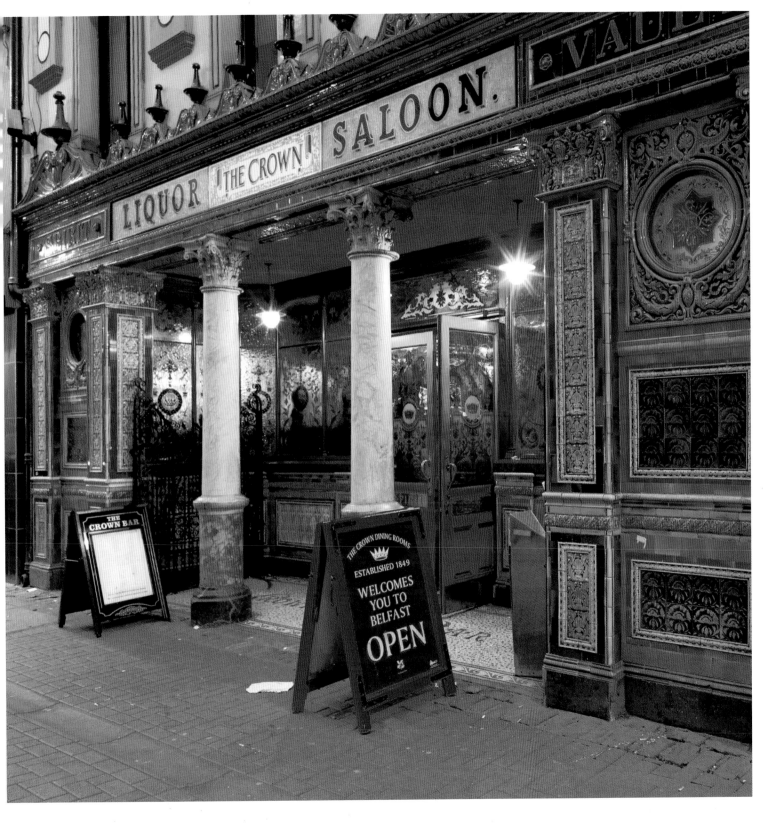

TITANIC BELFAST
BELFAST

The ever-enigmatic *RMS Titanic* was built in Belfast's Harland & Wolff shipyard in 1911 and, as everybody well knows, the White Star Line cruise liner sank on her maiden voyage from Southampton to New York on 15 April 1912. The magnificent Titanic Experience building, with its 72° lean, suggests the ship's hull, and glitters with a facade that is clad in aluminium sheetings that have been folded into asymmetrical shapes, and reflect in the water of Belfast harbour. The exhibition space is enormous; believe them when they say a proper visit takes hours. The building is sited just 100m from where the Titanic was launched; the Belfast skyline is still dominated by the two enormous shipyard cranes, Samson and Goliath.

FIND I WALK I EAT I SLEEP **PAGE 230**

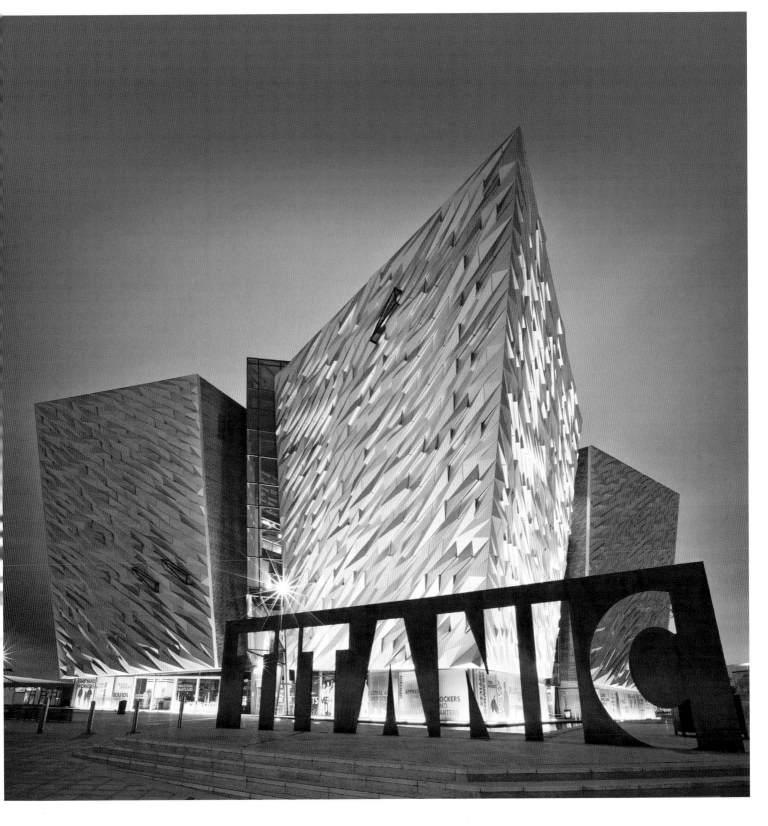

ROYAL COUNTY DOWN GOLF CLUB
NEWCASTLE, DOWN

Ireland has 50 of the 200 golf links in the world and, in Royal County Down, it has the finest links, and perhaps the finest golf course on the planet. The Old Tom Morris Championship Links presents a unique challenge with its lunar-rough terrain, multiple blind shots, obligingly capacious bunkers framed by marram grasses, and all that before the winds whip in off Dundrum Bay. The shorter Annesley Links is equally picturesque, and only slightly less daunting.

FIND | WALK | EAT | SLEEP **PAGE 230**

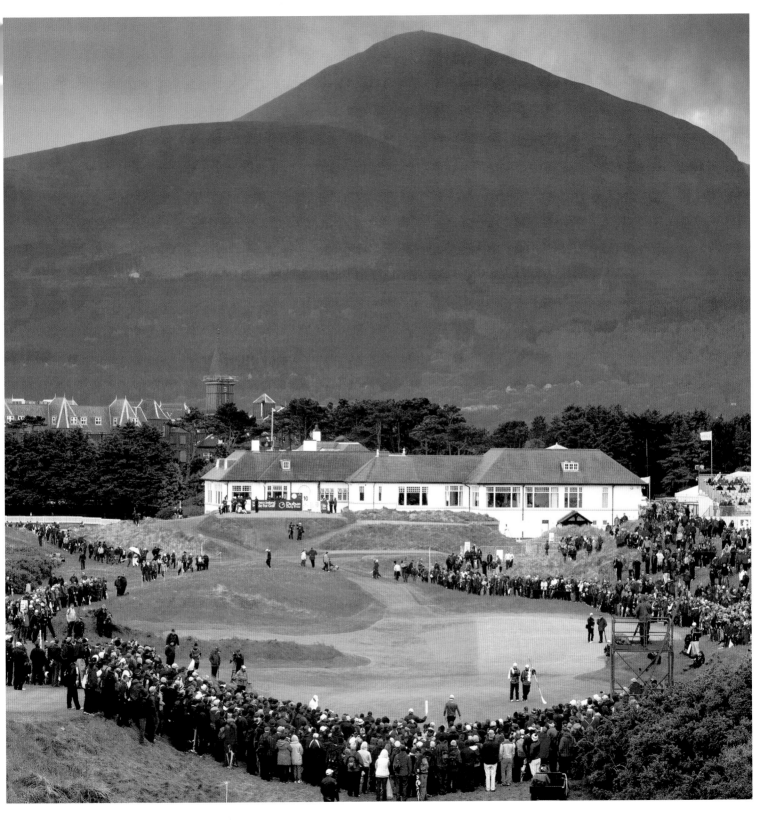

THE MOURNE WALL
THE MOUNTAINS OF MOURNE, DOWN

Constructed between 1904 and 1922 to keep grazing animals out of a water catchment area for Belfast, the Mourne Wall extends over the towering seven peaks of the Silent Valley. The granite boulders are so large that you reckon it must have needed giants to hoick them into place, but what is extraordinarily impressive is just how straight and smooth are the walls as they climb over 22 miles – 'like the tracks of some Stone Age rollercoaster', said *The Irish Times*. These are the obverse of the raggle-taggle dry stone walls of the West of Ireland, stern monuments whose restoration over the last several years is a mightily impressive feat.

The Mourne Wall Challenge is a hike for serious, fit walkers, with all the right gear and lots of sustenance. You can make it easier by staying in one of the three glamping cabins at the Carricklittle car park, where the trail begins, and you can also camp here and eat in the cafe, so it's possible to have an early start to make a successful circumnavigation. Up in the hills, 850 metres high on top of Slieve Donard, away from the frothy, blustery shoreline, is the other world of the Mournes: silent, grave and wind-washed.

FIND | WALK | EAT | SLEEP **PAGE 230**

SEAMUS HEANEY HOMEPLACE
BELLAGHY, LONDONDERRY

Seamus Heaney looms larger in the Irish imagination than any other poet or writer, simply because he mined the ground we all walk upon, and from it he drew up genius, which he vested in swaddling, unlikely words: brag, flax-dam, spraughle, farl, muzzle, thrawn...

The HomePlace, a rigorously disciplined building on the fringe of wee Bellaghy village, tells Heaney's story, and does so wondrously well. The HomePlace digs down into the poet's life and inspiration, and to hear him read his poetry as you are surrounded by images and memorabilia of his life is heart-stopping: don't be ashamed to cry.

There are excellent interactive stations for the youngsters to read and draw, and the cafe is very fine – locals come here to eat. Best of all, HomePlace pays proper tribute to a great and decent man, and a luminous poet: it catches him.

FIND | WALK | EAT | SLEEP PAGE 230

DARK HEDGES
BALLYMONEY, ANTRIM

The Dark Hedges fascinated people even before this short stretch of road became the King's Road in HBO's television series, *Game of Thrones*. The hedges are a simple row of beech trees that were planted in the 18th century to form a driveway as they approached Gracehill House. The trees grew into one another, forming a tangle of boughs that catch the light from all sides and today the roadway has become a globalised image that everyone recognises. If you want to get that classic photo with the empty road and the enfolding trees, then it's only at dawn or dusk when this is possible. At other times, the place is jammers.

FIND | WALK | EAT | SLEEP **PAGE 230**

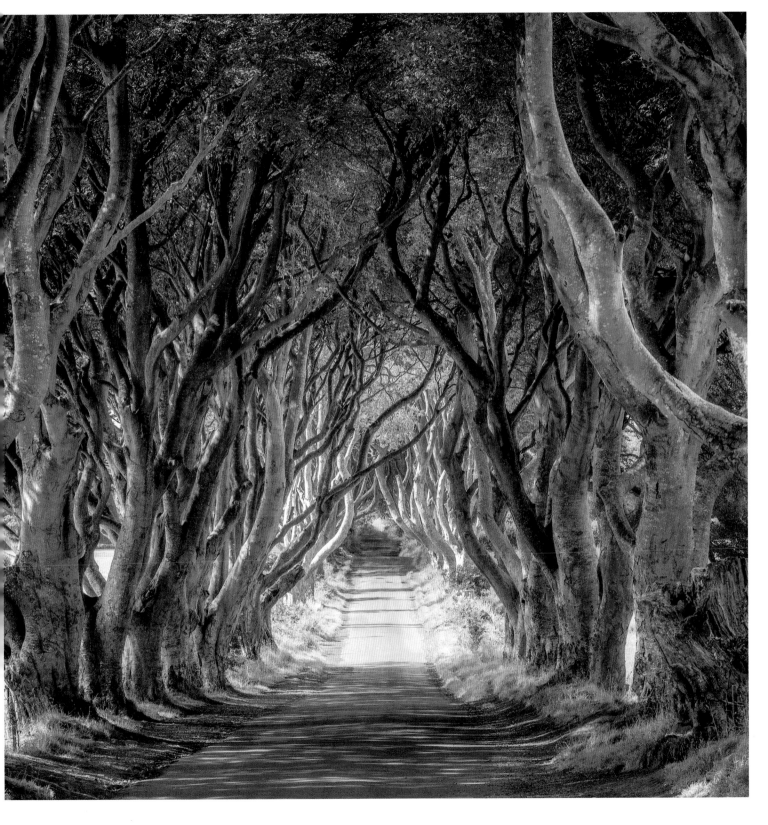

FIND | WALK | EAT | SLEEP

A DIRECTORY OF THE 100 PLACES AND HOW TO MAKE THE BEST OF VISITING THEM

For consistency all directions given for walks within this section are from the named 'place' itself and not from the nearest town.

All recommendations are personal, tried and tested selections. They are not chosen because they are adjacent or convenient but because they are good.

DUBLIN AND THE EAST

FIND | WALK | EAT | SLEEP

WHELAN'S PAGE 12

FIND www.whelanslive.com 01 478 0766 is in the Portobello district of Dublin, near to St Stephen's Green and very central.

WALK For breathtaking views of Dublin take the Hell Fire Club walk to the top of Montpelier Hill, where a ruined hunting lodge, known locally as The Brass Castle, was associated with tales of bad boy aristocratic debauchery, and gives the mountain its present-day name. Closes at dusk and best seen as the sun is setting. S of Dundrum on the outer side of the M50.

EAT www.lastapasdelola.com 01 424 4100, on the opposite side of Wexford St for fun times and a great buzz. • www.thebernardshaw.com 01 906 0218. Atmospheric vibey pub and home of Eatyard, a collection of food vendors operating in an open-air market beside the pub.

SLEEP The www.camdencourthotel.com 01 475 9666 is just up the road.

THE WINDING STAIR PAGE 14

FIND www.winding-stair.com 01 872 7320, overlooking the Ha'penny Bridge on the north side of the river.

WALK An easy to reach walk, not far from the city centre is the Great South Wall walk. This is the sea wall that leads to the Poolbeg Lighthouse. When constructed, the Wall was the world's longest sea wall, and from the car park, near the ESB chimneys, it is a 4km walk to the Lighthouse. Industrial landscape with the new Poolbeg Incinerator impacting on the skyline.

EAT The same owner operates the adjacent and brilliant www.thewoollenmills.com 01 828 0835, www. theyarnpizza.com 01 828 0839 and the superb www. thelegaleagle.ie 01 555 2971 gastropub further down the river.

SLEEP www.templebarinn.com 01 484 5010. Groovy boutique retreat with your high-speed, super smart tech needs all covered.

BLOOMSDAY PAGE 16

FIND Events centre around a number of the locations mentioned in *Ulysses*, notably the Martello Tower in Sandycove, Sweny's Pharmacy building on Lincoln Place and Davy Byrne's Pub on Duke St – consult www.jamesjoyce.ie.

WALK In the days before, during and after Bloomsday, walking tours are available at different locations and durations. • Tour of Sandymount, approximately 3 hours, beginning on the train from central Dublin. • Also a 'Footsteps of Leopold Bloom' tour beginning on Middle Abbey St. • The Joycean Pub Crawl sells out fast, so book early. More details from www. bloomsdayfestival.ie.

EAT City centre restaurants www.3fe.com on Grand Canal St Lwr • Thai www.sabadublin.com 01 679 2000 • The convivial Italian, www.osterialucio.com 01 662 4199 • Mega BBQ pub grub at Fowl Play in www.the-square-ball.com 01 662 4473 • For a literary flavour try www. bestsellerdublin.com wine café 01 671 5125.

SLEEP Ultra-chic Westbury Hotel www.doylecollection.com 01 679 1122 (don't miss their Sidecar cocktail bar) • The city oasis www.brookshotel.ie 01 670 4000 – both hotels are close to Sweny's Pharmacy • There are plans to reopen the Ormond Hotel in 2020 • www.pembroketownhouse. ie 01 660 0277 and www.ariel-house.net 01 668 5512 – both superior guesthouses with great housekeeping and superb breakfasts proximate to Sandymount.

ASSASSINATION CUSTARD PAGE 18

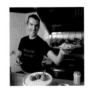

FIND On the corner, at the cross roads between Kevin St and Bride St (opposite the Garda Station). There isn't really a sign, just writing on the window.

WALK A circuit of Herbert Park is almost exactly a mile, and it's used by joggers and walkers to measure fitness progress. The park has been in existence for just over 100 years, and has seen very few changes during that time.

EAT @assassinationcu itself opens for lunch • Great food zone in nearby S Circular Rd with www.bastible.com 01 473 7409, www.clanbrassilhouse.com 01 453 9786 and pizzas at Gaillot et Gray 01 454 7781.

SLEEP Longtime favourite of student and budget travellers is well-run hostel www.kinlaydublin.ie 01 679 6644.

THE ALL-IRELAND HURLING FINAL PAGE 20

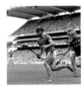

FIND www.crokepark.ie Jones Rd, Drumcondra, Dublin 3 • The stadium is 15 mins' walk NE of the city centre. Take public transport on match days as parking is limited – the nearest Luas station is Connolly Red Line, also 15 mins' walk.

WALK Unusual walking tour takes place atop the 17-storeys high rooftop of the stadium itself www.crokepark.ie • Clontarf, with its sculpture-rich promenade is just 4km away, and nearby St Anne's Park and North Bull Island with 5km of marram grass and shoreline.

EAT Super hip café www.twoboysbrew.ie • The soulful, rockin' www.bangbang.ie 086 857 6054 – both in Phibsborough • Fresh tasty cooking in Fairview from www. kennedysfoodstore.com 01 833 1400.

SLEEP Adjacent Croke Park Hotel 01 871 4444 www. doylecollection.com is superbly run – the obvious choice • The more traditional www.dublinskylonhotel.com 01 884 3900 also nearby.

HORSESHOE BAR, SHELBOURNE HOTEL PAGE 22

FIND www.theshelbourne.com 27 St Stephen's Green, Dublin 2 • Overlooking St Stephen's Green smack bang in the city centre, near the premier shopping area of Grafton Street.

WALK The flower bedecked, Victorian public park opposite the hotel, St Stephen's Green is only 22 acres, so walks here are short. Possibly a better place to sit on a bench and observe Dublin life • www.dublinwhiskeyexperience.ie historical and cultural walking tours of Dublin, that include a taste and understanding of Irish whiskey.

EAT The restaurants in this zone tend to be grand, star-studded affairs. For some of the finest cooking in Dublin book www.thegreenhouserestaurant.ie 01 676 7015 • Other smart restaurants in the zone are www.clifftownhouse. ie 01 638 3939, www.amuse.ie 01 639 4889 and www.onepico.com 01 676 0300 • The magical www. hugos.ie 01 676 5955 is almost next door.

SLEEP The Shelbourne Hotel, www.shelbournedining.ie 01 663 4500.

THE EVE OF ST AGNES WINDOW PAGE 24

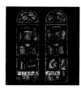

FIND www.hughlane.ie Parnell Sq N, Dublin 1 • The gallery is on the N side of Parnell Sq, which leads off O'Connell St in Dublin 1.

WALK Walking around the Hugh Lane Gallery is one of the best things to do in Dublin. Visit the Francis Bacon Studio, and see works by Renoir, Monet, Pissarro and Degas in their Impressionist collection.

EAT Also on Parnell Sq is www.mrfox.ie 01 874 7778 • Asian fusion from the charismatic www.bowls.ie • The much-loved classic www.101talbot.ie 01 874 5011 near the railway station.

SLEEP www.gresham-hotels.dublin.com 01 874 6881 on O'Connell St is the closest major hotel. • The stylish www. morrisonhotel.ie 01 887 2400 is also N of the river.

THE CHEF'S TABLE, CHAPTER ONE PAGE 26

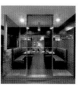

FIND www.chapteronerestaurant. com 18 Parnell Square N, Dublin 1 • Northside inner city location, behind the Rotunda Hospital and opposite the Garden of Remembrance. Chapter One is in a basement, under the Dublin Writers Museum.

WALK The restaurant is just over 2km from the National Botanic Gardens, a modern Noah's ark for rare and endangered plants. The garden is a delight, especially the atmospheric glasshouses.

EAT www.chapteronerestaurant.com 01 873 2266.

SLEEP The upmarket Westin Dublin www.marriott.com 01 645 1000, right beside Trinity College.

O'DONOGHUE'S PAGE 28

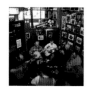

FIND www.odonoghues.ie, 15 Merrion Row, Dublin 4 • Just off St Stephen's Green, and near to The Shelbourne Hotel in the city centre.

WALK The Iveagh Gardens are known as Dublin's Secret Garden, landscaped with grottoes, cascade waterfall, a sunken garden, wilderness and woodland and a yew maze. Gates close at dusk.

EAT Almost next door, the critic's favourite, Italian-influenced www.etto.ie 01 678 8872 • Just round the corner, the impeccable basement hub www.elywinebar.ie 01 676 8986 • and the elegant Garden Room Restaurant www. merrionhotel.com 01 603 0600.

SLEEP The pod rooms in the eco-minded www. iveaghgardenhotel.ie 01 568 5500 are fun.

SUNKEN SITTING ROOM, NO 31 PAGE 30

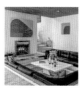

FIND www.number31.ie 31 Leeson Close, Dublin 2 • Leeson St runs between St Stephen's Green and the Canal, and No 31 is on a side lane that runs parallel to Fitzwilliam Pl.

WALK The Grand Canal was built to connect Dublin to the River Shannon, and its Walking Way is a linear towpath trail that runs from the city to just south of Athlone in Westmeath. The full trip takes approximately 5 days and covers a distance of nearly 120km, but the city-centre portion alone makes for a lovely amble, passing lock gates and grassy verges.

EAT Just on the other side of the canal is the tactile, contemporary www.forestavenuerestaurant.ie 01 667 8337 and its sister restaurant www.forestandmarcy.ie 01 660 2480 • The masterly www.dax.ie 01 676 1494.

SLEEP Both the modern and Georgian rooms at www. number31.ie 01 676 5011 recommended.

THE FORTY FOOT PAGE 32

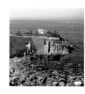

FIND The Forty Foot is behind the James Joyce Tower and Museum, just off the R119 in Sandycove.

WALK The E and W piers in Dun Laoghaire Harbour both afford bracing seaside walks overlooking the bay • If you want to walk a bit further, take in the People's Park, entrance near the E pier.

EAT In nearby Sandycove www.cavistons.com 01 280 9245 – emporium and seafood restaurant • www.rasam. ie 01 230 0600 – one of the city's best-loved Indian restaurants • www.cookbookcafe.ie 01 559 7999 – dishes curated from leading cookery books, best sounds on vinyl • Classic Ice Cream Parlour www.teddys.ie 086 452 9394 on the E Pier at Dun Laoghaire.

SLEEP The old style www.royalmarine.ie 01 230 0030 overlooks the bay • So does the new boutique hotel www. haddingtonhouse.ie 01 280 1810 – serious eats here.

HE LONG HALL PAGE 34

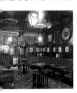

FIND 51 S Gt George's St, Dublin 2 • Backs on to the Chester Beatty Library in Dublin Castle on S Great George's St.

WALK The Dublin Literary Pub Crawl was one of the original walking tours of Dublin and it combines knowledge of Irish literature, history, architecture and pub culture and it has even produced a book of the same name by founder Peter Costello. The Long Hall is one of the pubs visited.

AT Emporium, coffee bar, wine bar and restaurant www.allonandbyrne.com 01 472 1012 • The big, bold New York-style www.sanlorenzos.ie 01 478 9383 • Many people's favourite pizza in Dublin www.pipizzas.ie.

SLEEP The TARDIS-like www.kellysdublin.ie 01 648 0010 packs a lot of comfort into a small space • Aloft, Dublin City www.marriott.com 01 963 1800 – high-tech amenities for the modern urban traveller.

TRINITY COLLEGE & THE BOOK OF KELLS PAGE 36

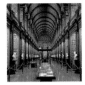

FIND www.tcd.ie College Green, Dublin 2 • The gates of the college face onto Dame St and the beginning of Grafton St, in the commercial heart of Dublin. Enter through the front gate for tours.

WALK Student ambassadors lead tours of the college on Mon-Wed at 11am • www.historicaltours.ie 087 688 9412 offer a well-regarded 2-hour tour looking at elements of the college in the context of Irish history. • Self-guided tour of the college and Book of Kells from www.tcd.ie.

EAT Some fine restaurants in Temple Bar, but choose carefully: Ireland's classic potato cake, reworked at www.boxtyhouse.ie 01 677 2762 • One of the very best restaurants in Dublin, Asian fusion/Irish chef www.chameleonrestaurant.com 01 671 0362 • Whacky space, amazing cooking, Italian/French winebar www.pigletwinebar.ie 01 707 9786 • Just beside the college, a cool room and great coffee waiting at www.coffeeangel.com • Ex-Ottolenghi chef bringing whole grains and sprightly salads to Dublin www.tillerandgrain.ie 087 680 8933.

SLEEP Boutique Temple Bar hotel, www.themorgan.com 01 643 7000 has recently had a facelift • Accommodation available in www.tcd.ie 01 896 1177 college itself, during the student holidays. Top value and so so central.

SAMUEL BECKETT BRIDGE PAGE 38

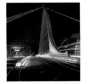

FIND The bridge is in the docklands area of Dublin, beyond the Financial Services Centre, and near to the imposing Convention Centre. The bridge joins Sir John Rogerson's Quay to North Wall Quay.

WALK The docklands N and S of the river offer 1,300 acres of land to explore. Look out for the *Jeanie Johnston* famine ship and the Rowan Gillespie famine memorial and other artworks on Custom House Quay. Dublin's new dynamism in architecture is on view in The Marker Hotel, the CHQ Building, The Grand Canal Theatre and the Convention Centre.

EAT Fine baking at www.ilvalentino.ie 01 633 1100 • The funky www.gertrude.ie 01 515 7563 is owned by 3fe Coffee • Atmospheric www.elywinebar.ie 01 672 0010 in CHQ has a great wine list and smashing cooking.

SLEEP The modish, modern www.thegibsonhotel.ie 01 681 5000 down by the docks • www.themarkerhoteldublin.com 01 687 5100 on Grand Canal Sq is an architectural jewel run by an ambitious team in a great location.

YEATS ROOM, NATIONAL GALLERY PAGE 40

FIND www.nationalgallery.ie Merrion Sq W, Dublin 2 • Situated in Dublin's Georgian quarter, near to Trinity College, overlooking Merrion Sq.

WALK The Dodder Walk ambles from Bushy Park to Dodder Park, alongside parkways and the fast-flowing riverbank. Linear trail, approx 3.5km. Start the trail at Clonskeagh and finish in Rathfarnham where you can get a bus back to the city.

EAT Contemporary Irish at www.hatchandsons.co 01 661 0075 • Classic Italian in a lovely room, www.dunneandcrescenzi.com 01 675 9892 • The noble, long established www.lecrivain.com 01 661 1919 • In amidst a lot of chain restaurants on Dawson St, seek out locally owned and managed www.featherblade.ie 01 679 8814 for steaks and cocktails.

SLEEP Luxury www.conradhotels3.hilton.com 01 602 8900, both classy and comforting • Deluxe www.themerrionhotel.com 01 603 0600 on Merrion Sq, and its Garden Room Restaurant for a spot of lunch before an amble around the exhibition.

EILEEN GRAY EXHIBITION PAGE 42

FIND www.museum.ie Museum of Decorative Arts & History, Collins Barracks in Dublin 7 • Just N of the river near Heuston Station (the Luas stops just outside).

WALK The nearby Phoenix Park, spanning 1,750 acres, is one of the largest enclosed parks in any European capital. Its 10km loop walk passes by historic monuments and houses, a fort, a huge papal cross, numerous wild deer and Áras an Uachtaráin, residence of the President of Ireland.

EAT Proximate are www.urbanity.ie 01 874 7288 – flexitarian/vegan-friendly menu, great coffee • www.fish-shop.ie 01 557 1473 – superlative seafood • www.grano.ie 01 538 2003 – echt Italian • L.Mulligan Grocer 01 670 9889 – the original Dublin gastropub.

SLEEP The street smart www.hendrickdublin.ie 01 482 6500 • Also in this square, the hip www.staygenerator.com 01 901 0222 hostel • A little way down the quays is the bustling www.ashlinghotel.ie 01 677 2324.

AIRFIELD ESTATE PAGE 44

FIND www.airfield.ie Dundrum is S of Dublin city centre. Leave the M50 at J13 and follow R825 to Overend Way. The entrance is on the right.

WALK There are seasonal walking trails taking place in the native woodland around the estate. Also, guests are encouraged to roam around the garden.

EAT They are firing out top-class cooking in the Overends Kitchen daytime restaurant on the Estate 01 969 6666 • More eats in nearby Dundrum Town Centre: www.anandarestaurant.ie 01 296 0099 – one of the very best Indian restaurants • www.dunneandcrescenzi.com 01 299 1700 for Italian • and www.harveynichols.com.

SLEEP www.thebeacon.com 01 291 5000 in Sandyford Business District is less than 2km away.

POWERSCOURT WATERFALL & GARDENS PAGE 46

FIND www.powerscourt.com Enniskerry, Co Wicklow • Powerscourt Estate is 20 mins S of Dublin and the Waterfall is 6km from the main estate building.

WALK There are walks and trails around the Estate, and the garden is open to the public daily until dusk (note entry fee applies).

EAT Kiosk at the Waterfall itself (and they encourage picnics and barbecues) • www.avoca.com 01 204 6066 on the Estate, as well as the original Avoca in nearby Kilmacanogue • Pink Salt 01 561 1777 for signature Indian dishes in Bray • Further S, Greystones is a good food destination: www.thethreeqs.com 01 287 5477, Chakra 01 201 7222, www.thehungrymonk.ie 01 201 0710 and the ebullient www.thehappypear.ie • www.thefirehouse.ie 01 287 6822 is worth the trip to Delgany.

SLEEP Five-star luxury in www.powerscourthotel.com 01 274 8888.

GLENDALOUGH PAGE 48

FIND www.glendalough.ie • Glendalough is well signposted in the area, and there is a public car park at the Visitor Centre, as well as parking in Laragh village, depending on the level of congestion. Charges may apply.

WALK There is a series of trails and walkways around the site • St Kevin's Pilgrim Path follows the footsteps of the Saint on his journey from the Wicklow Gap into the Glendalough Valley. 30km for the full linear walk. The Pilgrim way is part of a new 'Irish Camino' which offers walkers a 120km series of walks. www.pilgrimpath.ie

EAT www.glendaloughgreen.com, Laragh – a meeting point, a fount of local knowledge, and super café and shop • www.mountushergardens.ie 0404 40116 café is run by Avoca, and has a bakery and food market, as well as shopping and a truly great garden.

SLEEP The Glendalough International Hostel 0404 45342 is on the Wicklow Way, luxury hostel, all en-suite • www.brooklodge.com 0402 36444 in Macreddin Village is the only organically certified hotel in Ireland and has a destination restaurant, The Strawberry Tree.

KILKENNY DESIGN CENTRE PAGE 50

FIND www.kilkennydesign.com The Castle Yard, Kilkenny • The Centre is situated in what were the stables of Kilkenny Castle, just opposite, in the very centre of the city. You can't miss it!

WALK The Nore Valley Walk is a 1.2km linear route that meanders from Kilkenny to Bennettsbridge. Pass the mills where the famous Black Kilkenny Marble was honed, the stone that gives Kilkenny its name 'The Marble City'. Another short walk, just outside Kilkenny is the Jenkinstown Walk, a loop walk in which there is a garden to commemorate the Irish poet Thomas Moore.

EAT www.anochtrestaurant.ie 056 772 2118 in the Design Centre itself is a relaxed lunchtime space that morphs into an elegant dining setting during the evening • The two destination restaurants in Kilkenny are www.campagne.ie 056 777 2858 and www.rinuccini.com 056 776 1575 • For coffee and cakes don't miss www.cakeface.ie 056 773 9971.

SLEEP The central www.kilkennyhibernianhotel.com 056 777 1888 and www.kilkennyormonde.com 056 775 0200 both do a fine job • The classy www.zuni.ie 056 772 3999 is just around the corner.

COPPER COAST GEOPARK PAGE 52

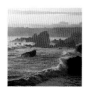

FIND The Copper Coast is about 25km SW of Waterford city, stretching 17km along the coast between Fenor and Stradbally.

WALK You can download a number of walking trail cards from www.coppercoastgeopark.com. The Annestown Heritage Audio Trail starts at Annestown beach and loops past Dunhill Castle and back to the beach, you can even download a free Audio E-Trail from the website.

EAT www.thecopperhen.ie 051 330179 has relocated from the middle of the Geopark in Fenor, to a new home in Tramore, and it is still a great destination for people exploring the area • If you begin the journey in Waterford city, then the relaxed options for a casual meal or even a picnic are Grow HQ 051 584422 www.giy.ie, www.granarycafe.ie 051 854428, www.ardkeen.com 051 874620.

SLEEP An inviting destination when walking or driving around the county and its coastline is www.glashafarmhouse.com 052 613 6108.

WATERFORD GREENWAY PAGE 54

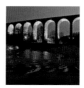

FIND www.visitwaterfordgreenway.com • There are several access points to get on the Greenway, beginning at the WIT West Campus, Waterford, and ending in Dungarvan. Access points are on the website, where you can download maps.

WALK The Greenway is both a cycling and walking trail. The full route is 45km, but it can be broken up to take in different points of interest. Recommended sections for walking are the section from Nursery Lane towards Kilmeaden station, detouring into Mount Congreve gardens. Or choose from the Dungarvan end, towards Durrow and go through the awesome tunnel.

EAT www.coachhousecoffee.ie is a series of rooms in a converted Famine Workhouse, at the midway point of the Greenway. Good coffee, sausage rolls and cakes for the throngs of cyclists and walkers • Recommended in Dungarvan: local favourite @merrysgastropub 058 24488, www.themoorings.ie 058 41461, gourmet house 058 40044.

SLEEP/EAT www.tannery.ie 058 45420 Townhouse and Cookery School, and the food destination address in Dungarvan.

WATERFORD WALLS PAGE 56

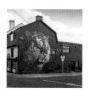

FIND www.waterfordwalls.ie Examples of street art, graffiti and mural art are on show throughout the city centre.

WALK You can take a guided Art Trail walking tour, lasting about 2 hours, that takes you through the city, looking at all the murals, installations, graffiti and street art. Follow the events guide at www.waterfordwalls.ie.

EAT www.bodegawaterford.com 051 844177 is always buzzing, great cooking and marvellous atmosphere • Same with www.burzza.com 051 844969 for burgers and pizza made with care and flair • Meticulous and heartwarming www.momorestaurant.ie 051 581509 • www.labohemerestaurant.ie 051 875645 for French culinary classics in a fine arched basement room • www.everetts.ie 051 325174 is the leading culinary destination restaurant in the city.

SLEEP www.granvillehotel.ie 051 305555 in Waterford centre • Or – on a little island in the city, at the mouth of the river – take the two-minute ferry to cross over to www.waterfordcastleresort.com 051 878203. The restaurant here has high ambitions, and the rooms offer both self-catering and B&B.

GUILLAMENE SWIMMING COVE PAGE 58

FIND The Cove is about 2km outside Tramore. Head for the pier in Tramore, then take the coast road W, until you come to the Newtown car park. Steps to the Cove, or take the flat path through Newtown Woods.

WALK Dunmore East is a centre for walkers, with an open and welcoming policy from local landowners. For the woodland walk, park at the Azzurro restaurant near the harbour, and follow the forest trail which opens out to a view of the harbour. Gravel footpath throughout.

EAT In Tramore, join the queue for the www.seagullbakery. ie 087 921 0534 • Good restaurants in Dunmore East: www.lemontreecatering.ie 051 383164, www.azzurro.ie 051 383141 and www.thespinnaker.ie 051 383133 • For a great crab sandwich try The Bay Café 051 383900 @dunmoreeast.

SLEEP SE of Waterford, 30 min drive from the Cove, find www.faithlegg.com, an 18thC mansion house, where the cooking is considered and imaginative.

KELLY'S RESORT HOTEL PAGE 60

FIND www.kellys.ie Rosslare, Co Wexford • 10km from Rosslare Harbour Ferryport, overlooking Rosslare Beach.

WALK The whole point of being in Kelly's is that, for the duration of your stay, you never return to your car. For those who want to walk, Rosslare Strand Blue Flag Beach is on your doorstep. The beach runs the length of a small peninsula jutting out at the southern edge of Wexford Harbour (at the Northern edge is Curracloe Beach, where *Saving Private Ryan* was filmed). The sandy beach is divided by wooden breakwaters to prevent erosion and you can walk the whole length of the peninsula.

EAT There are two restaurants in the hotel, and the packages are full board • But before and after your stay, there's www.crustpizza.ie 053 912 3685, www.thewilds. ie 053 923 7799 café, deli and lifestyle store, Kelly's Café (linked to the hotel) 053 916 8800 and www.lacote.ie 053 912 2122 for good seafood cooking • In Rosslare itself www.wildandnative.ie 053 913 2668 serves spot-on cooking.

SLEEP The hotel www.kellys.ie 053 913 2114 offers two, five, six and seven-day breaks.

HOOK LIGHTHOUSE PAGE 62

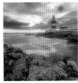

FIND www.hookheritage.ie Hook Head, Co Wexford • The Hook peninsula is S of New Ross on the Eastern side of the River Barrow as it joins the sea, an hour's drive from Waterford City to the W, and Rosslare Port to the E.

WALK There are three walking trails on the Hook Head Peninsula, beginning at the trailhead at Tintern Abbey. The Tintern trails traverse woodlands and coasts taking in monuments, bays, mudflats, historical landmarks and the historic monastery, Tintern Abbey itself – www.hookpeninsula.com.

EAT At Hook Head itself the Lighthouse visitor centre, www. hookheritage.ie, offers a café and bakery, The Lightkeeper's House • www.vinecottagebar.ie 087 6525 421 serves sandwiches and wraps from a food truck outside their pub in Saltmills • Travelling E to the next headline at Kilmore Quay you find www.thesilverfox.ie 053 912 9888 and the legendary Saltee Chipper 053 912 9911.

SLEEP www.aldridgelodge.com 051 389116, a restaurant with rooms in Duncannon features some fine cooking from local champion Billy Whitty.

THE MIDLANDS

FIND | WALK | EAT | SLEEP

ROCK OF CASHEL PAGE 64

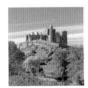

FIND Cashel is just off the M8 motorway, and the Rock dominates the whole region. Impossible to miss, just on the outskirts of town.

WALK The St Declan's Way Walk is a 96km pilgrimage route from Ardmore on the coast of Waterford to Cashel crossing the Knockmealdown Mountains and tracing the journey of Ireland's first Christian missionary, who walked to Cashel, and became Bishop of the Deise. This challenging walk takes 4-5 days to complete, depending on fitness.

EAT The classic www.chezhans.net 062 61177 in a deconsecrated church under the shadow of the Rock • Next door the equally classic Cafe Hans 062 63660.

SLEEP www.baileyshotelcashel.com is reliable and well maintained 062 61937 • Reopening as we go to press under trusted management, The Cashel Palace 062 62707.

SEAN'S BAR PAGE 66

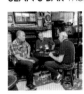

FIND Main St, Athlone, Co Westmeath www.seansbar.ie • Just next to the Castle and close to the river.

WALK Athlone is bisected by the mighty Shannon River, and the Shannon Banks Walk is a 5km loop that begins at the Castle and leads along the bank through parklands, river and canal bank. Well signposted and documented.

EAT Athlone boasts a number of top-class restaurants: www.thefattedcalf.ie 090 6433371, www.leftbankbistro. com 090 649 4446, www.thymerestaurant.ie 090 647 8850, www.kinkhaothai.ie 090 649 8805 and www. bastionkitchen.com 090 649 8369.

SLEEP Impressive lakeside destination, www.wineport.ie 090 643 9010.

HILL OF TARA PAGE 68

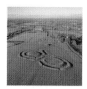

FIND The hill is 5km N of Dunshaughlin, just off the R147. There is a carpark and information point.

WALK The Tara Slí is a 4.5km loop walk, starting and ending at the carpark on the hill.

EAT In Navan: the hot local culinary destination is www.roomeight.ie 046 902 7663. Two great lunch spots are pub food from www.ryansbarnavan.ie 046 902 1154 and www.thecentral.ie 046 902 7999 or try the ever-consistent www.zucchinisnavan.ie 046 906 0459 • Take the kids to one of the three Meath restaurants from www.labucca.ie 01 689 6040.

SLEEP www.conynghamarms.ie 041 988 4444 is in Slane.

SHERIDANS CHEESEMONGERS PAGE 70

FIND www.sheridanscheesemongers.com Old Virginia Road, Pottlereagh, Co Meath • The shop is in a building that was the old railway station at Virginia Road, and is quite distinctive. Just off the N3 beyond Kells and heading towards Virginia.

WALK Trek, or take a guided walking tour of Slieve na Calliagh hill at megalithic burial site Loughcrew, a moderate climb that will repay with incredible views, as well as a chance to view inspirational stone carvings and rock paintings at the cairn. Guided walks from nearby Megalithic Centre www.loughcrewmegalithiccentre.com take you into the cairn at the summit – older than Newgrange!

EAT There is a farmers' market every Saturday at Sheridans and the Floods' Butcher's grill is recommended • Right next door is www.theforgerestaurant.ie, run by respected chef Raymond McArdle 046 924 5003 • There is also a coffee shop at www.loughcrew.com 049 854 1356.

SLEEP www.virginiaparklodge.com 049 854 6100 is an Irish country house owned and run by Richard Corrigan of Mayfair fame.

NEWGRANGE PASSAGE TOMB PAGE 72

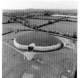

FIND www.newgrange.com Donore, Co Meath • Park and buy tickets at Brú na Bóinne Visitor Centre and then you are transported to the Newgrange and Knowth sites by shuttle bus.

WALK The Boyne Ramparts Walk is an 8km linear riverside walk along the banks of the Boyne. Begin at the ramparts car park near the city centre and follow the towpath. This is one of the most beautiful riverside walks and a special area of conservation.

EAT In Drogheda your destination is Eastern Seaboard Bar & Grill and their sister café the Brown Hound www.glasgow-diaz.com 041 980 2570 • www.ariosacoffee.com 01 801 0962.

SLEEP The welcoming www.scholarshotel.com 041 983 5410 in Drogheda.

TRIM CASTLE PAGE 74

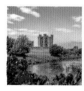

FIND Leave the M1 at J10 and follow the R161 to Trim. The castle is in the centre of town – on Castle St.

WALK The Trim Slí is a circular route of just under 4km starting at the castle that crosses over footpath and fields. The walk is signposted by the Irish Heart Foundation • The Trim Castle river walk, on the opposite bank to that of the castle is a linear riverside meander between the castle and Newtown.

EAT The recommendations in Navan for the Hill of Tara (see above) are all near to Trim Castle. Further W, there is a centre of good food and hospitality in Athlone. See Sean's Bar (page 217).

SLEEP www.headfortarms.ie 046 924 0063 is both a good place to stay and eat in their Vanilla Pod restaurant • www.loughbishophouse.com 044 9661313 further W, in Co Westmeath, is an inspiring country house and working farm.

MUIREDACH'S HIGH CROSS PAGE 76

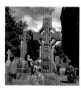

FIND The monastic grave site at Monasterboice is just off the M1 motorway N of Drogheda. Leave at J10. There is a warning of thieves working in the car park, so be careful.

WALK Drogheda is the location of the famous Battle of the Boyne, and Oldbridge House is the visitor centre from where you can learn about the historic battle, and walk the battle site, along the River Boyne. Part of the walk is on towpath, but much is on grass, so wear suitable shoes.

EAT www.theglydeinn.ie 042 937 2350 overlooks the sea and the mountains, and the food is excellent • www.thecrossguns.com 046 900 1918 is a gastropub showcasing local ingredients • There is a mobile fish and chip shop run by fishing legends www.fishermanscatch.ie at the pier at Clogherhead.

SLEEP www.ghanhouse.com 042 937 3682. Superbly run country house in pretty Carlingford.

CORK AND THE SOUTH WEST

FIND | WALK | EAT | SLEEP

BLACKROCK CASTLE OBSERVATORY PAGE 78

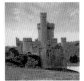

FIND www.bco.ie Blackrock, Cork • The castle is 12 mins from the city centre, on the S bank of the river Lee. The access road is narrow, but there's a good parking space just beyond the gate.

WALK There is a greenway along the disused railway track from Rochestown in Cork to Passage West which is for both walkers and cyclists. The full distance is 13km and the amenity has proved so popular they've had to put code of conduct notices up to slow down the cyclists.

EAT Great food in a great space, especially the terrace in the castle bailey www.castlecafe.ie 021 435 7911 • Famous cherry buns on the pier in Blackrock from www. thenaturalfoodsbakery.com 021 461 4555 • www. onthepigsback.ie 021 461 7832 bring their delicious French charcuterie and cheeses to Douglas.

SLEEP In Douglas, www.maryborough.com 021 436 5555 • In the heart of Cork, on the South Mall, The Imperial Hotel www.flynnhotels.com 021 427 4040.

THE BLARNEY STONE PAGE 80

FIND www.blarneycastle.ie Blarney, Co Cork • The Stone is in Blarney Castle. Book tickets in advance. The castle is 8km NW of Cork city, take the N20 Limerick road out of Cork, and follow signs for Blarney.

WALK There are several walking trails associated with the River Blackwater. The Blarney River Loop starts in the Waterloo car park in the town, a gentle loop of just under 6km.

EAT Welcoming, splendiferous country pub at www. blairsinn.ie 021 438 1470 • Fine dining without fuss at www.thesquaretable.ie 021 438 2825 • Deep in the countryside near Macroom, amazing pizzas and a fab shop at www.toonsbridgedairy.com 087 345 7790.

SLEEP The hotel at Blarney Woollen Mills is smart www. blarneywoollenmillshotel.com 021 438 5011 • Highly regarded destination in Macroom, www.castlehotel.ie 026 41074.

PARADISO RESTAURANT PAGE 82

FIND www.cafeparadiso.ie 021 427 7939 is on Lancaster Quay, overlooking the river, just down from Washington St in the city centre.

WALK The heart of Cork city is actually on an island between two channels of the River Lee. Take the self-guided circular City Centre Island Walk, which is well signposted with an orange walking sign. Download a map from www.discoverireland.ie, and learn about Cork's maritime history as you go.

EAT/SLEEP There are two luxurious rooms available above Paradiso, Paradiso Rooms • Comfortable and well run www.lancasterlodge.com 021 425 1125 is right opposite • The historic www.metropolehotel.ie 021 464 3700 is newly minted after a recent restoration.

THE OGHAM STONES PAGE 84

FIND www.ucc.ie College Road, Cork • The stone corridor is in the N wing of the UCC campus quadrangle. The main campus of UCC is 10 minutes' walk, SW of the city centre, S of the River Lee. Limited parking in the area, city-centre parking recommended.

WALK UCC Walking Tours are well worth doing. Tours run Mon-Fri at 3pm, and noon on Sat between the months Feb-Oct. Walk lasts 70 mins and the Ogham Stones corridor is one of the points of interest • The University walk is one of the trails on the Cork City Walks self-guided loops, which are well signposted with an orange walking sign. Download map from www.discoverireland.ie.

EAT The café in the Glucksman Gallery, 021 490 1848, on the UCC Campus, creative cooking, brunch and lunch, lovely space • Cork food hero Takashi Miyazaki runs both the acclaimed @miyazakicork takeaway, and the Michelin-starred kaiseki restaurant www.ichigoichie.ie 021 427 9997.

SLEEP The lovely River Lee Hotel www.doylecollection. com 021 425 2700 • Splendiferous breakfasts at the guesthouse www.garnish.ie 021 427 5111.

THE ENGLISH MARKET PAGE 86

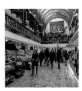

FIND www.englishmarket.ie Princes St, Cork • The Market is located by following various passageways and doors located on streets off the main thoroughfare in Cork, St Patrick's Street, and there are also entrances on Grand Parade and Oliver Plunkett St.

WALK www.fabfoodtrails.ie run a guided walk through Cork city, once the biggest exporter of butter in the world, and certainly the food capital. 2-3 hour stroll beginning in the English Market.

EAT At the heart of the English Market, a cultured space, www.farmgatecork.ie 021 427 8134 • Great attention to detail at the classy www.nash19.com 021 427 0880 • Unmissable www.crawfordartgallery.ie 021 427 4415 • The funky and stylish www.elbowlane.ie 021 239 0479 • The love shines in every bite at Iyer's 087 640 9079 for southern Indian vegetarian Ayurvedic cooking.

SLEEP Grand and peaceful www.hayfieldmanor.ie 021 484 5900 • Buzzing space with a great view over the city at www.themontenottehotel.com 021 453 0050.

BALLYMALOE HOUSE PAGE 88

FIND www.ballymaloe.ie Shanagarry, Co Cork • The house is near the village of Shanagarry, 30 mins' drive E of Cork City. Take the N8 and follow the signs from the roundabout just beyond Midleton.

WALK Ballycotton Cliff Walk, a coastal track that leads from Ballycotton to Ballyandreen beach. 10km linear path, overlooking the cliffs. Spectacular for bird watchers.

EAT www.ballymaloe.ie 021 465 2531, open for both lunch and dinner. The Sunday buffet dinner is special • In Ballycotton: scrummy seafood @pier26restaurant 021 464 6768 • great fish and chips from The Field Kitchen behind the pub www.blackbirdballycotton.com 021 464 7884 • Pizzas on Saturday afternoon www.saturdaypizzas.com served in the Ballymaloe Cookery School 087 711 1057.

SLEEP Stay in the House www.ballymaloe.ie 021 465 2531 • or the top-notch www.ballyvolanehouse.ie 025 36349.

KINDRED SPIRITS PAGE 90

FIND The monument is in Bailick Park just on the outskirts of Midleton, and you can also see it, briefly, whilst driving on the N25.

WALK The Carrigaline to Crosshaven Greenway is a linear 5km Greenway estuary path that runs along the inlet of Cork Harbour. Glorious for birds at low tide, and Crosshaven is a buzzy harbour • There are several walking trails based in and around the historic town of Cobh.

EAT Midleton has a fine collection of food destinations: www.ferritandlee.ie 021 463 5235 • www.farmgate.ie 021 463 2771 • www.sagerestaurant.ie 021 463 9682 • And www.cflennox.ie is an excellent chipper.

SLEEP Overlooking the Blue Flag beach at Garryvoe, the stylish and comfortable www.garryvoehotel.com 021 464 6718.

KINSALE PAGE 92

FIND 30km due S of Cork City, follow signs to the airport, and thereafter the road is signposted to Kinsale. There are several routes into the town, all of them scenic.

WALK In the Battle of Kinsale in 1601 the English forces defeated an alliance of Spanish and Irish troops and – recognising the importance of this port – proceeded to build two star-shaped forts, opposite one another, on either side of the narrow waterway that leads into the harbour. The Scilly to Charles Fort is a pedestrian path that runs just alongside the harbour, taking in Summercove and the Bulman Bar • The James Fort Walk takes you to the small promontory in Kinsale harbour where the ruins of the fort can only be accessed by foot. Bird song fills the air as you walk through wild-flower meadows overlooking the harbour.

EAT Pristine seafood www.fishyfishy.ie 021 470 0415 • Much-loved winebar @theblackpigwinebar 021 477 4101 • Smart culinary creativity www.bastionkinsale.com 021 470 9696 • Artful and charming www.maxs.ie 021 477 2443 • Great pub food www.thebulman.ie 021 477 2131 • Funky space, start with cocktails www.thesupperclub.ie 021 470 9233 • Artisan café www.oherlihyskinsale.com 087 950 2411 • Pretty tea rooms in Charles Fort.

SLEEP Lushly designed B&B www.blindgatehouse.com 021 477 7858 • Overlooking the harbour, the smart www.tridenthotel.com 021 477 9300 or www.longquayhousekinsale.com on the other side of the harbour.

THE BEACON PAGE 94

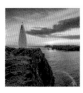

FIND Baltimore is SW of the town of Skibbereen. From Skibb, follow the signs and take the R595. There is a one-way system of traffic that needs to be followed once in the village.

WALK The Beacon Walk is a 3km walk, starting at Baltimore pier, and climbing up (40m above sea level, but it seems higher when you are looking down) to the beacon itself. The beacon is signed and there is a parking area nearby if you don't fancy the walk from the village.

EAT The magical www.mewsrestaurant.ie 028 20572 (seasonal restaurant) • Delightful garden courtyard café and gallery www.glebegardens.com 028 20579.

SLEEP Hotel and nano brewery www.caseysofbaltimore.com 028 20197 • Overlooking the bay estuary at Rosscarbery www.celticrosshotel.com 023 884 8722.

LOUGH HYNE PAGE 96

FIND Lough Hyne is 9km from Skibbereen. Take the R595 out of Skibb, and turn left just after the Golf Club. The road winds down to the Lough, and there are two places to park when you get there.

WALK The 3km loop walk at Knockomagh Wood Nature Reserve is a crooked hill that rises steeply over Lough Hyne affording a magnificent view over the coast and islands that stretches from the Stags to Cape Clear. After the summit the trail can be hard to follow, but all roads lead back to the carpark.

EAT Great home baking and pizzas at The Coffee Shop at Uillinn www.westcorkartscentre.com 083 308 6569 • Cute coffee shop @oneillcoffee 086 333 4562 • If you're in Skibbereen on a Saturday don't miss the town centre market, where you can buy a great lunch from any of the superb food trucks that sell beside local food vendors.

SLEEP In the heart of Skibbereen, the well-loved www.westcorkhotel.com 028 21277.

LEVIS CORNER HOUSE PAGE 98

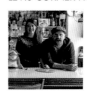

FIND www.leviscornerhouse.com 028 37118 is on Main St in Ballydehob village.

WALK The Old Butter Road travels between Ballydehob and Schull, travelling just S of the R592, taking in the 12-arch railway bridge in Ballydehob as it goes. Butter Roads are named to describe the routes that people took with their horse and cart heading to the Cork Butter Market.

EAT Ballydehob is the fine dining destination in these parts with the soulful www.restaurantchestnutwestcork.ie 028 25766, pizzas at www.antonioristorante.ie 028 37139, wholefoods from Hudsons, and informal cooking from www.budds.ie 028 25842 • Hackett's Bar in Schull is a great pub with delicious soups served at lunch 028 28625. • Further down the peninsula, the Crookhaven Inn 028 35309 and O'Sullivans Bar 028 35319.

SLEEP You'll love www.fortviewhouse.ie 028 35324 in Goleen • and Grove House Schull www.grovehouseschull.com 087 249 4722.

THE SHEEP'S HEAD WAY PAGE 100

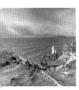

FIND The Sheep's Head Way can be accessed either through Durrus or from the N via Bantry. The peninsula extends down to the lighthouse, and there is a narrow road that circles the route, crossing from N to S of the head at Kilcrohane.

WALK You can walk the full Way or select parts of it. The main looped walk from Bantry to the lighthouse and back is approximately 93km, and it takes about 5-6 days to cover the whole route, with some steep ascents. The paths are all well maintained; follow the yellow arrow on a black background. Individual loop walks are mapped out on www.thesheepsheadway.ie and the website www.livingthesheepsheadway.com.

EAT Heron Gallery is a delightful gallery and café 027 67278 • Sit outside and enjoy good pub food from www.arundelsbythepier.com 027 67033 • At the end of the peninsula near the lighthouse, go for the salmon sandwiches at Bernie's Cupán Tae in the Tooreen car park 027 67878.

SLEEP Stunning location and superb cooking, especially the hors d'oeuvre table in www.blairscove.ie 027 61127 • Two fine B&Bs just outside Durrus: www.gallanmor. com 028 62732 • www.carbery-cottage-guest-lodge.net 027 61368.

ILNACULLIN PAGE 102

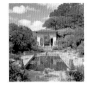

FIND There are two ferry companies operating services to the island; you can buy tickets in Glengarriff. Note, expect to pay twice, first for the ferry, and then on the island itself.

WALK The whole island is laid out in beautiful walks. Don't miss the Martello tower on the southern shore, which has an amazing view of the bay.

EAT Splendid for brunch, lunch and pizzas www.manningsemporium.ie 027 50456 • We love www.organico.ie 027 55905 • Expert baking from @TheStuffedOlive 027 55883.

SLEEP www.eccleshotel.com 027 63003 Splendid Victorian building overlooking the island, and they are working hard to bring this institution back to life • Warm country house in terms of ambition, fine hotel in terms of service www.seaviewhousehotel.com 027 50073 • Stay in a stately home – the magnificent www.bantryhouse.com 027 50047 lets out a small number of rooms for B&B.

THE EWE EXPERIENCE PAGE 104

FIND www.theewe.com Kenmare Road, Glengarriff, Co Cork • The entrance is marked by an old Austin car, on the N71, 3 miles N of Glengarriff, travelling towards Kenmare.

WALK Esknamucky Walk in Glengarriff Wood, a multi-terrain walk through the nature reserve, one of the finest sessile oak woods in the country. Look for the native Arbutus, or Strawberry tree. The trail through the reserve includes a river walk, where the River Glengarriff is home to the freshwater pearl mussel. You see bats at dusk. Magical for all ages.

EAT Exceptionally good crepes and cute shop at www.strawberryfield-ireland.com 064 668 2977 • www.avoca.com 064 663 4720 outlet, high up in the hills at Molls Gap • In picture perfect Kenmare: the vivid www.mulcahyskenmare.ie 064 664 2383, the genial and delicious Packie's 064 664 1508 and classic cooking from www.thepurpleheatherkenmare.com 064 664 1016.

SLEEP In Kenmare, the quietly efficient boutique service at www.brooklanehotel.com 064 664 2077 or try Glamping in www.dromquinnamanor.com 064 664 2888 • A spectacular destination in itself beside Gougane Barra lake www.gouganebarrahotel.com 026 47069.

THE RING OF BEARA PAGE 106

FIND The towns of Kenmare to the N, and Glengarriff to the S are the gateways to the Ring of Beara, and the route takes you to the end of the peninsula and Dursey Island.

WALK The 220km Beara Way is a long-distance walking route based on the march of O'Sullivan Beare in 1603. The walk circles the peninsula taking in its colourful towns and glorious landscape. You can choose selected loop walks, download maps from www.bearatourism.com.

EAT www.maccarthysbar.com 027 70014 was a popular Castletownbere pub long before the late Pete McCarthy declared that it 'might be the best pub in the world' • Teddy O'Sullivan's Bar, 064 668 3104 Lauragh, locally known as 'Helen's' – freshest mussels, or crab by the pier • Super fresh fish perfectly cooked in www.berehavenlodge.com, self-catering accommodation and restaurant • Murphy's Dursey Deli 086 366 2865 – just-landed fish served from a food van at the car park of the Dursey cable car.

SLEEP Waterfront boutique hotel www.bearacoast.com 027 71446. Local food well sourced and beautifully cooked, nicely considered design • www.dzogchenbeara. org Buddhist Meditation Centre takes bookings for those looking to spend time alone, or unwinding with friends and family. This clifftop perch is quite extraordinary.

SKELLIG MICHAEL PAGE 108

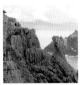

FIND Boats to the island depart from Portmagee, Caherdaniel and Ballinskelligs Pier. The trip costs approx €75 per person (no credit cards accepted). Trips take place from mid-May to late Sept, and landing is weather-dependent. It takes 45-90 minutes, depending on weather and boat. Boats generally give you 2.5 hours to explore the island. The last boats back to shore usually arrive before 3pm. There are no toilet facilities on the rock. Bring sunscreen, and observe the safety advice. A video, published by the Office of Public Works 'Visiting Skellig Michael – A Safety Guide' is available on YouTube.

WALK The Skellig Monks Trail is an atmospheric 2km walk along Ballinskelligs Beach, run as a guided tour from www.skelligsmonkstrail.com. Overlooked by 'the castle on the beach' – McCarthy Mór Tower and the 12thC Abbey, the white sands Ballinskelligs Blue Flag beach is said to have been described by the Skellig Monks as 'the nearest thing to heaven'. Part of the Kerry Dark-Sky Reserve, and a good alternative to the island itself.

EAT/SLEEP Classic coastal bar with rooms, where the crew of *Star Wars* chose to eat and drink, www.moorings.ie Portmagee, 066 947 7108.

SLEEP There are some truly great hotels on the Ring of Kerry peninsula: www.butlerarms.com 066 947 4144, www.qc.ie 066 947 2244, www.sneemhotel.com 064 667 5100, www.parknasillaresort.com 064 667 5600.

KELLS BAY GARDENS PAGE 110

FIND www.kellsbay.ie Kells, Co Kerry • From Killorglin, follow the N70, direction Caherciveen. Approx 13km after Glenbeigh is a right turn, signposted to the house and Gardens.

WALK There are seven suggested walks from Kells Bay House & Gardens, all mapped out by host Billy Alexander. They range from an easy stroll from Kells Post Office to the house, to the challenging Carrauntoohil. More information on www.kellsbay.ie • Carrauntoohil is the highest mountain in Ireland. There are eight different routes to the summit. For more info www.kerrymountainrescue.ie.

EAT There is, surprisingly, a Thai Restaurant in Kells Bay House itself, the Sala Thai Restaurant www.kellsbay.ie 087 7776666 • Killorglin is a gourmet hub: www.nicks.ie 066 976 1219, www.solysombra.ie 066 976 2347 in The Old Church of Ireland, www.zestcafe.ie 066 979 0303 • www.jackscromane.com in Cromane 066 976 9102 is a svelte room with superlative sea views.

SLEEP There is a series of rooms and suites in www.kellsbay.ie 087 777 6666, some of which overlook the garden • The gorgeous www.ardnasidhe.com 066 976 9105 is on the shores of Caragh Lake.

MUCKROSS ABBEY PAGE 112

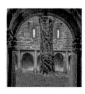

FIND The road into the Abbey grounds is almost opposite Muckross Park Hotel & Spa, on the N71 just S of Killarney.

WALK Killarney National Park Muckross Abbey Loop – You can take a guided walk with a local guide (www.killarneyguidedwalks. com), or follow the trails. Expect to see red and sika deer, mountain goats, and hope to see sea eagles. Look out for the Arbutus Strawberry Tree. The Muckross Abbey Loop takes in the mesmeric Muckross Abbey, the lake and the woods.

EAT In Killarney try the www.celticwhiskeybar.com 064 663 5700 for punchy cooking and whiskey tastings, or @Petitdelicekerry 064 662 6723 for a coffee and a croque monsieur.

SLEEP Two good nearby hotels are the www.muckrosspark. com 064 662 3400 and the beautifully located www. lakehotel.com 064 663 1035. In Killarney itself, you'll find hotel perfection at www.killarneyparkhotel.ie 064 663 5555 or the funky www.theross.ie 064 663 1855 • www.killeenhousehotel.com 064 663 1711 is the most welcoming place we've ever stayed in.

DINGLE WREN PAGE 114

FIND The town of Dingle is nearly at the end of the Dingle Peninsula. You can take the N86 from Tralee, or the shore hugging R561 from Castlemaine.

WALK The Dingle Way peninsula trail is around 50km long and feels like the end of the world. This circular route takes you the whole length of the peninsula, passing Inch beach and over Mount Brandon. Expect to see ancient beehive huts, castles and ring forts. There are some ascents, but no significant climbs.

EAT Some smashing dining destinations in Dingle: www. globalvillagedingle.com 066 915 2325, www.solastapas. com 066 915 0766, www.outoftheblue.ie 066 915 0811, www.thecharthousedingle.com 066 915 2255.

SLEEP And equally smashing places to stay: www. dinglebayhotel.com 066 915 1231, www. greenmounthouse.ie 066 915 1414, www.pax-house.com 066 915 1518.

SLEA HEAD DRIVE AND DUNQUIN PIER PAGE 116

FIND The Slea Head Drive is a circular route beginning and ending in Dingle. Best to travel clockwise, in the same direction as the tour buses.

WALK The Saints Road path – Cosán na Naomh – is a pilgrim walk of 17.7km, across the Dingle peninsula from S to N, from Ventry to An Baile Breac. This is a straightforward walk with no major challenges, and with spectacular sea and mountain views on one of the old pilgrimage roads.

EAT Don't miss Caifé na Caolóige, the wonderful café at www.louismulcahy.com 066 915 6229. Take some pottery home too, or throw a pot while you are there. Magnificent, and open all year despite its faraway location.

SLEEP Have you ever wished to stay in a brewery? There are several en suite rooms attached to Tig Bhric pub www. westkerrybrewery.ie 087 682 2834.

GALLARUS ORATORY PAGE 118

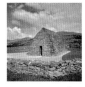

FIND www.gallarusoratory.ie Caherdorgan S, Dingle, Co Kerry • On the Slea Head Drive at the far end of the Dingle Peninsula. Look for signs to Murreagh. The visitor centre is signposted from the road, and the Oratory is just behind it. The Oratory stays open even on days when the visitor centre is closed.

WALK Mount Brandon is a destination for hikers and pilgrims, and the walking route from Faha is startlingly scenic, sweeping up the summit at 952m, Ireland's 9th highest mountain. Immerse yourself in history, culture and scenery in this 13km hike.

EAT Two Dingle coffee spots are www.beanindingle.com 087 299 2831 and @myboybluedingle.

SLEEP Fabulous guest houses side by side, and overlooking the bay, www.castlewooddingle.com 066 915 2788 and www.heatonsdingle.com 066 915 2288.

BALLYBUNION BEACH PAGE 120

FIND Ballybunion is W of the town of Listowel, and the beach is at the edge of the town centre.

WALK There is a short clifftop loop walk around the Ballybunion beaches that includes the Nine Daughters Blow Hole, where a local chief supposedly threw his own daughters to avoid the possibility of them eloping with Vikings. There is also the secluded Nun's beach, named after the convent that overlooked the bay. Access to the beach is down a steep track, but there is a rope for assistance. Start and end in Ballybunion.

EAT In Ballybunion, tasty classic cooking from www.mcmunns.com 068 28845, a Kerry gem – www.daroka.ie 068 27911 and fine simple daytime cooking @lizzyslittlekitchen 087 149 7220 • Over in Tralee your destinations are coffee and a burger in www.theroasthouse.ie 066 718 1011 or seafood www.spaseafoods.com 066 713 6901.

SLEEP Pretty, ivy-clad www.listowelarms.com The Square, Listowel 068 21500.

LIMERICK MILK MARKET PAGE 122

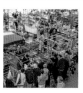

FIND www.milkmarketlimerick.ie • The market folds around a central square in the heart of the city, just off Mungret St.

WALK In the centre of Curraghchase Forest Park is the shell of an 18thC mansion house, Curraghchase House. The house was the home of poet and author Aubrey de Vere. The house is magnificent, but the grounds are special too. The house overlooks a lake, and is surrounded by Curraghchase forest. The looped trails, in the 313ha of mixed woodland, are especially fun for cycling as well as walking.

EAT www.milkmarketlimerick.ie 061 214782 • Genuine Limerick cooking, all cooked from scratch in www.mortellcatering.com 061 415457 • Great pub food in www.curragower.com 061 321788 • Over in pretty Adare, classy cooking in both www.1826adare.ie 061 396004 and www.thewild-geese.com 061 396451.

SLEEP Overlooking the river, the smart www. strandhotellimerick.ie 061 421800 • In the Georgian quarter www.oneperysquare.com 061 402402 • Just out of town the sublime www.mustardseed.ie 069 68508.

GALWAY AND THE WEST

FIND | WALK | EAT | SLEEP

LOOP HEAD PAGE 124

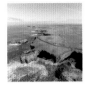

FIND www.loophead.ie • Loop Head is the headland at the N side of the mouth of the River Shannon. The gateway to the zone is the town of Kilkee, and the headland leads down to the landmark lighthouse.

WALK The sea cliff walk in Kilkee is known locally as The Cliffs of Nowhere, in deference to the more famous cliffs up the road. The cliff walk is accessible from behind the Diamond Rocks café, and loops around with incredible views of cliffs and sea stacks.

EAT Destination restaurants on the Loop are BiaBaile at www.murphyblacks.ie 065 905 6854
- www.diamondrockscafe.com 086 372 1063
- @liratkilkeegolfclub Kilkee 065 905 6048
- www.naughtonsbar.com 086 6493307
- www.thepantrykilkee.ie 065 905 6576
- www.thelongdock.com 065 905 8106.

SLEEP www.stellamarishotel.com 065 905 6455
- www.thestrandkilkee.com 065 905 6177.

THE BURREN PAGE 126

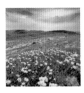

FIND The Burren is an area of 350 square kilometres of karst landscape in N County Clare, S of Ballyvaughan, N of Lisdoonvarna and W of Kinvara.

WALK Tolkien is said to have been inspired by The Burren to write the story of Middle Earth, and this extraordinary landscape of limestone pavement interspersed with wild flowers is one of Ireland's greatest treasures. Walk the Burren Way and expect to see many ancient relics and ruins, fascinating terrain, stone fields, and plenty of wild flowers.

EAT Upmarket pub grub and craft beer at Roadside Tavern and pizzas at The Storehouse, both part of www.burrensmokehouse.ie 065 707 4432 • Bean to Bar chocolate factory and café at Granny's Coffee House www.hazelmountainchocolate.com 065 707 8847 • Meticulous www.kilshannyhouse.ie 065 707 1660.

SLEEP Family-style hospitality and very good cooking at www.sheedys.com 065 707 4026 • The Old Ground www.flynnhotels.com just outside the zone in Ennis 065 682 8127.

POULNABRONE DOLMEN PAGE 128

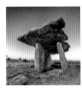

FIND Literally just beside the road on the R480 between Leamaneh and Ballyvaughan (and keep an eye out for the ghostly Leamaneh Castle as you drive by).

WALK Dromore Woods Loop is a continuation of the Burren landscape with limestone pavement, and flooding turloughs and callows. The diverse nature of the wood also supports fen peat and reed beds. O'Brien Castle is an 18thC ruin by the lough, and fauna living happily here includes pine marten, red squirrel, stoat, fox and hare, as well as shrews, wood mice and plenty of bats. There are many dragonflies. The Trailhead loop is at Killian, Ruan, and the loop is well marked.

EAT Lovely www.burrenwine.ie on Corkscrew Hill 087 763 3241 • Take a day to visit www.aillweecave.ie 065 707 7036 • And also find time to dream and dine in delightful www.burrenperfumery.com.

SLEEP www.hylandsburren.com hotel in Ballyvaughan 065 707 7037.

GREGANS CASTLE PAGE 130

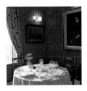

FIND www.gregans.ie Ballyvaughan • Just outside the town of Ballyvaughan, just before the famous Corkscrew Hill, on the N67 in N Clare.

WALK The Wood Loop in Ballyvaughan is not a forest walk, but a trail through the limestone terraces around the town. The walk is 8km and takes you up to near the Aillwee Cave. Trailmap available from www.burren.ie.

EAT Carefully sourced and beautifully delivered cooking at www.stonecutterskitchen.com 065 707 5962 • Feel the surfer vibe at www.randaddys.ie 065 708 2740 • Funky and smart www.littlefox.ie 065 707 2311 • Get cosy in @CheesePressEnnistymon 085 760 7037.

SLEEP In www.gregans.ie 065 707 7005 of course but nearby is • Glorious www.moyhouse.com 065 708 2800 • The enjoyable www.hoteldoolin.ie 065 707 4111 • Take a suite at the www.redclifflodge.ie 065 708 5756 • The romantic, beachside www.armadahotel.com 065 707 9000 • Chic www.vaughanlodge.ie 065 708 1111.

DRUID THEATRE PAGE 132

FIND www.druid.ie – The Theatre is on Druid Lane which runs between Quay St and Flood St in central Galway.

WALK The Canal Walk in central Galway allows walkers to amble beside the canal that loops around Nun's Island meeting the River Corrib at each end. Join at the Bridge on Father Griffin Road from where you can stroll to the University campus.

EAT www.handsomeburger.com 091 533992 for whizzo burgers and a great experience • Wild creativity and perfect pizzas in www.thedoughbros.ie 091 395238 • Rock steady cooking in the North Italian influenced www.ilvicolo.ie at the bridge.

SLEEP Intoxicating design at www.theghotel.ie 091 865200.

THE KINGS HEAD PAGE 134

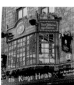

FIND www.thekingshead.ie 15 High St, Galway • The pub is on High St, the pedestrian zone in the city centre, just near the junction with Mainguard St. You'll know it from the buskers who are always performing outside.

WALK The Salthill Prom is a Galwegian tradition, 2km long, and passing the Blackrock diving boards and Mutton Island. Tradition has it that when you reach the end of the walk you literally 'kick the wall' before turning round and coming back.

EAT The most lovable and characterful places to eat in Galway include www.cavarestaurant.ie 091 539884, www.mccambridges.com 091 562259, www.coffeewerkandpress.com 091 448667, www.sheridanscheesemongers.com Winebar 091 564829 • www.americavillage.com Apothecary Tasting Room.

SLEEP www.thegalmont.com 091 538300 is part of the fabric of the city, where many community events take place. The lough view premier rooms are worth the extra spend.

SPANISH ARCH PAGE 136

FIND The Arch overlooks the River Corrib, and was once part of the city walls.

WALK The Long Walk with its pretty multi-coloured waterfront houses, runs from Spanish Arch to The Docks. The route was created way back in the 18thC, but, despite its name, it's a short walk. To make it longer, you can continue through the dockland down to Lough Atalia Road, and walk around the Lough.

EAT One of Galway's funkiest and most revered restaurants is located in Spanish Arch – www.ardbia.com 091 561114 • Also creative cooking in www.thekitchengalway.ie, which is in the Galway Museum at Spanish Arch.

SLEEP Hostels and good value places to stay: www.theheronsrest.com 091 539574, www.thenestaccommodation.com 091 450944, www.galwaycityhostel.com 091 535878.

MACNAS HALLOWE'EN PARADE PAGE 138

FIND www.macnas.com • Galway's Latin Quarter extends from the Spanish Arch to O'Brien's Bridge, to St Nicholas' Church, to Middle Street, and the carnival takes place in this zone.

WALK Sheena and Gosia's www.galwayfoodtours.com, a 2-hour walking and tasting event, is a great way to see and taste the city.

EAT Some of the very best places to eat in Galway are: www.aniarrestaurant.ie 091 535947, www.loamgalway.com 091 569727, www.kaicaferestaurant.com 091 526003, www.tartaregalway.ie 091 567803.

SLEEP Our personal favourite: www.thestopbandb.com 091 586736 • Defining the Latin Quarter www.thehousehotel.ie 091 538900 • Simply a great place to stay – www.huntsmaninn.com 091 562849.

POLL NA BPEIST PAGE 140

FIND/WALK It's a bit of a hike to find Poll na bPeist, best to go in a group. It is near the village Gort na gCapall, from where you can follow the signs and the worn path. You reach the worm hole after a scramble across fields and limestone.

EAT Run by Guatemalan chef, Byron Godoy Flores, www.bayviewrestaurantinishmore.com 086 792 9925 • Man of Aran Crafts & Café for coffee 085 710 5254 • A lively pub that is an Aran institution is www.joewattys.ie.

SLEEP Treasa and Bertie run the best B&B on the island, and make the best breakfasts in Kilmurvey House www.aranislands.ie/kilmurvey-house • Ten handsome pods which each sleep four at www.irelandglamping.ie 086 189 5823 • Not on the island, but on the road west is marvellous www.thetwelvehotel.ie in Barna 091 597000, a before or after spot.

TEACH SYNGE PAGE 142

FIND Just beside An Dún restaurant, near the Roman Catholic Church and Post Office.

WALK The Inis Meain Way is a trail that goes past two stone forts, a wedge grave, the rocky chair that was John M. Synge's favourite spot, and some puffing holes. Not bad for an 8km walk!

EAT/SLEEP The glory of Inis Meain is the Restaurant and Suites, but this gets booked up way in advance so think ahead www.inismeain.com 086 826 6026 • There are 5 rooms and a small restaurant with short seasonal menu in An Dún www.inismeainaccommodation.ie 087 680 6251.

MV PLASSY PAGE 144

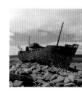

FIND Walk past Inis Mór airport and Loch Mór, and down to the shoreline and you can't miss the wreck.

WALK The tiny island of Inis Oirr has a road with very little traffic that creates a natural loop walk. Start at the pier, go past the airstrip, then look out for the signal tower, O'Brien's Castle, the loch, the lighthouse, the Plassy wreck and views of the Cliffs of Moher amongst many other things to see.

EAT Delightful café, run in the family home of the Donoghue family, good baking, and local ingredients showcased, including Aran Island Goat's cheese, Teach an Tae www.cafearan.ie 099 75092.

SLEEP Chef owner run www.southaran.com and the Fisherman's Cottage restaurant 099 75073.

TWELVE BENS PAGE 146

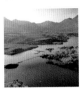

FIND The range extends between Oughterard and Clifden in Connemara. Take the N59 out of Galway.

WALK You need very good fitness and expert climbing skills to hike the Bens, but if you have those skills then some of the peaks at the centre of the range are accessible from the roadside. The Glencoaghan Horseshoe loop provides a 7-8 hour route. Travel anti-clockwise (so that you can descend rather than ascend the scree slopes) this climb takes in 6 of the peaks, including the highest of the 12, Benbaun.

EAT www.odowdsseafoodbar.com 095 35809 the archetype of the rural country gastropub • www.bogbeanconnemara.com 095 35825 great coffee, soulful cooking • Coynes Bar & Bistro 095 33409 for classic chowder, perfect brown bread, music sessions at the weekend • Mighty cooking @powersthatch 091 557597.

SLEEP www.roundstonehousehotel.com 095 35864 Family-owned, modest hotel • www.screebe.com 091 574110 Waterside Victorian fishing lodge.

KYLEMORE ABBEY PAGE 148

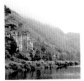

FIND www.kylemoreabbey.com Pollacappul, Connemara, Co Galway • You can see the Abbey across the lake on the N59 between Clifden and Westport.

WALK The Famine Walk at Killary Fjord is a 12km looped walk along the only fjord in the Republic, which was once a hiding place for U-boats. This is a moderate walk along a famine relief path with stunning views of the fjord and Mweelrea Mountain.

EAT Superlative food truck in Leenane, @MisunderstoodHeron 087 991 5179 • In picturesque Tullycross, try Paddy Coyne's pub (ask about the gravestone in the garden).

SLEEP/EAT The magical www.renvyle.com 095 46100 is someplace special • www.maolreidh.com 095 43844 hotel in pretty Tullycross.

DERRIGIMLAGH BOG PAGE 150

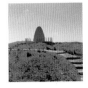

FIND Just outside Clifden on the R431. Look for the Wild Atlantic Way Discovery Point.

WALK The 5km looped Derrigimlagh Walking trail takes place on raised boardwalk over the bog. There are information points throughout the walk where you can learn more about this fascinating story.

EAT In Clifden: www.mitchellsrestaurantclifden.com 095 21867 ultra-professional, first choice in the town • @SteamCafeClifden 095 30600 funky, fun and colourful.

SLEEP www.thequayhouse.com 095 21369 • Iconic waterside destination down the hill at the old harbour • www.bluequayrooms.com 087 621 7616 from the family that operates the Quay House and equally as beautiful • www.mallmore.com 095 21460 • classic Georgian address set in elegant gardens • www.clifdenstationhouse.com 095 21699 comfortable town-centre lodgings.

CROAGH PATRICK, HOLY MOUNTAIN PAGE 152

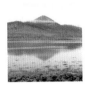

FIND Take the R335 out of Westport for 10km, and you will see the visitor centre on your left.

WALK The hike up Croagh Patrick is a moderate to strenuous 4-hour trail up Mayo's third highest mountain. The summit has a little church at 762m above sea level. Stunning views of Clew Bay. The last section of the walk is very rocky, and we always end up scrambling up to the peak on all fours.

EAT www.tavernmurrisk.com 098 64060, accomplished and meticulous • www.anportmor.com 098 26730 friendly, quintessentially Mayo cooking • @thismustbetheplacewestport 083 059 9229 hip and welcoming, great coffee skills • www.thepantryandcorkscrew.com 098 26977 distinctive, personal food • www.ciansonbridgestreet.com 098 25914 impressive modern Irish food.

SLEEP www.westportplazahotel.ie 098 51166. Busy and lively town-centre hotel.

GREAT WESTERN GREENWAY PAGE 154

FIND The Greenway meanders between Westport town and Achill Island, taking in the villages of Newport and Mulranny on the way. Entry points at all stages of the route.

WALK The Achill to Mulranny section of the route is 13km long and makes for a lovely walking trail, as much of it is off road. The section on Achill Island is particularly striking. Shower and changing facilities at the Mulranny Park Hotel.

EAT Shauna Kelly is the local food hero @KellysKitchenNewport 098 41647 • Excellent savoury and sweet baking www.bluebicycletearooms.com 098 41145.

SLEEP www.mulrannyparkhotel.ie 098 36000. One of the finest hotels on the west coast.

THE DESERTED VILLAGE PAGE 156

FIND On the southern slopes of Slievemore mountain, close to Dugort. From the R319, look for the Keel Holiday Cottages, continue onto Slievemore road until you get to Dugort Beach Holiday Homes, turn left and you will see the rocky houses on the hill.

WALK There are several astoundingly beautiful walks crossing Achill island. The Keem Bay Walk is a moderate walk that begins steeply, but becomes less strenuous after the initial climb. The walk takes you to the tip of Achill Head. Begin at Keem beach car park and walk to the top of Carraig Fhada. That's the hard bit done. The path travels parallel to the cliff top before turning inland and downhill back to Keem. It should take you about two and a half hours.

EAT @TheBeehiveCraftCoffeeShop 086 854 2009 iconic destination for eating and shopping • www.puremagic.ie/achill 085 243 9782. Good funky pizzas for surfers.

SLEEP www.bervieachill.com 098 43114 Comfortable lodgings in the old Coastguard station • www.achillcliff.com 098 43400. Understated and welcoming.

NATIONAL MUSEUM – COUNTRY LIFE PAGE 158

FIND www.museum.ie/Country-Life Castlebar, Co Mayo • The museum is just off the N5, well signposted in Turlough Park.

WALK The Western Way is a linear route that takes you from Leenane to Ballycastle, through mountain and moorland, bog and around lakes. Mayo is considered to be one of the most remote parts of Ireland, and this route is an unforgettable pilgrimage that takes in the holy mountain of Croagh Patrick, with its views over Clew Bay.

EAT Foxford Woollen Mills Visitor Centre and Café 094 925 6104 www.foxfordwoollenmills.com • www.caferua.com 094 902 3376. All the flavours of Mayo in one of the great west coast rooms • www.barone.ie 094 903 4800. Super-professional outfit with great cooking and drinks • www.houseofplates.ie 094 925 0742. Excellent plot-to-plate cooking.

SLEEP www.knockrannyhousehotel.ie 098 28600. Set outside the town, the hotel is an ocean liner: you never need to leave. Superb cooking.

MARSHALL DORAN COLLECTION PAGE 160

FIND Take the castle road out of Ballina and the castle entrance is 3km further, through Belleek Wood.

WALK There are trails throughout the nearby Belleek Woods in the former Belleek estate. Mixed woodland and riverbank scene, and a number of historical features including a hermitage, ice house and the grave of one of the original owners of Belleek Castle who was buried with both his horse, and his wife.

EAT/SLEEP www.belleekcastle.com 096 22400 nice cooking, brilliant staff and good informal food in Jack Fenn's Courtyard daytime café • www.icehousehotel.ie 096 23500. Super-stylish hotel right on the river's edge • www.heffernansfinefoods.ie 096 73528 is the top choice in the town.

CÉIDE FIELDS PAGE 162

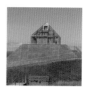

FIND 7km NW of Ballycastle. Wear protective clothing and footwear suitable for walking on uneven terrain in the rain.

WALK The Ballycastle Loop is a 9.5km trail along country lanes and bogland. Fine views of Downpatrick Head.

EAT Mary's Cottage Kitchen in Ballycastle 096 43361 – friendly old-style cooking.

SLEEP www.thetalbothotel.ie 097 20484. Colourful, modern decor and some good cooking • www.leimsiar.com is a great B&B destination in the ultra-wild part of Mayo.

ENNISCRONE SURF PAGE 164

FIND Drive off the main town thoroughfare towards the beach, and there are access points through the marram grass.

WALK The Aughris Head walk starts and ends in the carpark of the Beach Bar, so you can look forward to a bowl of chowder at the end of the 5km cliff walk • A large portion of the Union Wood Loop in Keadue is set aside for growing mature sessile oak mixed with downy birch, holly and rowan in this ancient woodland site. The forest has a car park, a picnic site and about 8km of pathways and forest trails. To reach the trailhead follow the road to Keadue, and look for the signs.

EAT www.puddingrow.ie 096 49794 some of the best food in the North West • @NookCafeRestaurant 071 911 8973. Polished, satisfying cooking from Ethna Reynolds.

SLEEP www.waterfronthouse.ie 096 37120. Boutique waterfront hotel with ambitious cooking.

BENBULBEN AND YEATS COUNTRY PAGE 166

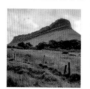

FIND Yeats' grave is in Drumcliff church, just off the N15 8km from Sligo.

WALK 'Where wandering water gushes' wrote W.B. Yeats in *The Stolen Child*, describing the 15m-high Glencar waterfall, gushing from steep, steep hills and wandering down to Glencar Lough. There is another, lesser-known waterfall nearby called 'The Devil's Chimney'. With the right wind conditions and after heavy rain, the water sprays back over the cliff and you understand how the waterfall got its name • Or take a walk up the Queen Maeve trail on top of Sligo's other mountain – Knocknarea, which leads you to the massive cairn. The route, marked with red arrows, takes about 2 hours.

EAT @VintageLaneCafe 087 662 2600 for savvy drinks and sarnies • www.eithnasrestaurant.com 071 916 6407 for the best seafood in the area • www.langs.ie 071 916 3105 for good pub food • www.drumcliffeteahouse.ie 071 914 4956 for good cups of tea, cake and retail therapy.

SLEEP www.theglasshouse.ie 071 919 4300. First choice for hotel accommodation in Sligo town • www.thecourthouserest.com 071 984 2391. Simple rooms in the old court house, but the Sardinian cooking is the real draw.

BALLYMASTOCKER BEACH PAGE 168

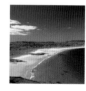

FIND On the E of the Fanad peninsula, stretching from Portsalon Pier to Magherawarden.

WALK Ballyarr Wood Nature Reserve is being managed as a semi-natural native woodland. Wild oak flourishes in what was always a wild forest. Pathways and boardwalks have been built to make the wood more accessible to walkers. The circular path takes you through the oldest part of the woodland.

EAT www.thecounterdeli.com 074 912 0075 don't miss the legendary sausage roll. And everything else • www.thelemontreerestaurant.com 074 912 5788 where the Molloy siblings offer lovely food and terrific value • @ShackCoffee.ie for beautiful coffee at a beautiful beach.

EAT/SLEEP www.rathmullanhouse.com 074 915 8188. One of the leading lights of the far North West for four decades. Their Tap Room sends out great pizzas and local craft beers.

EAGLE'S ROCK PAGE 170

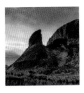

FIND The car park is signposted from the R280 that leads from Kinlough to Glenade.

WALK The walk to the rock is a steep unstructured scramble that begins at the car park. Cross the stile to the right of the car park, but be prepared for the good path to quickly run into grassy, rocky unmarked track. Two-hour energetic walk there and back.

EAT/SLEEP www.w8centre.ie 083 383 3615 and its restaurant Osta at W8 071 985 6300 is a dynamic development in Manorhamilton. The enterprise, with self-catering apartments and café and evening time restaurant all reflect the glorious terroir of the region. • In Kinlough, the elemental and charming Sardinian restaurant with rooms, www.thecourthouserest.com 071 984 2391.

ST AENGUS CHURCH PAGE 172

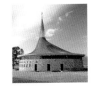

FIND In the centre of Burt on the road that leads up to An Grianán.

WALK Inch Wildfowl Reserve, Burt, on the Lough shore, is home to thousands of migratory birds. The pathway around the reserve is used by walkers, runners and cyclists. There is an 8km looped path with bird hides that are open to the public so that you can get closer to the wetlands.

EAT www.mcgrorys.ie 074 937 9104 worth the trip for the chowder and the brown bread alone. Famous also for music sessions and concerts.

SLEEP www.glenhouse.ie 074 937 6745. Close to the Glenevin waterfall, the house is quiet and comfortable, beloved of hikers • www.angriananhotel.com 074 936 8900. A popular hotel sited hard by the main road in Burt.

GRIANÁN OF AILEACH PAGE 174

FIND 3km from Burt, take the road up beside Burt Church and it is signposted from there. Car park at the top of the hill and a short walk to the fort.

WALK The Inishowen Peninsula Loop starts at the World War II tower at the carpark on Inishowen head, and then loops for 8km along wild and remote coastline, passing bog roads, laneways, and the lighthouse.

EAT/SLEEP www.foylehotel.ie 074 938 5280. Sublime modern Irish food from a crack team and clean simple rooms.

GLEBE HOUSE AND GALLERY PAGE 176

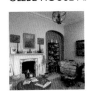

FIND Churchill, Letterkenny, Co Donegal • Between the Loughs, just off the R251, beside Glenveagh National Park.

WALK Further W at the coast, One Man's Pass on the Sliabh Liag Cliffs, is one of the scary glories of Donegal. To reach the start, drive 6km beyond Teelin to Bunglass Point Car Park (through a gate). The lower car park is recommended. Once parked, follow the marked path for the summit. The path goes inland, but rejoins the cliff edge later. At one point, you reach a very narrow passage with steep slopes on either side. If this is too scary, you can choose an alternative route via the Pilgrim's inland path and rejoin the route after a few hundred metres. Follow the pass to the summit. You can then descend via the Pilgrim's Path, known as 'Old Man's Pass' which takes you past the ruins of a small chapel. The Sliabh Liag Cultural Centre in Ti Linn has a very good café.

EAT www.fiskseafoodbar.com, The Harbour Bar, inspired seafood cookery from an on-fire team • For crepes: @crepehousedownings 087 616 9710 • @therustyoven – charming pub, great pizzas at the back of Patsy Dan's Bar.

SLEEP www.breac.house 074 913 6940. One of the most distinctive destinations in the entire country: staying here is unforgettable • www.themillrestaurant.com – one of the defining R'n'Rs, with delicious Donegal foods.

NORTHERN IRELAND

FIND | WALK | EAT | SLEEP

DERRY CITY WALLS PAGE 178

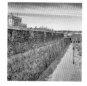

FIND You can access the wall at a number of points climbing stairs that take you to the ramparts.

WALK The City Walking Tour www.derrycitytours.com brings history to life – 100% recommended. The walk looks at the Bogside, The Murals, the story of Bloody Sunday, the history of the Apprentice Boys and the Marching season. It's all done in a cheerful and non-political witty style, that shows the city that brought you *Derry Girls* in its best possible light.

EAT www.sodaandstarch.com 028 7137 1635. Accomplished heartwarming cooking • www.nonnas.pizza 028 7122 4422. Mighty pizzas and mighty fun.

SLEEP www.bishopsgatehoteIderry.com 028 71140300 The old Northern Counties building has been beautifully converted, and has a perfect location.

FREE DERRY CORNER PAGE 180

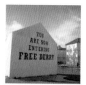

FIND Free Derry Corner is in the Bogside area of the city at the intersection of the Lecky Road, Rossville St and Fahan St just a few hundred yards outside the City Walls.

WALK Take the journey to Ireland's most northerly point at Malin Head. There is a short walk from the car park, at the Caffe Banba coffee cart, to the tip at Banba's Crown, but because of the wind the walk seems longer, and the wind is unrelenting. The word Eire, placed in stones, was to signify neutral Ireland to passing planes during the war. Banba's Crown is marked by an early 20thC tower, later used as a signal station.

EAT www.saffronderry.co.uk 028 7126 0531. Beautifully executed Indo-European food • www.primrose-ni.com 028 7137 3744. Sublime coffee and cakes, but all the cooking is assured • www.pykenpommes.ie 028 77 438 92108. Food cart hero gets hip bricks and mortar set-up.

SLEEP www.shipquayhotel.com 028 7126 7266. Intimate rooms, excellent staff, great location.

THE PEACE BRIDGE PAGE 182

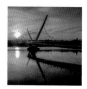

FIND Beside the Peace Flame at the bottom of Shipquay Street, and leading over to Browning Drive, connecting the Cityside to the Waterside.

WALK Where Derry's River Foyle empties into the Lough, there is the 5ml lough-side Lough Foyle Walk that starts at Ballykelly and travels along the bank of the Foyle until you get to the River Roe Estuary National Nature Reserve. Look out for the wreck of a WWII aircraft at low water just after you cross the footbridge.

EAT www.walledcitybrewery.com 028 7134 3336. Dynamic craft brewery also has funky, smart modern food • @guildhalltaphouse 028 7136 4888. You have to have a pint of Dopey Dick when in Derry • www.guildcafe.co.uk 028 7136 0505. Good food served with consummate good taste • www.thewarehousederry.com 028 7126 4798. Bistro and gift shop beside the Guild Hall.

SLEEP www.cityhotelderry.com 028 7136 5800. Overlooking the river, the hotel is a great big tall pile, animated by excellent staff.

DUNLUCE CASTLE PAGE 184

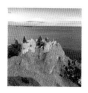

FIND 87 Dunluce Road, Bushmills, Co Antrim. Park in the roadside car park and walk down to the rock, where a bridge carries you over to the castle itself.

WALK The Causeway Coast Way is a 2-3 day, 33ml, trail from Ballycastle to Portstewart, passing the Giant's Causeway, Carrick-a-Rede Rope Bridge and Dunluce Castle. The Coast Walk covers a section of the Ulster Way Trail. The path is low-lying and not too remote, so it's great for the novice walker.

EAT www.wearelostandfound.com local heroes, offers all the best local foods • @babushkaportrush 07787 502012. The room is tiny, the cooking is huge • www.ramorerestaurant.com 028 7082 4313. The busiest restaurants in the land, and an iconic fixture in Portrush • @HarrysShack 028 7083 1783. Wooden beachside National Trust room has fine cooking.

SLEEP www.ardtara.com 028 7964 4490. Part of the ultra-professional Browns Restaurant group: very comfortable.

GIANT'S CAUSEWAY PAGE 186

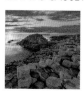

FIND www.giantscausewayofficialguide.com 3mls NE of Bushmills. Ample parking, and approach the site itself from within the visitor's centre.

WALK You can walk the ½ mile to the Causeway by road, or follow a longer circular walk, following the cliff path, then cut back to the causeway, 1¾mls. If you take the road to the site, then you can walk another 2mls on a path, underneath the organ-shaped cliff rocks, and beside the oval sockets known as the 'Giant's Eyes'. All paths are surfaced, but the rocks themselves are a clamber.

EAT www.ursaminorbakehouse.com for great sourdough breads and baking and delightful service for lunch or picnics.

SLEEP The National Trust owned www.thecausewayhotel.com was built to service travellers who came to see the stones way back in the 1840s. Fussy and cluttered, to maintain the century-old style, you get free entry into the Causeway as part of the deal.

CARRICK-A-REDE ROPE BRIDGE PAGE 188

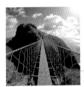

FIND On the B15 White Park road, just past Ballintoy and 2mls from Ballycastle.

WALK There is a gentle walk of about a mile from the car park to the bridge itself, though you can extend the trail if you walk from Ballintoy.

EAT www.centralwinebar.com 028 2076 3877. The place where everyone eats after a pint of Glens of Antrim beer across the street in O'Connor's Pub.

SLEEP www.marinehotelballycastle.com 028 2076 2222. A big refurb job has given the hotel new vigour.

OLD BUSHMILLS DISTILLERY PAGE 190

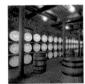

FIND 2 Distillery Rd, Bushmills www. bushmills.com. On the Distillery Road in Bushmills, in the centre of town.

WALK Kinbane Castle is yet another spectacular location featuring a castle on a rock promontory on the Antrim Coast at Kinbane Head, 3mls W of Ballycastle. Take the path down towards the head, Rathlin Island is in the distance. The walk is signposted from the main road. Featured in *Game of Thrones*, naturally.

EAT Tartine at www.distillersarms.com 028 2073 1044. The destination address in the town, with ambitious and well-realised food • www.bothycoffee.com 028 2073 2311. Very busy, very characterful room with fine, smart food.

SLEEP www.bushmillsinn.com 028 2073 3000. Classic coaching inn with atmospheric public rooms.

BUBBLE DOMES PAGE 192

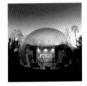

FIND 41 Letter Road, Enniskillen www.finnlough.com On the R232, near to Belleek.

WALK There are short walking and cycling trails throughout the estate • See Legnabrocky Cuilcagh Mountain Boardwalk Trail (bottom left) • Further afield, the Ulster Way is made up of nine sections, linked by six link sections, which are on public roads – walkers are advised to take public transport on the link sections and walk the rest. The route circumnavigates the entire Province in a route of over 600mls. The way marker disc is blue with a yellow leaf. You can download route maps of each section from the website: www.walkni.com.

EAT The restaurant in the Estate is recommended. Multi-national staff are super-professional and they serve wise modern food • www.28darlingstreet.com 028 6632 8224 in Enniskillen serving polished and refined cooking in a funky, Gothic room.

LEGNABROCKY BOARDWALK TRAIL PAGE 194

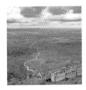

FIND/WALK Start at the Legnabrocky car park, which is about ½ml from the entrance to the Marble Arch Caves. Linear route, 7½mls there and back • The Marble Arch Caves nearby run guided tours throughout the day, each tour lasts around 75 mins www. marblearchcavesgeopark.com.

EAT www.diceys.com 071 985 1371 Craft beer bar and brewery with excellent burger truck at weekends • @buoysandgullsbunduran 087 949 1603 surf, Pilates and coffee.

SLEEP www.finnlough.com 028 6838 0360. The bubble domes are the covetable places to stay (see top right) • www.lougherneresort.com 028 6632 3230. Set amidst a golf course, offers gargantuan bedrooms and some excellent cooking.

ST GEORGE'S MARKET PAGE 196

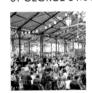

FIND 12 East Bridge Street, Belfast. Opposite the Waterfront Hall near the river.

WALK The Lagan Towpath walk takes you from Stranmillis in Belfast, along the towpath to Lisburn through the picturesque Lagan Valley. Access is from Lockview Road, and you can park near Stranmillis College. The walk highlights a mixture of quiet rural river paths and industrial architecture, including the old gasworks and various locks. There are several opportunities to exit the route if you don't want to go the whole distance.

EAT www.rootandbranch.coffee may be the best brunch in the city, and some of the finest coffee • www.established. coffee 028 9031 9416. Hipster central, with serious food and brews • www.biarebel.com 028 95 435964. Award-winning ramen bowls.

SLEEP www.grandcentralhotelbelfast.com 028 9023 1066. The rooftop terrace is where everyone wants to be in the city.

BELFAST WALL MURALS PAGE 198

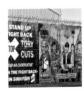

FIND There are a number of Taxi Tours available on line – we recommend the original tour operators Taxitrax www.taxitrax.com.

WALK The C.S. Lewis Trail is a self-guided walking tour that begins at The Searcher Sculpture outside Holywood Arches Library and includes the C.S. Lewis Sq, which has seven Narnia-inspired sculptures. Stop for a coffee here in the architecturally interesting Freight Belfast, NI's first shipping container restaurant.

EAT www.jamesstreetsouth.co.uk 028 9560 0700. A leading light in the local food culture • www. themuddlersclubbelfast.com 028 9031 3199. For many people, the first choice in the city • www.lataqueriabelfast. co.uk 07748 786654. Two branches in Castle Street and Ormeau Road. Echt Mexican cooking, and sublime murals.

SLEEP www.themerchanthotel.com 028 9023 4888. Palatial and sumptuous city-centre destination. Good cocktail bar • www.bullitthotel.com 028 9590 0600. In homage to Steve McQueen's iconic movie, and the place everyone wants to be.

THE CROWN LIQUOR SALOON PAGE 200

FIND www.nicholsonspubs.co.uk 46 Great Victoria St, Belfast. Opposite the tall Europa Hotel and just down from the Grand Opera House.

WALK The silhouette of the basalt rocks at Cave Hill dominates the Belfast skyline and it is said that the rocky hill inspired Jonathan Swift to write *Gulliver's Travels*. The 4½ml walk of Cave Hill Country Park takes you over moorland and heath. It is a challenging route due to the terrain, but the views are spectacular. Begin and end at Belfast Castle.

EAT www.michaeldeane.co.uk for Deanes Eipic, Meatlocker and Love Fish – Three restaurants in one serving high-end food, lush meats, or fine seafood • www.gingerbistro.com 028 9024 4421. Hippy simple, with ace vegetarian dishes • www.shu-restaurant.com 028 9038 1655. A paragon of professionalism.

SLEEP www.fitzwilliamhotelbelfast.com 028 9044 2080. A beacon of reliability: the rooms are excellent • The Europa Hotel www.hastingshotels.com 028 9047 1066. Famous destination, always aiming to improve standards and service.

TITANIC BELFAST PAGE 202

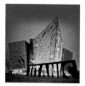

FIND 1 Olympic Way, Queen's Road www.titanicbelfast.com • The centre is just on the E bank of the river, between the Stadium and the two giant cranes.

WALK The Titanic Trail is a 2½ml linear walk around Belfast. You can download the App to your mobile, and learn about the city's maritime building history on a walk that takes in sites from the City Hall, the Titanic Quarter, to the Titanic Memorial Garden • The Window on Wildlife Nature Reserve www.rspb.org.uk is adjacent to the shipyard. Look out for the black-tailed godwit just before they head N. Visit at high tide.

EAT www.oxbelfast.com 028 9031 4121. Starred culinary creativity, and outstanding wine service • www.hadskis.co.uk 028 9032 5444. Cracking savoury Irish cooking.

SLEEP www.titanichotelbelfast.com 028 9508 2000 Incredible location – the old Harland & Wolff HQ. Service can get a little overheated when it gets busy. The bar in the old Drawing Offices is spectacular.

ROYAL COUNTY DOWN GOLF CLUB PAGE 204

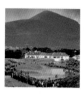

FIND www.royalcountydown.org 36 Golf Links Road, Newcastle.

WALK Northern Ireland has become the centre of interactive tours, from the Murals, to *Game of Thrones* to George Best to *Derry Girls* where clients can dress up, shoot with bows and arrows, drink coffee and generally present themselves for an Insta-ready photo op. At the centre of this is Castle Ward in Downpatrick aka Winterfell www.gameofthrones-winterfelltours.com, now a top attraction featuring walking tours, boat tours, movie set archery tours, cycle trails, Medieval banquets and more to come.

EAT www.mourneseafood.com 028 4375 1377. The original seafood bar, and one of the very best • Café at Castle Espie Wetland Centre 028 9187 4146 overlooking the wetland sanctuary • www.oldpostofficelisbane.co.uk 028 9754 3335. Landmark building with welcoming food and service • Balloo House www.ballooinns.com 028 9754 1210. One of the vital Co Down culinary destinations • The Poacher's Pocket 028 9754 1589. Sister to Balloo Inn, with tasty cooking • www.montaltoestate.com 028 9756 6100. No-expense-spared luxury, good flatbreads.

SLEEP Slieve Donard Hotel www.hastingshotels.com 028 4372 1066. One of Northern Ireland's most famous destinations, for many decades • www.portaferryhotel.com 028 4272 8231. Landmark coaching inn by the water, great cooking.

THE MOURNE WALL PAGE 206

FIND Park at the Carricklittle car park, at the end of the Oldtown Road, Annalong.

WALK The Mourne Wall Challenge takes in 7 of the 10 highest mountains, tracing the path of the wall. Start at the Carricklittle car park. See www.walkni.com.

EAT www.thegalleyannalong.co.uk 028 4376 7253. Charming ladies serve charming Ulster food: delightful • @TheHatch2016a 07921 428099. It may be a food truck in Newcastle, but the food is deeply thought-through and delicious. • One of the North's finest gastropubs @TheBucksHead Inn 028 4375 1868.

SLEEP www.carriagehousedundrum.com 028 4375 1635. Artsy and delightful B&B with views of Dundrum Castle and Murlough Bay.

SEAMUS HEANEY HOMEPLACE PAGE 208

FIND www.seamusheaneyhome.com 45 Main Street, Bellaghy, Co Londonderry. Right in the centre of Bellaghy Village, which is 2mls from the Belfast Londonderry road, A6.

WALK Nearby Portglenone Forest has won the right to be classified an 'Ancient Forest' through various indicator species which take centuries to establish. The Portglenone Forest Walk offers a series of trails through the ancient woodland, leading down to the River Bann. Visit at bluebell time for an even richer experience.

EAT The café in HomePlace is very good and attracts a regular local audience for Irish stew and sandwiches 028 7938 7444 • www.dittysbakery.com Castledawson 028 7946 8243. Also in Magherafelt. Good Ulster baking.

SLEEP www.laurel-villa.com 028 7930 1459. The guesthouse has had an association with the poet for many years. Heaney gave a reading at Laurel Villa in 2009 • www.marlaghlodge.com 028 2563 1505. The restoration of Marlagh Lodge is a charming labour of love: superb Ulster cooking.

DARK HEDGES PAGE 210 & OPPOSITE

FIND There is no signpost until you get there. The trees are on a strip of road about ½ml in length. The road is actually the Bregagh road, just before Gracehill House. Note, the best photographs are taken from the Southern end.

WALK A 2½-hour guided walk through the Gobbins Experience, at Islandmagee is a narrow path set into the cliff face. A good level of fitness is required to traverse the walk, which takes you over bridges and through tunnels and up at least 50 flights of steps. But it's worth it, this is an awesome experience, on a path that has existed since the early 20thC, but has only recently been rebuilt as a tourist attraction.

EAT/SLEEP www.galgorm.com 028 2588 1001. Plush, pricey destination address with enviable levels of professionalism.

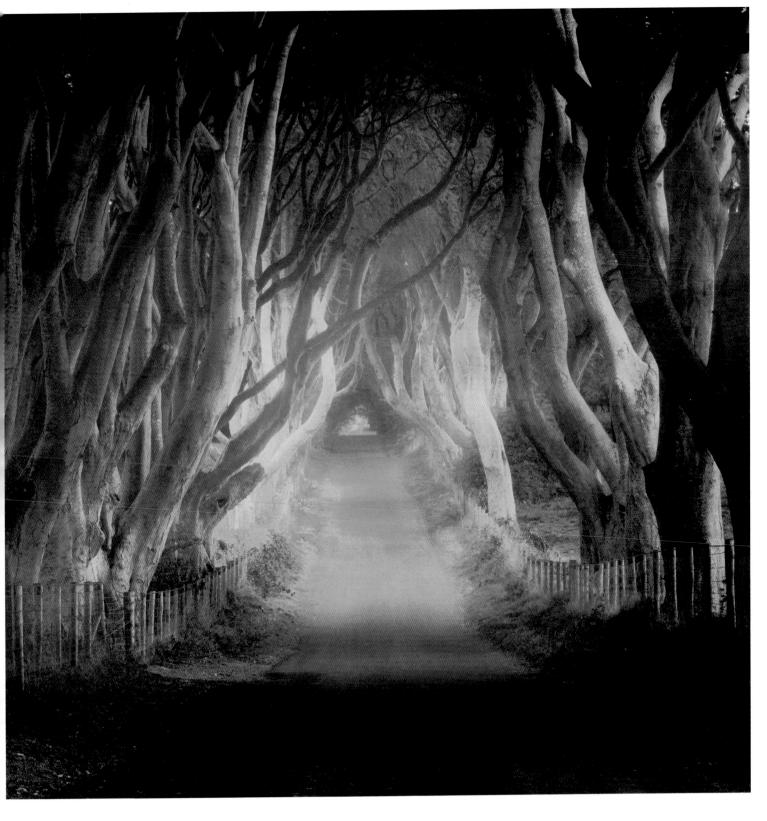

PHOTO CREDITS

Front cover: The Beacon (see page 94)
Front endpaper: Dunquin Pier (see page 116)
Back endpaper: Spanish Arch (see page 136)

Sally and John McKenna have travelled throughout Ireland for more than 30 years, ever since they first bought a second-hand Renault 4 for £100, and set off to explore the country.

Their books have won many awards, and they have been described by *The New York Times* as "Ireland's leading food writers."

In 2018, Sally and John were each awarded an Honorary Fellowship by GMIT Galway, in recognition of their work describing Ireland's artisan food culture.